LAGUNA BEACH
of Early Days

LAGUNA BEACH

of Early Days

J.S. THURSTON

THE
History
PRESS

Published by The History Press
Charleston, SC
www.historypress.net

Opposite, top left: The author, Joseph S. Thurston. *Opposite, top right*: The author dressed in his finest. *Opposite, bottom*: The home place where we first landed in Aliso Canyon as we came up the trail from the right corner. The grapes and the walnuts are gone. They have been replaced by apples, and most of them are gone. The pump was located directly back of two tall cottonwood trees where the road crossed the creek and Dandy played his little joke. *Images courtesy of First American Financial Corporation.*

Originally from the Press of Murray & Gee, Culver City, California
Copyright © 1947 by J.S. Thurston
Printed in the United States of America
The History Press edition 2017

Manufactured in the United States

ISBN 9781625859129

Library of Congress Control Number: 2017938353

Notice: The information in this book is true and complete to the best of our knowledge. It is offered without guarantee on the part of the editor or The History Press. The editor and The History Press disclaim all liability in connection with the use of this book.

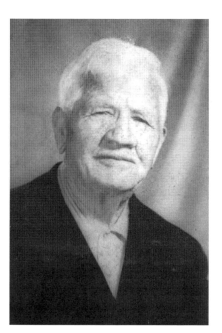
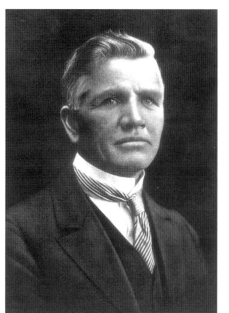
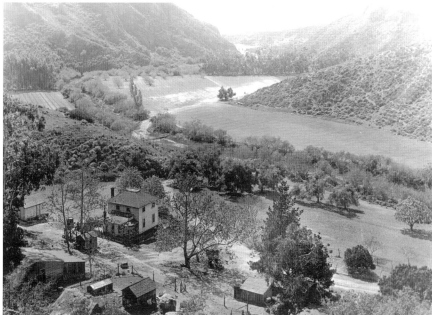

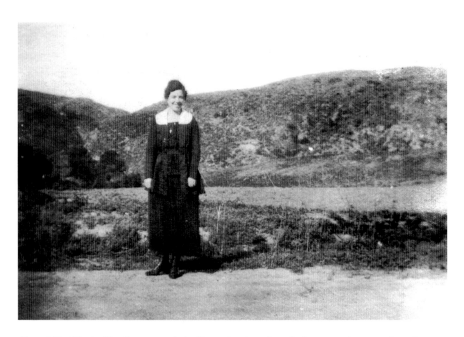

Above: Miss Marie Harding, one of the first schoolteachers in Laguna who stayed, and in 1921, she and Joe married. Marie is the namesake for the middle school in Laguna, Thurston Middle School. *Historical Collection, First American Financial Corporation.*

Opposite: Photograph of the original oil painting of Marie Thurston. *Faye Chapman Photography, Laguna Beach.*

Dedicated to my wife, MARIE,
who kept the home fires burning
while I was writing.

—J.S. Thurston

CONTENTS

FOREWORD

REPRODUCED HERE THAT WHICH WAS PRINTED
IN 1947 ON THE ORIGINAL BOOK JACKET

LAGUNA BEACH of Early Days

Picturesque and inspiring, it is only natural that Laguna Beach with its blue skies, brown hillsides and fabulous seascapes was destined to become a famous California art colony. Its growth from a few scattered buildings to one of the most beautiful seaside resorts in the West was witnessed by the author through three quarters of a century's growth.

Few of the late-comers to Laguna Beach are acquainted with its historic background. In this volume, the author recalls the struggles of the pioneers of this community and paints a graphic picture of early citizens and their contributions to the growth and development of Laguna Beach.

J.S. THURSTON
Laguna Beach Pioneer

The best picture of the author of this volume may be obtained by reading the book itself. The turn of events in the development and growth of the community naturally centered around its pioneers, of which J.S. Thurston

was the first. The simplicity of life of the early settlers, the struggle for survival, the joys and comforts of home-life in the pioneer days, the tragedies, small and large, laughter, play and work made for a full and wholesome life.

J.S. Thurston at 78 is young of soul, hale and hearty, with a weather-eye on the future.

PREFACE

Being the oldest resident in this locality, I was asked by the editor of the local paper to write up some of the early history of the town, thus making a record of that which might otherwise become lost. I wrote short articles for this paper, covering a period of over a year, which were carefully edited and well received by the public. There were, however, many things of a personal nature that could not go into these articles, while they created a demand for something more complete in book form.

In writing this story, it becomes apparent that it will have to be centered around my own life, thus giving the appearance of a personal record. However, I can write of nothing except what came within my own observations. It is also evident that my experience is a part of the history of this locality, the same as anything else that has taken place.

While this story covers a period of nearly three-quarters of a century and may seem cut short in places and drawn out in others, I have tried to do my best with the material at hand and also to be charitable to all the characters concerned, including myself.

It is a record of events that came with my own experience, including a few observations. It has been said that "Life is stranger than fiction." If this is true, perhaps this work will be of interest to people who know nothing of this locality.

The little side trips mentioned have been used partly to tie up with the general conditions of the country at the time and as a prelude to this "Rapidly changing world."

One of the difficulties I found in trying to write was deciding what to leave out. A book is much like a marble statue: its value depends greatly on what has been left out, while the value of a marble statue depends entirely on what has been taken off.

In the early days, as we made our way in this place that seemed so forsaken, how little we realized that we were living right in the path of civilization as it moved forward in its march toward the setting sun—perhaps the greatest movement ever to be made by civilization as it forged its way to the west.

As I did not live directly in Laguna Beach, there may be interesting events of which I did not know, but I was in a position to get a general view of most of the happenings in the early formative days before the time when such events became a matter of record, and it is my purpose to tell of these in as interesting a way as possible.

2017 REPRINTING

*L*aguna Beach of Early Days, a book written by my grandfather Joseph S. Thurston, is uniquely written, presenting an intimate and personal accounting of his life (hardships, survival, friendships, observations, joys and romance) while growing up in Laguna beginning at the age of three.

It was a dream of mine, and my wife, to be able to have this book reprinted to keep my grandfather's written personal history of his life growing up in Laguna Beach available for future generations. As reality TV is popular in the twenty-first century, this book represents *reality history*.

In the book, grandfather recalls an acquaintance, George N. Chase, asking him, "You're a philosopher; why don't you write a book?" to which grandfather's reaction was that it would give anybody the jim-jams to read it, for he felt he was not qualified to write a book, and as his emotions were uppermost, it would not make good reading.

He also recalls a meeting with Mrs. Baldwin, president of the Palmist Society of California, who read his palm. She said he had something for the world, that she did not know what it was, but it was something. Perhaps his writing of this book and its reprinting for the delight of future generations is what the palmist could have been referring to.

In 1921, my grandfather married Marie Harding Frazier and adopted her two daughters, Virginia and my mother, Doris, each of whom married and had children of their own, Virginia four and my mother five. My father, Robert Boyd, owned and operated several restaurants in Laguna Beach, and I learned the restaurant business from him beginning at an early age. In

1982, I married my wife, Michelle Vierstra, and in 1987, my brother Bo and I purchased the well-known Marine Room Tavern on Ocean Avenue, which I managed until my retirement in December 2012.

I am fortunate to have lived and worked in Laguna Beach all my life and served several terms as a Laguna Beach councilmember, serving as its mayor in 2009, 2013 and soon to be 2018, being that I am presently mayor pro-tem. The Laguna Beach High School land site was gifted to the school district by my grandfather. In earlier times, the school included the elementary grades, where my siblings (Happy, Bo, Cindy and Randy) and I attended all twelve grades. Thurston Middle School was named in honor of my grandmother Marie for being one of the first schoolteachers in Laguna (who stayed in Laguna) and her many, many outstanding contributions to the community. Grandfather died in 1957 at the age of eighty-nine.

I wish to acknowledge my deepest gratitude to my wife, since without her efforts, passion and commitment to this project, the reproduction of my grandfather's book could never have been made possible!

—KELLY H. BOYD, grandson of the author

PART I

WE ARRIVE

"There's a house! There's a house!" A light farm wagon, bearing a family of eight, was moving slowly over an unbeaten trail when, on coming over a slight rise in ground, a cabin was revealed a short distance ahead.

The writer, who was just three years old at the time, was sitting in the seat with his father and mother, while the other members of the family were sitting in the back on various articles of equipment that made up the load. Mother was carrying a babe in arms who was less than three months of age. As we drew up beside the little cabin, father got out and began to unhitch the team, while the rest of us investigated the surroundings. One of the first, and by far the most important things discovered, was a huge yellow rattlesnake that was coiled up near the cabin basking in the evening sun. He was soon dispatched with a garden hoe, and war was declared on all of his kind. Up to this time he had apparently been living in peace with a reasonable chance that his peace would not be disturbed, but now an enemy had entered his domain, he had lost his life and all of his kind were in danger.

As we were making our way down the little winding canyon it had presented a rather dismal picture. Though I was too young at the time to think much of it, this picture returned to me later. The only sign of life was the scampering of ground squirrels as they rushed to cover or stood up on their hind legs, chattering as if in protest against the invasion of their territory.

There were a few dried mustard stalks that had not yet been broken down, and there were many piles of white bones scattered over the country where cattle had died and their bones had been left to bleach in the sun, the country having just passed through a series of very dry years when cattle had died to the extent that many of the ranchers had gone "broke."

The cabin nestled in a little cove, flanked on the east by a steep, rugged hill that was marked by a large sand rock bluff, while on the south there was a little point of the hill that ran down to the creek and formed a sheltered cove.

In less than an hour after we arrived at our destination, some Mexicans drove in with farming tools in their light wagon. They informed father that the land belonged to them and that they had come to farm it. They could speak but little English and father could not speak Spanish, but they made themselves understood. Father made it clear that he had possession, did not intend to relinquish it and that he had come to stay. They seemed very much disturbed and acted as though they might make trouble, but they had nothing to prove that they had any right there. The place had been abandoned and was legally open for settlement. Possession was the important point, and they finally turned and drove back whence they came. If we had been one hour later, they would have had possession, and we would have been the ones to drive away.

We had been camping for about a month a mile southeast of a little trading post called Tustin. Father had been looking for government land since coming to the country nine months before, but most of the land had been parceled out in great land grants and it was difficult to find any that was open for settlement. We had been camping on the edge of a land grant that lay to the south, which contained more than 125,000 acres. One day, father got on a horse and started out across this land. The trail he followed led to a little canyon known as Laguna Canyon, and when he came to the beach (which was about fifteen miles away), there was a man fishing along the shore. In talking with this man he made it known that he was looking for government land and was directed by him to the cabin in Aliso Canyon, which was about four miles away. After looking it over he decided to move down at once.

In returning, he rode over another grant, a distance of about ten miles, which contained twenty-two thousand acres. On this trip he passed near the ranch house and had evidently been seen, strangers attracting attention at that time. No doubt the owner of the property was behind the attempt of the Mexicans to claim possession, with the idea of preventing father (in case he should return) from settling on that land, as it would interfere

with their free use of the range. One of the ways these ranchers had of extending their lines was to get an employee to take up land in his own name, and then by giving him a little bonus, it could easily be transferred when the title was secured. There was evidence right above our place where this had been done. There was a crude stone chimney still standing, but the cabin had been removed.

The homestead in the Aliso Canyon upon which this story is based contained 152 acres, one corner (containing about eight acres) running down in the ocean. However, by coming into the country, we had offended the owner of the ranch, which was known at the time as the Rawson Ranch. Most of our land lay on the steep side hills and was covered with brush, producing very little feed. The creek that meandered through the place flowed only in winter time, describing a letter Z as it crossed the canyon from point to point. In fact, one could pick out two of these letters in the three-quarters of a mile of creek bed that we owned. This divided the land up into a number of small pieces, and ended at the seashore as a small lake.

At the place near Tustin where we camped, there was a flowing well and nearby a swamp. At the edge of this swamp there were a number of sheep that had died, victims of the drought. One day, I went over with George, my brother, who was nearly ten years my senior, and watched him. I thought at the time he was skinning them, but he told me later that what he was really doing was pulling the wool off, it being sold afterward for a few dollars.

Father had come to California expecting to find an abundance of government land, but he was sadly disappointed. Whether he had been looking in the right way or not, I do not know, but he had come to the conclusion that the United States Land Office was either under the control of large landholders or was being handled in such a way as to favor them, for he found it difficult to get any information.

When he rode down Laguna Canyon he was passing government land on one side of the canyon and land that was comprised in a grant on the other side for a distance of about four miles. After he reached the beach, where he found the man fishing, he was passing over government land all the way until he came to the cabin. This also was a distance of about four miles, and less than two miles farther down the coast, this strip of available land came to a needle point. This was all the land that was open for settlement in this part of the country, and it was only about two miles in width at the widest point. It all looked alike, and there was no telling government from "grant" land. He had no information and no map.

However, it is natural that he should have chosen the place that was supplied with a cabin, for this was important. The next day, he pulled stakes and started on the trip that proved to be the end of the journey and to the place where the first words were spoken that opened this narrative.

We had been on the way almost exactly nine months, and fate had finally decreed that we should make our home at the mouth of a little valley known as Aliso Canyon.

We were about a half mile from the ocean and were also midway between Los Angeles and San Diego, with the difference that when going to San Diego, after traveling the distance of eight miles, we were farther from that city the way the crow flies than when we started.

When we reached the cabin that we were to call home, the money that father had started out with had been reduced to just forty dollars. There were eight in the family, the youngest child being only about two and a half months old. Father had two horses, a plow, a few hand tools and one blue hen. He also had a fairly good set of carpenter's tools, which was very important.

There was no chance to produce anything from the soil for at least six months, unless it might be a few vegetables. We had brought a few short pieces of board that father had salvaged from the building of a fence. These were used for building a floor in front of the cabin, and on this the tent was pitched, thus giving us two rooms. As nearly as I can remember, the cabin was about fourteen by sixteen feet, while the floor on which the tent was pitched was about two feet wider.

One day there was some little excitement among the children. I was too young to be informed of the cause, but when I went to look, there was father coming up the trail leading a large red cow. I was told sixty-odd years later that he had gone away and worked for Irvine, the man who owned the large ranch spoken of earlier, and he had taken his pay in the cow. So we now had milk, but even taking that into account, forty dollars is not much on which to feed and clothe a family of eight until the time when we would be able to produce something from the land. Our nearest neighbor was eight miles through the hills, and there was no chance to make any money.

I was too young at the time to know just how the living was made, but we pulled through some way. There was one thing that was very much in our favor, however, and that was the ample supply of game. We were near the ocean where we could get seafood, and there were lots of rabbits and quail, as well as deer. We had a small muzzle-loading rifle with which George was able to bring in a good many rabbits, while now and again he got a deer. At

one time, he killed eight quail at a single shot. They had lighted on a gate with their heads all in line.

The surrounding country was a haven for quail. There were several places where there must have been about a thousand of these birds roaming together. Having no shotgun, we could not hunt them, but father made traps and succeeded in getting plenty of them. These traps were made the same as small chicken coops, with two or three small holes at the bottom. Then he made runways that were just large enough at one end for one quail to go through at a time, while at the other end they were about sixteen inches wide and just high enough so that a quail could go through when his head was down. The small end would be placed over the hole at the bottom. A few handfuls of wheat would then be thrown in the coop, in the runway and outside on the ground. When the quail found this good picking they would get excited and follow in, not realizing they were trapped until the wheat was all gone. Having been accustomed to fly from danger, they did not look for the small hole at which they had come in. This is no reflection on their intelligence, but they have well-formed habits as well as all other living creatures. This trapping was much more satisfactory than shooting, as it never made them wild. However, although the trap was used for a number of years, the practice was discontinued when we finally got a shotgun.

OUR NEIGHBORS

While I was too young to know much about how the living was made for the first two years, I do know that we were all living at the end of that time, that we had another cow, a flock of chickens and a few ducks. I was old enough, however, to feel the isolation of the place. One morning, I asked my oldest sister, Sadie, how long she thought we would stay in this place. She looked up to the hills and said, "Oh, about forty years." This was not very consoling, and I said no more.

There was no one living along the coast from Newport Beach to San Juan Valley, a distance of about twenty miles, and three miles up this valley was located the old mission known as San Juan Capistrano Mission. The man who owned the twenty-two-thousand-acre ranch before mentioned lived eight miles to the northeast up Aliso Canyon, by the road we had to travel in going either to Los Angeles or San Diego. There was a family living near Capistrano, whose name was Rosenbaum and whom father

met owing to the fact that the road passed their house, but none of the rest of us knew them until years later. This was about eight miles through the hills but about twice that distance by way of the road, so our neighbors were not important to us.

OUR MARKET

It is impossible for me to imagine how father could have had anything of importance to take to the market in less than two years. Los Angeles and San Diego were the only places that he considered as real markets. The town of Santa Ana was only two years old when we arrived, the business section consisting of one store where everything was sold from pins to plows and from groceries to postage stamps. It was twenty-five miles distant. Anaheim was a little farther and a little older town, but both places were supported by their own local people. It was a number of years before father would stop at either of these places to trade, for they had to depend on hauling their supplies from Los Angeles and had to charge for this service.

It was so far to market that it was not profitable to haul anything except such things as butter, eggs and honey, so our efforts were bent toward producing these items; but this leaves the first two years blank, for I never learned what he had to sell during that time.

There were some wild bees in the country. Father and George collected a few colonies of these out of the rocks or from the trees, wherever they were found, and we soon had some honey to sell. I presume this was the first product we had to market.

As butter was a vital source of income, we children were not allowed to have milk as a regular food. The folly of this is very apparent, but at least we were permitted to have a certain amount of butter. Hulda, the first child born on the homestead, was a little puny and was therefore permitted to have a glass of warm milk every evening. One night, we all went out to watch George milk the cow, and when she saw where it came from, she refused to drink any milk for several days. We did not know the value of buttermilk as a food, but anyway, it was needed for the pigs and chickens.

Father made a practice of going to market once every month. If he went to San Diego, it meant seven days out of the month, and if he went to Los Angeles, it took five days. At such times, he would bring a newspaper, and we would learn what was going on in the outside world.

In traveling along the road in those days, there were people who were always glad to have company, and I do not believe he ever paid anything for his keep. As he only had the farm wagon, he could take hay for the horses but not enough to last for the trip. If the weather was bad, he had to make the most of it, and sometimes he would get caught in the rain, but one of the worst things was in traveling after the rain when the ground got sticky and would ball up on the wheels. Then he would have to stop and cut it off with a hatchet. I was too small to be of any importance at the time, and most of this information was gathered from listening. However, with all the difficulties I noticed that he nearly always got back on time.

Other Game

The little lake down by the ocean made a haven for ducks, great numbers of them coming there to winter. Also, great flocks of geese would go by, but they did not land, for they liked the wide open spaces. They would go south in the fall and north in the spring, nearly always flying in formation, but sometimes they would go by in confusion. They always made their presence known by their loud honking.

When we finally got a shotgun, the ducks furnished us with another game bird and some very fine eating. The hunting was done with the idea of getting as much game as possible with a given amount of ammunition. I once killed seventeen quail with a single shot and have killed all the numbers below that at various times. Years later, I went up the canyon about three miles one evening where the rabbits were thick. I got out to shoot a rabbit, and another one popped up his head. After shooting him, I went over and picked up three. I brought in sixteen rabbits that evening, after firing only thirteen shots. We had a buckboard, and father was driving. This was the only time he ever went with me on any of these hunting trips and the only time I ever had such luck. He drove by some large nettles that were about six feet high or more. I moved my foot to keep them from hitting me in the face, and got it caught in the spokes of the wheel. The horses were trotting, and in a wink over I went onto the ground behind them, with a loaded gun in my hand. If they had made one jump, it would have wrapped my leg around the axle, but they were stopped before the wheel had made a turn, and I climbed back, with no harm done.

THE DATE IN HISTORY

We arrived at the homestead in Aliso Canyon the latter part of November 1871 (almost, if not exactly, on the date when I became three years old). You will not get the full meaning of this date until it is tied up with contemporary history, so if you will refresh your memory, you will realize that this was the year that Mrs. O'Leary's cow kicked the lantern over, which started the fire that laid the city of Chicago in ashes, and when we reached the canyon, the fire had hardly stopped smoldering. The newspapers carried nothing much but stories of this fire for some time.

You will also recollect that this was the year that the Treaty of Paris was signed and Germany became one of the great powers in the world. It was just about ninety-five years after the Declaration of Independence and twenty years after California had been admitted to the Union. It was before the lowly, but now indispensable tomato had been accepted as a food.

A lot of water has passed under the bridge since that time. Indeed, greater changes have taken place than ever before in thousands of years. It was the greatest history-making period of the world. Man had just begun to enter into the machine age, and into the art of mass production, which meant the end of individual handicraft. Clothes at that time were made at home, and it was many years before garments for women could be bought in a store. Mother had an old carder, a contrivance that was used to prepare wool for twisting into thread before it could be made into cloth. While this was no longer used, we did make our own candles, which helped out with the coal oil lamps. We made our own soap and leached the lye out of ashes for this purpose. When I was nearly grown, we bought one hundred bars of soap for three cents a bar. Even this was homemade soap, but we never made any more.

The hay was cut with a scythe and raked up with a hand rake. It was many years before we got a troublemaker, called a mowing machine. It was a troublemaker because a bolt had been sheared off and the hole it left had been used for an oil hole, 'til years later when I took the wheel off while out in the field and found it was not the fault of the machine. This was the first thing that indicated the entry from primitive conditions into the machine age. "Out of the frying pan into the fire."

EXCITEMENT

One day, two small boys came across a large skunk out in the field. Now this skunk could not run very fast and so he became an object of attack. By throwing stones at him, it was easy to keep out of the way of the perfume with which he had been provided as a means of self-defense.

Now it is one thing to throw stones at a skunk and another thing to kill him, but he got in a cactus patch, which limited his ability to spray his particular brand of perfume, while it gave two small boys a chance to keep him in his little hideout, which was furnishing very little protection from the pelting stones.

Finally, after the cactus had been well beaten down, he gave up and in due time was pronounced dead. The task now was to get him out and drag him home, which was about half a mile. After a great deal of trouble, by twisting the end of a stick in the long hair of his tail, he was dragged out and started on his way to the house. The stick would not hold and kept coming out, but the patience of small boys under such circumstances is remarkable, and he was finally drawn up into the yard. Here they were to learn that they had done nothing heroic and, in fact, were barred from the house!

FARMING TOOLS

We had one blue hen as a start in the chicken business, and, as stated before, father had a plow and a few hand tools, but a plow must be followed by a harrow, the only way to get one being to make it at home. This was done by making a frame in the shape of a letter *A*. By fitting this with a set of harrow teeth, it made a very good harrow that served us for many years. However, to do farming without a cultivator was practically impossible, and as it was equally difficult to buy one, this also had to be made at home. It was made by the same pattern but was fitted with wooden teeth made from scrub oak that grew in the hills and was fitted with handles from the same source. This was the only cultivator we had for many years. It served the purpose but did poor work. The teeth were sharpened with a carpenter's drawing knife.

ON THE WAY

As we only saw a newspaper about once a month, we heard very little of the outside world. For some months, all the news was built up around the Chicago fire. When anything of a scientific nature came out, father would read that aloud, so in that way we were somewhat posted on what was going on, but we heard very little of what had gone on before in the nature of history. We heard almost nothing of the Civil War, although it had been only a few years since it had taken place. I never heard of Abraham Lincoln until I was about twelve years old, at least not enough so that I knew what part he took in the war. Then Oscar Rosenbaum told me about his freeing the slaves, though I had little idea of how it was done, except that it was the result of the war.

While I had a fairly good idea of our trip to California, gleaned from listening, the picture was not clear until I got a little information from George a few years ago, from which I will fill in some items.

We had left Utah nine months before reaching our final destination, coming to San Francisco by train and, after staying there for about six weeks, took a boat to San Diego. From there we went up into the mountains, where we lived for six months before moving to the place near Tustin.

George informed me that when we reached San Francisco we were met at the station by a mob of hotel buses, as was the custom of the time. Upon reaching the hotel, father found the rates so high that he determined to look further for accommodation. He was gone for some time, and when he returned, the family had eaten dinner. By the time he had eaten and the bill was presented, it was so large that he took exception, and this started an argument. Now his earthly belongings were all piled in the lobby and could not be removed till the bill was paid; the hotel keeper asked him not to talk so loud because other guests could hear, but he replied that he wanted them to hear the whole story. Finally, George said, he came over closer and said, "I know what you want. You want some money." He took a quarter out of his pocket and handed it to father, saying that he might take his belongings and go. The bill being canceled in this way, he went to another hotel where he stayed two weeks, after which he rented a house for a month. He had come to California because there was so much government land that could be had for the taking, but during the six weeks he became discouraged in his search for land and decided that the U.S. Land Office was being handled for the benefit of the large landholders, instead of for the man who was seeking to make a home.

He happened to meet a man who claimed to have large holdings in Mexico and who made him an attractive proposition, so he bought a wagon and such things as he thought he might need and took passage on a boat to San Diego.

When he reached port, the captain refused to let him have his goods until the freight was paid. As he claimed to have paid this freight in advance, there was some difficulty. Whether or not he had lost the receipt, I never did hear, but I heard him speak of it a number of times, saying that he had paid the freight twice.

After buying a team, his money was running so low that he gave up his intended trip into Mexico. He met a man by the name of Lovet, who was living up in the mountains and who said there was plenty of government land that father might take, where they could live as neighbors. George said this was a beautiful place, with many oak trees; however, it was difficult to reach as the road was poor, and it was quite high in the mountains. Mother had never before been far from her own folks, and this seemed desolate. He said she would sometimes go away by herself and stay for hours, and when she returned would show visible signs of weeping, in spite of what she did to conceal it.

We were living in a tent, as also was Mr. Lovet and his family. There was a bear in the hills nearby, and though his presence was well known, he was not included in the social activities. Mr. Lovet had to go to town, and he came past our place with a load of sweet corn, giving us children an ear which we took into what I thought at the time was a house. There we roasted it in front of the grate. In order to furnish his family with better protection while he was gone, he built a platform up in an oak tree. He had a cow, so for the same reason he brought her down and tied her near the tree. However, this happened to be the bear's night out, and as he had no fear of the family who were sleeping up in the tree, he killed the cow and helped himself to what he could eat. As the cow furnished the best part of the living for the family, this was a severe loss.

It was in this place that another member was added to our family. When I saw father with the little thing in his lap, I asked him where he found it, and he said, "In the ash pile." The ash pile was marked by a rock two feet high and about fifty feet from the door, over which the ashes were thrown. I did not think the infant looked as though she had been picked out of the ash pile but asked no more questions. She was named after Joan of Arc.

The little valley where we were living had been known as Cross Valley, because of two little ravines that formed a cross, so George said, but after the above incident of the bear, it became known as Bear Valley.

George said he was wandering around the hills one day with one of the Lovet boys, who was a little older than himself, when they came to a place in the dense brush where there had been a slide, which had left quite a quantity of foundation rock exposed. He said this rock was covered with human footprints, most of them being fairly small, and which looked as though they might have been made by children who were playing in the mud when the material was soft. I mention this because it will be of historical interest if it is ever rediscovered.

After staying in Bear Valley for six months, father decided to look further for a place to live. He had found government land but not a satisfactory place to live. He came down from the mountain resort and started north into Los Angeles County, where he finally pitched his tent in the place mentioned earlier, near Tustin.

I not only remember that we had trouble getting up a hill on this trip, and that we were traveling in a covered wagon, but I remember two events that happened before we left Utah.

Father had a brother who was waylaid and shot. I begged the folks for a long time to let me see him. Finally, the door was opened, and there he was lying on his right side, to the left of me as I entered the room. He seemed to be quite a young man, and he died shortly afterward from the wound.

I also remember visiting grandmother. She gave us all a bunch of raisins. There was a boy there called Fred, who was about my age. This was probably just before we left for California, and I was only slightly over two years old, but the early awakening of memory accounts for the observations I was able to make while coming down the canyon at the opening of this narrative.

DISILLUSIONED

When I was about five years old, I followed father a short distance from the house. He went to the creek, knelt down and started to dig in the ground with his fingers. This is the first time I remember going this far from the house. I did not follow anyone out to work and was cautioned to stay near the house on account of rattlesnakes. Presently, he asked if I had pulled up a little tree from where he was digging. I replied that I had not, but he was not satisfied and asked if I was sure I had not pulled up the tree. I told him "Yes." He kept questioning me and finally said that if I lied to him he would give me a whipping. I assured him I was not lying. Finally, he said

he did not believe I was telling the truth, so he got a switch and gave me a severe thrashing.

Now the tree in question was not a tree at all; it was nothing but a small willow cutting that had apparently failed to grow. It had no value whatever except the time it would take to put another in its place. He had no cause to think that I had ever been there before, much less to believe that I had pulled up his so-called tree. Also, he had no reason to think I would lie. Why he should have taken this attitude, I have never been able to determine.

If he thought to give me a lesson in telling the truth, he should have waited at least until he had a reason for doing so. Then there would have been some excuse for what he did. If my memory serves me right, this was the first time I had ever followed him just for the sake of being with him. It was also the last time.

HERDING DUCKS

At this time, we had a small flock of ducks. When they went out along the creek, they made easy prey for coyotes and wildcats. The chickens also ran far and wide, but they were not quite such easy prey. If I was out watching the ducks, I would serve as an advance guard to keep these animals entirely away from the place, so I was given the job of herding ducks. This was not so bad when the weather was warm, but the sun did not show itself over the hill to the east until late in the day. I would have to go out when there was ice on the water and frost on the grass, and I had no warm clothes. I had a shirt, a jacket and a pair of pants, all homemade, but there were no warm underclothes. Shoes were of no service because they would get wet; my feet would get so cold that I would find the icy water felt warm, but it would not last, so the only thing to do was to take the ducks farther up the canyon where the sun was shining. There was no reason whatever to go out so early, but this was not taken into consideration. I was out in this way by myself until about four o'clock, when I could come in for dinner, we having only two meals a day. After this I had the eggs to gather, and they were scattered far and wide. Then the "setty" hens must be caught and put in a coop, for all that set out in the open would be likely to afford a meal for some wild animal.

From this time on, my duties alternated between herding the ducks and doing other things that might be of more importance at the time.

DOING CHORES

As there were many gophers on the place, Lafe (one of my brothers) and I were given the job of trapping gophers. Lafe was about twenty months older than myself, and we were given five cents for each scalp, but we did not always have a knife that would cut, and if one of the many hungry cats succeeded in taking one before the scalp was removed, we got nothing. We were supposed to look at the traps before breakfast and after dinner, as this was not a part of the day's work. We had to buy our own traps. Then we had to buy our own shoes and hats, all other clothes being made at home. We did not mind buying these things because we were willing to help, but this was not part of the bargain in the first place. Sometimes we had shoes and sometimes we went barefoot, but it did not make much difference. For a while, when times were hard, the bounty on gophers was reduced to three cents, it then taking thirty-three scalps to make one dollar.

THE MAIN CROP

As eggs were one of the principal products that could be taken to market, most of the land was planted to corn. But the squirrels had been having their own way for so long, they thought we were planting the corn just for them, and they would start digging it up just as soon as it was planted and continue until the stalks got quite large. I was therefore stationed in the field to keep them out. This was an all day job, for the squirrels did not keep union hours. As the land was divided into several small pieces, the corn was planted so that as soon as one field was out of danger there would be another ready for attention.

In order to have the corn planted in rows both ways, father would have us drag a fence post over the ground to make a mark to plant by. This would have to be dragged both ways over the field, and the corn was planted where the marks crossed. Lafe and I would get some willow sticks and peel the bark off so that they would be white, then we would drag the poles as straight as possible, but they would sometimes roll over clods of earth and other times would slide where the ground was not level. It was a thankless task dragging that pole over the ground all day long, but we had to do it that way.

Years later, when I had to do the entire job without any help whatever, I put a cross bar on the pole, hung a chain on each end and made three marks

at a time, planting crosswise. In this way, I had the field planted in much less time than it took two of us to mark the ground. Later, I planted without marks and realized that all this work had been wasted effort.

THE HONEY BEE

As stated before, shortly after we arrived it was discovered that there were a few wild bees in the country. They were found mostly in small caves or cracks in the rocks. A few of these colonies were collected, and father made regular hives for them. As they multiply rapidly, it was not long before we had quite an apiary and were gathering considerable honey.

Bees, like everything else, require a great deal of attention. For several months in the spring, they must be watched very closely, this being the breeding season. They will come out of the hives and alight on the limb of a tree or some other convenient place; then they send out scouts to find a new home. They must be taken before the scouts get back, or they will be lost. As the queen follows the scouts, and the rest of the bees are able to follow the queen from the fact that her wings make a different sound, if they got started they were difficult to handle. Sometimes, however, we would beat on tin pans and confuse the sound so that they were forced to light, when they could be taken and would be satisfied if they had a place to live. Under this old system of handling bees, they must be watched closely or a great many would be lost.

Taking the honey is another job. This is not difficult if it is done in the right way, but as the bees were given no guide and the combs were built in all kinds of shapes, we had to spend time driving the bees out from among the combs with smoke before taking any honey. The honey-filled combs were then put in a sun extractor and melted down, while the bees were given an empty hive. Father and I worked one whole day taking honey from four hives at one time, when we should have taken much more than that in one hour. It took the bees most of the summer to build up the necessary combs for a full supply of honey. The hills and valley were filled with flowers, and the flow of honey was enormous. The hives could have been filled with honey in a week or ten days if the combs had been preserved. We could have taken four or five times as much honey as we did, and it would have been much easier. The cost of making the change could have been repaid from the flow of honey in one week, but father continued in his own way. There were people in the

bee business who came to the beach and told father how they handled their bees, but he made no effort to take their advice.

We built the apiary up until we had 160 stands. The country was wild and unspoiled for the making of honey, but most of the bees spent a great part of the summer in making wax, while the time was being wasted in taking a small portion of the honey that might have been taken. Father made good hives but did not make good use of them. He preferred to do things in his own way. He finally sold them for little more than what the hives were worth, and the bee business came to an end.

Education

Each child, when it reached the proper age, was taught to read, so I learned to read when I was quite young. Outside of a little instruction in spelling and an occasional explanation about punctuation marks, this is about all I was ever taught. One day I was given a couple of copy-books. These books began with straight lines, then came curved lines, which were finally formed into letters. I was allowed about twenty minutes each day to write in these books, and by the time I reached the end of the second book, I was joining two or three letters together. This was the final touch of my book instruction.

One morning, Sadie was giving me a lesson in spelling. One of these lessons was found with each of the little stories in *McGuffey's Reader*. This lesson had one word that contained a silent letter. Now it was hard enough for me to spell when the words were spelt the way they sounded, but I always stumbled on this one. Finally, father, who was still in bed, called me and said to bring him the book. He gave me a few words and then the one with the silent letter. My spelling ability was not improved by coming into his room, especially when he called me over to the bed and gave me a blow on the side of the head that sent me reeling to the other side of the room. Of course, this was a good lesson in memory. At least, I never forgot it. Mother, who was still in bed, did not dare to say anything, and after the lesson, I was relieved to be permitted to leave the room.

Occasionally, while we were growing up, someone would ask where the children were educated. Father would say proudly, "They are being educated at home." The other children had a chance to help each other, but after I was eight years old I was deprived of this opportunity, at least to a large extent. Very little of this education that we received at home was found in books.

Part I

Herding Cattle

When I was eight years old, I was informed one morning that I was to take the cattle up the canyon and herd them off the wheat patch. I had heard that there was wheat growing up the canyon but had never seen any of this crop growing. I assumed that it looked very much like barley and that I would be able to tell what it was when I came to it, so asked no questions, which would have given father a chance to say, "Go and do as you are told."

After breakfast I was given a lunch of bread and honey in a little cornmeal sack, my books being in another, and I started out with the cattle. After going what seemed a long distance, although it was only a mile, I began to wonder if I would be able to tell the wheat from the grass. There had been good rains, and the grass was up about six inches. Everywhere I looked, it appeared the same, so I went over where the point of the hill came down to the creek. Sure enough, from the point of this hill I could see the wheat a little farther up, which was indicated by the rows, showing that the land had been plowed. So I left the cattle and went up there.

By the corner of the field there was a pile of boards showing there had been a small shelter there that had fallen down, and here I made my home. The first day passed away quite normally, everything being new and interesting, but the second and third days I became very lonely and longed for the sun to go down. For some reason or other, it appeared motionless, holding its position in the middle of the sky and staying there. By long and dismal watching I could tell that it was moving a little, but it had never seemed so slow before. When it finally went down behind the hill, it was still a long time before I could go home. It was necessary to get there just in time to gather the eggs before it got dark, and the shadows that stood on the little sharp peaks that I could see on the hill beyond where the house stood must reach the right shape before it was time to start, for to get there a little too early or a little too late meant a scolding. These two days stand out in my memory in such a way that I often wonder what Joshua might have done if he had been favored with two such days. He might have been able to change the history of the world.

After this I refused to let the days drag in this way, and I got along better. Occasionally, I saw some kind of an animal, and I knew there was a mountain lion living in the hills because he would sometimes come down and kill sheep, according to the reports of Old Jake, the herder, who was taking care of a band of sheep that was kept nearby. He said he would sometimes get up at night or in the early morning and drive him away with a tin can, but I knew

he did not come out except at such times, so gave him no thought. If I left my lunch, the squirrels would cut holes in the bag and help themselves, so I had to carry it wherever I went. One day, I came to my shack, and a squirrel ran out of it. I gave him such a chase that he dived into the first hole he came to. I had a stick about two and a half feet long and one inch thick that I had cut from a bush. This I rammed down the hole, which proved to be too shallow for his protection. He found it so uncomfortable that he took his chances of coming out and getting into another hole, but he miscalculated, for I had him by the back of the neck and had his head smashed before he knew what it was all about. He didn't even get a chance to scratch or bite.

One day I had to go up on the hill after the cattle. On the way I saw a wildcat. He was across a little canyon and went into a clump of brush. I figured he was far enough away so that I would be in no danger, so I went around and drove the cattle out. I had seen these cats (which are one of the lynx family) fight with dogs, and had heard father remark how they could tear a man to pieces. The next day, the cattle were in the same place, and I had no idea where the cat was. I had to go up through the scattered brush, not knowing what bush he might be hiding behind, so I took a firm grip on my little stick and kept a sharp lookout. I had no fear, my only thought being that if he should undertake to jump on me I was going to hit him first right on the head. However, he did not make his appearance. That evening, I told mother that I had seen a wildcat, and she told me there was no need to be afraid as they were afraid of me. While I had not been afraid, it was not because I trusted the critters.

It was only a short time after this that I had a chance to test the matter out while I was bringing the cattle home. I saw a cat where the creek touches the point of the hill. He was coming my way as the cattle were going along the trail in Indian file. A cat seldom looks far ahead, and as he stepped into the trail behind the last one of the cows, he had not seen me although he was barely twenty feet away. I said, "Boo!" When he saw me so near, his eyes turned a vivid green before he could make up his mind which way to go; then he made tracks, thus proving why he was called a wildcat.

I made a notch in a stick for every day, and when this season of herding was finished, there were seventy-two notches in the stick. This meant seventy-two straight days, for there were no Sundays off.

The first year I had no dog, but the next year I got one that we called Carlow. He was great company. One day when I was nearing home, I saw a wildcat near the creek bed, and thinking to have some fun, I sneaked as close as possible and set Carlow on him. Then I started on my way, as I had to

get home on time. I left them making hot tracks up a side canyon. Presently, I heard Carlow barking and knew that he had the cat cornered, so I went back, though I was taking chances of being late home. The cat was up in an oak tree, but as I approached, he jumped down into the heavy brush. Presently he was cornered in an open place, and as I made my way near, he jumped into the brush and disappeared. He was more nimble in the heavy brush than the dog, but Carlow was strong and soon had him cornered again, this time in a small opening, and as I made my way to the spot I could see that Carlow's sharp teeth were so close to him that there was no chance for him to turn without those sharp teeth sinking into him, so I stepped up beside the dog and hit the wildcat on the head with my stick. This was the same little stick I had carried the year before, and now it had actually been the means of killing a wildcat.

I put him over my shoulders and started home and fortunately had not lost enough time so as to be late for the chores. The younger children seemed quite impressed with this feat, but outside of this, I do not remember that it attracted much attention, even though I was only nine years old. Later, we got another cat, but this one was chased out of the hills and was killed in the open.

MORE EDUCATION

During the seven years that I herded cattle, I carried a copy of *McGuffey's Reader* and *Ray's Mental Arithmetic*. Every year or two I would get a new copy of the *Reader*, but it was only after the old one had been worn to shreds. I would look in this old book and try to find something that I had not read for a week or so, but they were worn out just carrying them around. After mastering the first book in the mental arithmetic, I was given a second book that had some very stiff examples, but I did them all, forward and backward. I did them both ways to prove that I was right. I once came to a lesson in the first book which said to reduce certain numbers to a common denominator. Now I did not know what a denominator was, so, after puzzling over it for some time, I passed it up. Some time later it occurred to me what it meant, and I found it was one of the easiest lessons in the book. I found one example that read "A man bought $13\frac{1}{2}$ yards of calico at $13\frac{1}{2}$ cents per yard, what did it cost?" As this was complicated, I thought there should be an easier way to do it, so I finally put all the halves over on one side and multiplied 14 by

13, then added a quarter that had been stranded in one corner. I laid this off on the ground and proved that it was right, and all examples of this kind became very easy. Years later, when we had neighbors and they were going to school, one of the boys showed me how to use a pencil. He showed me how to multiply, divide, subtract and add. He probably spent about fifteen minutes in this. It looked rather odd at first, but I tested the plan out and found the principle was correct, and it opened a new opportunity in figures. This was the final instruction. When I was working, I would practice juggling with figures so that I became very familiar with them, and it came in very handy later in making change, as well as in many other ways.

EVENING AT HOME

At rare intervals, the children would start playing in the evening. Before this had gone far, we would hear the command, "Stop that noise and get your books!" Everything would be as quiet as a graveyard; the children would get their books and sit around the table (the books that had been read until they were threadbare and were as interesting as last year's birds' nests). We would soon begin to get sleepy and find refuge by going to bed. We were given the impression that father did not like to see us enjoying ourselves.

Father had a good library, which was well stocked with the classics. He would get one of these books down in the evening, and when he was through with it he would put it back on the shelf. I do not believe he would have objected to us children reading them, but this was not encouraged. In fact, they were handled in such a way that I, for one, never saw the inside of one of his books. He was not the frontier type and had many of the finest books that were published at the time, and he reveled in them, but we children were supposed to be satisfied with such childish stuff as he saw fit to hand out. Even the newspapers that he brought home about once a month were put on the shelf, and I, for one, never got a chance to look at them. No reading matter was put in our way except those few childish books. We were disinclined to ask for favors, but finally I asked him to get me a story book, which he did. At the same time he got a picture book and gave it to Lafe. Lafe, being the older, did not like this and wanted me to trade, which I did, knowing that I would get a chance to read it anyway. The picture book I still have.

CHARACTER

Father was puritanical, but as I look back over the situation, I realize that his principal fault was that he allowed himself to be ruled by his emotions. These were not very reliable and were not properly guided by reason. He once said, "If I can't make my children love me, I'll make them fear me!" He overlooked the fact that it would have been impossible to have prevented them from loving him if he had treated them right. He once said, "I want you where I can put my finger on you whenever I want." "Yes," I said to myself, "You would like to have me under your thumb."

At various times, he showed that he had respect for me, but he always tried to keep from revealing this fact. At one time, he gave me a book on grammar, saying for me to study it and that I would get a lot out of it. I looked and found that it was an advanced book, that it did not explain the first principles of grammar. I laid it away and never did know what became of it, but what he expected me to get out of a book that was published for college students, I am still at a loss to know. He apparently expected me to dig it out by myself.

THE DINNER TABLE

One of the things that father wanted to impress on the family was that he was superior. He was not only taller and stronger and older than the rest but was superior on general principles. One of the ways he had of showing that superiority was by finding fault with what the other members of the family did. For some reason or other, he did not complain of the cooking or the coffee that he and mother had in the morning, but the tea that was served at dinner did not fare so well. We would hear "This tea is like dishwater!" If anyone was talking, this would stop, and silence would prevail for the balance of the meal. In a few days, when a suitable time had elapsed, we would hear "This tea is like lye!" At once the air of a funeral would settle down around the table. The three-tined forks, the steel knives and even the spoons would touch lightly on the tin plates. No one was afraid that it would go any further, but there are times to talk and times to keep silent. As a matter of fact, there was a bountiful supply of tea used, and it was measured carefully; then it was set on the stove and boiled! It was always like lye. If he had always used this complaint there might have been some changes made, less tea might have

been used or they might have refrained from boiling it. But as long as it was alternating between lye and dishwater, there was nothing to do except to continue to make it in the same way.

Family Feud

It seems that when father was preparing to leave Utah, Grandfather Snow had offered to take care of mother and the five children if she would stay there and refuse to go to California. No doubt he wanted to shield her from hardships that he knew would be worse than what they were enduring in that country. Like all good parents, he wanted to keep the children in the fold, and father had left the church; also, he was well aware of father's disposition.

Father was so incensed by this offer that he refused to allow mother to write to any of her own people who had been left behind. There was no way that she could send a letter, because there was no one to send it by except father. Whether she ever smuggled one through or not, I never learned, but she went to town with him about once a year. However, it would have been very difficult for her to receive a letter. Father wrote many letters himself so the people were posted, but it was only from his viewpoint. Grandfather came out at one time with two of his associates and stayed with us for two or three days, but I was too young at the time to know of the undercurrents.

Farm Life

The old wooden cultivator was not very effective. It left many weeds that had to be killed with a hoe. In due time, we had a small vineyard that was directly across the creek from the house and a little farther on a small walnut grove that was raised from the seed and did not bear for eight years. The vines were trained up high so it was impossible to get among them with the wagon, and all the trimmings had to be carried out of the field in armloads. This was one of the disagreeable jobs that fell to two small boys. The limbs were allowed to grow low on the walnut trees so we could not get near them with the horses, and it left a great deal of work that had to be done with a hoe. We did not mind cutting weeds but did not like to do the cultivating with a hoe. The hay was cut with a scythe and raked up with a little wooden

rake. This was a job we did not like. Two small boys put in about eight hours steady work daily on this work. This was the time between breakfast and dinner, as we only had two regular meals a day and the rest of the day was put in doing chores, so between these things and dragging the ground for planting corn we had plenty to do. This was not only thankless work, but much of it was useless. Lafe and I frequently worked together, but most of the time I was alone.

As stated before, our work was a seven-day week. We had no Sundays or holidays, not even the Fourth of July. Birthdays came and went unnoticed. The only day we had to look forward to in the year was Christmas. On Christmas, we always had a chicken dinner and did not have any work to do, except the chores. We could always count on a handful of peanuts and two or three cookies; sometimes we got more, but we could count on that much. One time Lafe and I each got a little tin wagon. They were about five inches long and cost about ten cents each. These were the only toys we ever had.

Dining Out

We were invited to a Christmas dinner at Rosenbaums. This was eight miles through the hills the way we went, and as I was the younger of the two and we had but one saddle, this gave me the chance to ride bareback both ways. They were to have a turkey dinner, and there were two boys about our age, so it was a treat to look forward to. The only trouble with Christmas was that they came so far apart, and we would start to count the days two months before it came, and then it was all over in one day.

We arrived in good time and had a chance to look the place over and get a little better acquainted before dinner. There was a great plum pudding cooking in a large kettle outside of the house. They said it had been cooking for three or four days. This was our first visit, and it was all so different. When we tried the turkey we found it about equal to chicken but no better. The pudding was served with a rich sweetened sauce. When we tasted it, we found that both the pudding and the sauce were highly flavored with brandy. This was a foreign flavor, and neither of us could eat it. Much to the disappointment of ourselves and everyone else, we had to pass it up. It is true we were not hungry by this time, but it was the flavor alone that was responsible for the disappointment. I have often wished that I could have just one more chance at that same dish of pudding, and it reminds me of what a

disadvantage it is to have an uncultivated taste. We had to start back rather early on account of the distance but enjoyed both the trip and the dinner, in spite of the plum pudding.

NEW NEIGHBOR

The first two years that I herded cattle they were in the valley on the large land grant before mentioned, but for some reason, in the third year, I was told to take them up on the hills to the north. The hills are about a thousand feet high, and at the place where I reached the top, it was about a mile and the house was still in sight. I could take them along the ridge about two miles farther, but there were a lot of wild oats at this place and I took them farther when I wanted a change. I had to carry my books, lunch and water. As I had no shoulder strap, these all had to be carried in my hands, and as I had to carry a stick to drive the cattle, I had to have at least one hand free so my water was put in a little powder can that I could put in my pocket, and I learned to get along on less than a pint of water a day.

My shoes were made in cobbler's shops and were straight up the back. I had no socks, and the friction would make blisters on my feet, so I would have to leave the shoes home and go barefoot to give my feet a chance to heal. Then my knees would sometimes get sore from going up and down hill so much, but it was not hard work. However, from the standpoint of isolation, it was a complete success. The great trouble was that I had nothing to read. I carried the same old book for a year or two that I could read through in one day. I would look in it to pass the time away, but there was nothing of interest. The arithmetic was better, but there was nothing new in it. I was never questioned at home to see what I had accomplished out of this book. This is the time when I humiliated myself to ask father for a story book.

One day when I had the cattle far along the ridge above Laguna Beach I discovered a small cabin nestled in a little protected spot down on the lower edge of the hills. Occasionally, I would see someone moving around, and there were four cows feeding on the side of the hill above the cabin.

Neighbors were coming into the country. As a matter of fact, there were several families who had already settled in some places. We had heard something of this but had not seen any of them. These people had settled

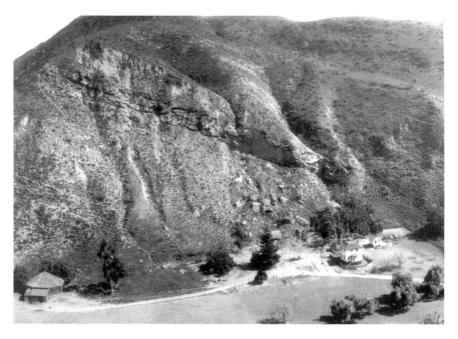

A view of the Thurston homestead. *Historical Collection, First American Financial Corporation.*

on land that father had ridden over before he found the place where we were living. They had come prepared and had located on the little strip of government land that was still open for settlement.

I would frequently bring the cattle over to this part of the range and would sometimes see a boy come out on the hills with the four cows. One day he came up a little higher, and I went down and met him. His name was Leon Goff, and he was several years older than myself.

One day, when I was down on the side of the hill with my newfound companion, my cattle also wandered down, and when it came time for me to start home, I found that the large bull that was in my herd had become interested in one of the cows he had met, and he positively refused to leave. We both chased him up and down over the slippery grass on the side of the hill until we were worn out before we got them separated. By this time, I should have been nearly home, and there was no way to hurry the cattle. By the time I got to the top of the hill it was dark. Halfway down the hill, father suddenly appeared out of the darkness and gave me a severe thrashing. He did not ask why I was late; I had failed to get home on time, and that was all that mattered. When I

got home, I told mother what made me late, and the only response was that father forbade me from going to see this boy any more. Of course, this was an order he could not enforce, but I was careful not to let the cattle get together any more.

Discipline

One night I was trying to catch a "setty" hen. The hens were all trained runners, and they had wings to help out. It began to get dark, and she succeeded in hiding where I could not find her. The next evening, father asked if I caught that hen, and I told him that she got away. He got a stick and gave me a thrashing, saying I was "Too g-- damned lazy to breathe," that I could eat and that was all I was good for. These words were common and were far from new, but he had knocked my hat off and I reached down to pick it up, but before I had a chance to put it in place, he hit me on the head with the butt of the stick that he still held in his hand.

On smaller offenses such as doing something different from the way he expected it to be done, he was free with the flat of his hand. He called it boxing one's ears. Probably for this reason I have gone through life with defective hearing. There was not the slightest use trying to say anything in one's own defense, for it seemed that he took every occasion to humiliate and crush the spirit in us, and when the children would come together in the evening, they would compare notes. This would be the news of the day. The evening was about the only time that I was with the rest of the children.

Things Found along the Way

At the top of the hill, which was in sight of the house, there were a lot of rocks from which I built myself a stone house. This was of loose rock and was about five by six feet in size. It served no purpose except to give me something to do and furnish a little protection when the wind was blowing. I put some brush over the top to make a little shade, and one day when it was cold I made a fire in the fireplace and set the roof on fire; however, I prevented it from spreading.

Nearby was a point covered with rocks, some of which must have weighed several tons. One day I was sitting on one of these when a huge yellow rattlesnake crawled out on an adjoining rock. I looked him over and decided that he was over five feet long and his body was as large around as my thigh. I had nothing with me with which to go after him, and anyway he would only have rolled off the rock and gone beneath it. I did not care to go prodding around among the rocks because there were probably other snakes of equal size lurking around, so I allowed him to go his way unmolested. When I was on top of these rocks I did not mind what was underneath, but I did not care to get down with them. This is the only one of these reptiles that I remember which was permitted to escape. Occasionally, I would see one which would crawl down a hole before I could get anything with which to kill him, but I would come around next day in the heat of the day when he would be out, and I would be prepared for him. One day I laid my book sack on a small rock while I rounded up the cattle, and when I came back, there was the tail of a rattlesnake sticking out from under it. The only weapon handy was a little piece of mustard stalk, so I took this, lifted up the sack and hit him on the head. Now they were not as thick as this might imply, but they were not rare.

One morning when I was quite small, I was following the trail of a large rattlesnake along the edge of a field of corn when I was startled by the most unearthly hissing and rattling I had ever heard. I looked around and there was a rattler rising up from the ground like a spiral spring from where he had been coiled. The sun was warm, and he was on the warpath. This is the only one I ever saw which showed fight without provocation, and if he had kept still, it might have saved his hide. Father happened to be nearby, and he came over armed with a large club.

We would frequently go to the ocean for a bath, the women folks going among the rocks where it was protected, while the men folks would go on around the point and bathe in the open ocean. It was many years before there was any danger that we might be observed by outsiders. On these occasions, we would frequently bring back about a bushel of mussels, which were excellent eating both in soup and fried. On one of these occasions, Lafe and I came on ahead of the rest to do the chores. I was walking along a little path and looked down just in time to avoid putting my foot on a large rattlesnake that was coiled in the path. Lafe had passed on ahead and had evidently stepped over him, and it was as well for me that some intuition caused me to look down before my bare foot came in contact with him. He crawled into a small thicket of thorn bushes, horse nettles and poison oak.

We beat a trail through this thicket and drove him out on the other side where we could get at him.

One day, Lafe was running between two rows of potatoes when a rattlesnake struck at him. He missed his mark and became tangled up with a pair of fast moving legs, but he only succeeded in losing his own life.

Nearly every member of the family had some close call from one of these creatures, but none of us were ever bitten.

OTHER THINGS

As grapes began to ripen in the little vineyard, wild animals acquired a taste for them. There were coons, coyotes and foxes. They all liked grapes. The coons thought they went well with the fish diet that was picked up along the shore, while the foxes and coyotes liked a few grapes with the squirrels that furnished most of their diet. If we expected to get any grapes, we would have to protect them. We tied dogs in the field, but the marauders went to another part of the vineyard. George caught a fox in a steel trap, but his foot was not injured, so he brought him to the house and we made a pet of him. Finally, he was tied in the vineyard. This was an experiment, and just what was expected of him was not clear, but the next morning the poor fellow was dead. Whether the other animals thought he was exceeding his authority or whether they were trying to release him from confinement we never found out, but he had been badly mauled.

Apparently, the only way to save the grapes was for one of us to sleep in the vineyard; then the dogs could stay out and run free. Lafe and I were given this duty. We had some bed covers laid on the ground. Frequently, one of us would go out by himself, but when a coon was treed or if he was cornered up on the steep hillside, we would be out and after him. If it happened to be pitch dark and there was no lantern, it made no difference. There was little chance that he would be able to escape, and we accumulated quite a string of coon skins (for which there was no market). We caught one in a gopher trap, but he broke the chain and escaped. Shortly after this there was evidence that he was returning, still wearing this appendage. One night we were out on a hot trail and bagged a coon when we had only gone about a half mile. Next morning, we found that half of one of his feet was gone, so we backtracked over the trail of the previous night and found the trap, still holding the balance of the foot. Nature, however, had taken good care of him, for his foot was not inflamed.

Deer

The deer would come in and feed on our little field of alfalfa. They seemed to like it better than the grass on the hills, and the field was only just large enough to furnish feed for them. I therefore slept in the alfalfa, but the mosquitoes were bad, the green stuff furnishing a harbor for them. I became quite adept at killing them, lying awake and striking as soon as one alighted on me. I could get them every time, but I couldn't lie awake all night to kill mosquitoes, so the dogs were tied in the field. Now animals in the wilds have a way of reasoning things out for themselves, and after staying out of the field for a few nights, they could see that the dogs were tied and their bark didn't hurt, so they began to nibble on the edges. As time went on, they became bolder, and finally, we found the situation was not profitable. The dogs had wallowed down all the crop they could reach, and the deer were eating to within a few feet of this. This meant that each dog was saving a little ring around what he had wallowed down, and the deer had eaten the rest.

Finally, George devised a scheme that he thought might help the situation. He rolled up a large ball of rags, soaking them with kerosene, and these he took down to the field from which the dogs had been removed. This ball of rags was fastened to a long stick, ignited and the torch thus made was held over his shoulder. This enabled him to sight his rifle, the deer being unable to see anything but the flaming torch, and their eyes shone like two balls of fire. Instead of being frightened, they stood and looked at this strange sight. The crack of the gun, however, was a sound they all understood, and all but one bounded away into the hills. Deer are smart, and it did not take more than one lesson to teach them that it was better to stay on their own stamping grounds. After this, they gave us very little more trouble.

Another Job

One day, father started down to this little field with a scythe in his hand, telling me to come along. When we got there he asked me if I would like to learn how to cut hay. Now, I was still quite small and was certainly not in need of anything further to do. I had been kept pretty well employed since I was five years old and could not see any reason why I should be expected to take on any of his particular work, so I replied "No." This made him

angry; he handed me the scythe and told me to cut the field, after having first made two or three swings with it himself to show me how it was done. Then he started for the house. Now I did not blame him for not wanting to cut this particular crop of hay, it not only requiring skill but patience, and patience was a quality that had passed him by. This was the first crop of the season, wild grass, mustard and other weeds having come up beforehand. It had been a wet season, and the growth was heavy. Rain and wind had matted the grass down and tangled it up in knots, the alfalfa having come up through this mess and it was standing among the weeds. I had to chop the latter down with the heel of the scythe to keep from bending the blade, then I had to go around in all positions to chop or dig the other stuff out the best I could. It took seven days to cut this little field, which was only a little more than an acre. Then it had to be raked up into piles. During this time father never came near; he never asked how I was getting along and never found any fault after the job was finished. He just gave me other work to do.

THE OLD WOOD PILE

The wood we used for the kitchen fire was gathered from the hillsides in the fall and thrown into a pile. It was hard wood, and when it was well seasoned, it was very difficult to cut. This was of no consequence, however, for there were two small boys who had nothing else to do except the necessary work and chores. While cutting the wood was only a chore, it was not a part of the day's work. This was not so bad, but it was slow work grinding the old axe on the grindstone. Father always did the grinding, while one of the boys turned the crank, and in order to make the job as short as possible, most of the grinding was done near the edge. Year after year, the blade kept getting thicker and thicker above the cutting edge, until the axe would bound back instead of going into the hard wood. It required skill as well as hard work to cut any wood at all. Many of the sticks were rather large, and it took a lot of wood to cook for a large family.

As the years went by, father finally decided to get a new axe. When it came, it was painted red and was lettered to show by whom it was made. It would be a pleasure to cut with a new axe, and father thought he would give it the first try-out, at the same time giving me a lesson in cutting wood. There was a sycamore tree about half a mile from the house that had been recently cut down, so we started for it. It was about fifteen inches in diameter and was

seasoned to the proper state of toughness. Father started in with wide swings. He had brought out a few chips and made a fairly good start. He planted a few vigorous blows as he began to get warmed up, when suddenly we heard a little noise like "ping." He lifted the axe and looked at the blade. There was about a third of it broken off. He looked at me and without a word handed me the axe and started back to the house.

I then looked at the blade. The best corner was still left, and it would cut. It was better than the old one so I started to work on the tree. As the years went by, the break partly disappeared, but it was disappointing that I never had the chance to cut a single stick while the blade was in perfect shape.

OBSERVATIONS

One day at the old wood pile I picked up a stick that was larger some distance from where it had been cut from the tree than it was at the place of contact. As this is contrary to the way things grow, I examined it to see if I could determine the cause. I soon discovered evidence of where it had been resting on a rock, which had relieved it of the burden of bearing its own weight, while beyond this point it was stronger. This awakened a train of thought. The sap that had come up from the roots bearing the material that was used in the growth of the tree must have had some mysterious way of knowing where this material should be deposited. It could not have been done by following a certain routine, for this was contrary to the ordinary plan of growth. This material had been carried to the point where it was most vitally needed. This question would frequently come to mind until I finally realized that it is the plan of all nature: to deposit material and build up strength where it has been shown by stress and strain that it should be reinforced. This is a law that is observed by nature, and it is a law of growth which makes it possible for nature to be a success. It governs all life, both animal and vegetable. The life that is able to endure the burning sands of the desert, and that which is able to live in the depths of the sea, is made possible because nature tries to protect herself and builds so as to be able to endure the conditions of her environment, regardless of what they may be. Though we may understand this law, we can never determine how far-reaching it may be.

One day when I was bringing the cattle down the canyon I noticed a number of ants running around a large worm. The worm seemed to be

dead, and I stopped to see what they were going to do with it. Presently, they began to take hold of it and pull. As far as I could see, each one was pulling for himself, and I thought, "Now if you would just pull together, you might accomplish something." Presently, the worm was lifted and dragged some distance toward their hole; then they all let go and started to run around as before. They were doing very much like a group of Irishmen might do, except that they took their rest while running around. So I made my way after the cattle, down through the tall mustard.

I observed that there was moss growing on many of the large rocks and that this moss grew only on the shady side of the valley where the moisture was permitted to linger in the morning. In more favorable places, it would grow about three-quarters of an inch in length, and in the heat of day, it was as dry as powder and would crumble into dust at a touch. All through the dry summer it would appear as if dead, but by the application of a few drops of water, it would spring into life in a few seconds and would become a green and living thing. I felt that this minute plant had been growing there for untold centuries, and while it had not been able to grow any larger, it had been able to maintain life. The only way this moss had of obtaining soil was when it might be blown over by the wind or from the disintegration of the rock. In other places on the cliffs, where conditions were a little more favorable, a little plant had succeeded in growing with the moss. This plant even bore a beautiful little yellow flower, and in places, it gave a very charming effect.

I once grafted four different kinds of fruit on an almond tree. There were peaches, apricots, prunes and plums. With the limb of the original tree, this made five kinds of fruit growing on one tree. Now the material that was brought up by the roots of this tree was all the same; it was divided up, sent out to the different branches and produced five different kinds of fruit. I wondered how this could be possible and finally decided that the transformation came about through the action of the leaves of the various branches.

REFLECTIONS

I once asked George a leading question, and he gave me a ready answer. As he was about twice my age, I trusted that the answer was correct, but I was not satisfied. After some reflection, I decided the matter for myself, and I

came to the conclusion that he was wrong, that one is not necessarily right because he is older. I found that when I reached a conclusion in this way, it would usually stand the test of time.

I was walking down to the barn, and the thought came to me: "What am I but a slave? I am ordered here and ordered there, with no consideration of the fact that I have a mind of my own except to obey orders—never requested, but ordered, with no sign of the respect that is due to a human being." As I walked along the road, it occurred to me that there was one thing I could do with which no one could interfere—I could think what I liked—but another thought followed, "You may think what you like, but unless you keep those thoughts to yourself they become public property, and are subject to any kind of interference." I was about ten years old at the time, and these were my lessons.

One day I was hoeing corn in the field where a large rock was standing. I was feeling lonely. In *McGuffey's Reader* there were a few stories that were founded on the Old Testament. I thought, "If there is any truth in those stories, and there is a power anywhere that has ever guided the human race, or has ever been interested in the affairs of man, it must have moved far away and left him to his own devices." I felt far removed from anything that could be depended upon. I had experienced nothing so far that would furnish a foundation upon which I could build and feel secure, a foundation that would furnish evidence that life was worthwhile. Human contacts had not furnished such evidence, and I wondered if there was such evidence to be found.

It occurred to me that if there was anything more than physical existence, it would be governed by justice. Another thought followed at once, "What is justice?" with the answer, "Justice is what you get as a reward for what you do," and the only guide that one could have was to do what seemed best. This must furnish the foundation upon which to build. While this is an invisible foundation, it is also something that can be kept in mind, while if there is nothing to life but a physical existence, it is not worthwhile.

It also occurred to me that the reward of justice cannot be attained in physical life; therefore, there must be something more to look forward to, though where or how to look was not clear. As time went on, these reflections came to mind with increasing importance.

A TRIP TO TOWN

One day, father asked if I wanted to go to town with him. I was about twelve and had never been off the place except to the Christmas dinner at Rosenbaums. When we had gone about two miles up the canyon, he asked if I had washed my feet and stopped that I might go to the creek to perform that duty. We were on the road eight or nine hours and spoke just three times.

After traveling some hours, we met the stage that carried the mail between Los Angeles and San Diego. There appeared to be no passengers aboard. After some time, we met some Mexicans in a spring wagon going toward Capistrano. They spoke, and I replied to them. Father said I did not need to speak to everyone I met. It was in the spring of the year, and we had had a dry season. There was no grass growing except around the squirrel holes where the soil had been loosened. In the distance, toward Santa Ana, there was an old barn that appeared to be standing all by itself, and I asked father how it came to be there. He said a man had attempted to raise barley on a large scale and had gone "broke." This is the only time I attempted to speak to him on the way.

As we neared our destination late in the afternoon, he stopped for a few minutes to see an old friend who was known as Gasy Smith and was invited to come back and spend the night. This was the custom of the times.

When we reached Santa Ana, he stopped in front of a store, took his box of eggs and went inside. I am under the impression that he handed me the lines, but am not sure. However, I was left sitting in the wagon. The business part of the town was built on two blocks of one street. There were several brick buildings that were two stories high, but most of the buildings were of unpainted wood. When he finally came out of the store, he said he had been detained. He drove down to the corner and stopped at another store on the opposite side of the street. I was a little confused whether I was looking east or west, as the street looked just the same. When he got through, he drove back to Main Street and turned south, where there was a man in a tent with a photographer's outfit. Here he stopped and told me to get out. He told the man he wanted him to take my picture. He brushed my hair back and in a few minutes had the pictures finished. He handed father four tintypes, for which he was paid one dollar, and we were soon on our way back to Gasy Smith's. It was getting dark. We had started quite early in the morning, and I had been sitting in the wagon all this time, except the two times I had been out for a few minutes. I had come to town for the first time and had not

seen the inside of a store, and as far as I know, the men where he traded did not know that he had a boy sitting in the wagon. He had evidently asked me to come with him for the sole purpose of getting a photograph but had not deemed it necessary to inform me of this fact. He could not have been less considerate if he had brought in a pumpkin or a freak potato to be photographed.

We arrived home very early the next day, and by way of explaining the doleful look expressed in the picture, he said he had a notion to tell me to smile but was afraid I would laugh and spoil the picture. This was a precaution, however, that was quite unwarranted.

More Neighbors

One day, father came home and said there was a man building a cabin on his land down by the ocean, adding that he had told him where the lines were and he was going to move it to another place. This man proved to be the father of the boy I had met while herding cattle, and his name was Frank Goff. In a short time, he and his two brothers, with their families, had located along the coast nearby. One brother, Lee, had taken a place south of us, Frank was on the north and Hubbard (or "Hub," as he was called) had settled on the northern corner of the land that had been taken by Frank. The houses that they built were very small and received but slight additions later. By the liberal use of pick and shovel, they had made a road over the sharp, steep gulches so that it was possible to travel over, but it was not safe, as was made evident by the fact that care had to be taken to prevent wagons from tipping over, and once or twice this care did not prevent them from having to drag a wagon and its contents up from the bottom of a deep ravine.

About a year or two after we arrived, there was a family by the name of Damron who built a house in Laguna Canyon, but they were never considered as among the early settlers because they did not stay. They had a band of horses that roamed the country and would sometimes come down and get into our crops, which did not encourage friendship. Whether or not father spoke to them about this, I do not know, but they finally moved away with their horses.

Now, after about eight or nine years, we really had neighbors who in a way were sharing our lot. "Hub" was a blacksmith and the genius of the outfit. It was he who kept the picks sharp and the tires on the wagon wheels. It was

also he who kept the plows in condition so the farming could be done. There were repairs and even new things to be made, and without him it would have been hard sledding. At first he had no coal, and his work was done by the use of hard wood gathered from the hills, but he was soon able to get coal.

He had a violin, or fiddle as it was called. (This was probably the more fitting name, as it was one he had made himself.) We had been adding to the little cabin in which we lived. Another room had been built, and when the tent wore out, it was replaced by a room. Then the front of the old cabin was removed. This gave us a kitchen, dining room and living room all together. It also made a room large enough so we could use it for dancing, and we soon began to get together and learnt to dance. "Hub" also had a room that could be used, and we would get together at one or the other of these places about once a month.

There were quite a number of people who had settled in Laguna Canyon and at the beach, but we seldom saw any of them because it was too far to go. Most of these people also belonged to the church and did not dance. While the Mormons in Utah encouraged dancing, and these people claimed to be Mormons, they considered it a sin to dance, so if any of them came the evening would be spent playing games. We could make a cart wheel and put as many spokes in it as we liked, we could play "Post Office" and put as many letters in it as the law allowed, build chicken coops and put ever so many chickens in it, we could build side-hill plows and plow as many furrows as the forfeit called for, but just why it was a sin to dance and not a sin to play kissing games, we never did find out.

We boys all learned to play the violin and accordion, so we were never short of music for the few simple tunes that we knew, and when all the available members of the party were on the floor, there were just five or six couples.

RAISING POTATOES

The Goffs soon learnt that they could raise early potatoes along the coast, as it was quite warm and they would grow all through the winter. They were able to get them on the market several weeks before any others in the county; therefore, they could get a good price. Things began to date from one potato crop to another. If the crop was good, we would see new shoes, new clothes, sometimes even new things on the farm. However, the crops

were not always good, and there were two things that were dreaded. One was a dry season and the other a high wind from the ocean. A dry season meant a light crop of small potatoes, while a wind meant that they stopped growing at whatever stage they happened to be in, and it might be worse than a dry season. I found later that it was the salt that was blown from the spray that did the mischief, for the growth would stop even though they might not be actually touched by the wind.

The dry seasons were quite distressing, and when it refused to rain, Frank became very ambitious and said he would like to see eight feet. Father said he would be satisfied with three inches that would take about a week in falling, but Frank insisted he would like to see the ground soaked for once and held to his eight feet.

Now one of the entertainments that we indulged in at this time was a Valentine's party. Everyone would think up all the silly things they could that would make a rhyme. On Valentine's eve, we would gather at Hub's place and the valentines would all be put in a basket. Then they would be taken out one at a time by Mrs. Goff, who read them aloud. This was one of the big events of the year to which we looked forward.

The winter of 1884 had been quite dry up until the time of this party, but on this day, the weather was threatening. The other children went early and left me to do the chores and come later with the wagon. When the time came for me to start, it was dark. I took one look at the lowering clouds and decided the best place for me was at home. The next morning, there was a flood overflowing the banks of the creek, and much of the farmland was under water. This had never happened before during our tenancy. The children had not attempted to come home, but they came down that evening to look things over, and the water being low enough, I ferried them across one at a time on a horse. Father and I worked for a week, repairing fences and building protection along the banks against the coming of another such flood. At the end of this week, we had another flood of equal size.

Now this rainfall could still be measured in inches; some parts of the potato crop had been covered up, and we heard plenty of kicking about this. The crop was good, but it was not as good as it might have been if the rainfall had been confined to three inches. However, Frank Goff was completely cured of demanding eight feet of rain.

One good turn that I have always been thankful for was that a shovel plow that had been left standing in the vineyard had been taken away. It was all iron except the handles, but it had been removed and deposited in some other place. Where this place was is still a secret, but a pleasant memory,

for father had just had some new shovels made to replace the old ones that had worn out. He told me he had them tempered as hard as glass, and I was wondering when the day would come when one of them would strike a rock and break. I had used it just once when the flood was kind enough to relieve me of this anxiety.

WATER

The water in the creek was quite salty. The stock could drink it without harm, but that was all it could be used for. All of our domestic water was hauled from a place nearly three miles up the canyon. As the Goffs had to depend on the same source, they had to haul their water about four miles. While we had the advantage of good roads and could haul three barrels at a time, they had steep hills and could haul but one barrel at a time, so water was a problem. They spent some money tunneling in the hills, finding a little water, but it was heavily laden with minerals. Frank dug a well nearly one hundred feet deep, finding a small amount of water but no place where it could collect. Lee sunk a well over a hundred feet deep in solid rock and found nothing else, so they had to continue to haul their water.

In the side hill near our property, there was a seepage, and father hired Hub Goff to drive a tunnel where a stream was developed about the size of a pencil. By building a dam in the tunnel, we had a reservoir about forty feet long, but in order to use it, we had to have pipe and pipe cost money, so we continued to haul water.

Finally, father got 1,600 feet of three-quarter-inch pipe, which we laid on the edge of the hill, exposed to the weather. The little stream of water was allowed to run through the pipe while we were putting it together, and it collected air pockets so that the water came through only in a trickle. Father said it was on account of friction, but I did not believe it. One cold night, the water froze and the pipe broke in seventeen places. Father tried to solder it, but it was a mess. By using a tank, we collected enough water so we and the neighbors all had water. The pipe, however, did not reach to the house. Years later, when I was in charge, I stopped it up at the spring and drained the pipe. Then I opened it up, and the water came through in force.

I told mother that we had all that investment in pipe and still did not have water at the house; that with three hundred feet of pipe I could put it in the valley where I could cover it, bringing it past the barn where I could water

the horses and then extend it to the house. I finally got the pipe, borrowed some tools from Nate Brooks, cut all the bad places out of the pipe and when I got through and the water was running at the house, I had a piece of pipe left about sixteen inches long.

MacManus

In their search for water, the Goffs brought a miner in by the name of MacManus. When they got through, they did him a good turn by telling him where he could get government land. This was south of Lee Goff's place. So he filed on this land and built a small cabin. Now, for a miner to live all by himself on a piece of dry land was against all tradition, so though he was no longer young, he sent away and got himself a wife. Where she came from I do not know, but judging from speech and appearance, she must have come from Ireland. Mac said whenever he dug for gold he found water, so he went up into the hills and dug a tunnel, but he was not looking for gold and so found no water, but he did find a good place for a powder house. In the meantime, his wife told him if he would go to a certain place near the bluff, he could get water, so he dug a hole about ten feet deep and got all the water he could use.

Finally, a baby came to live with them. Now this was another thing; he still was not a farmer and also his money was about gone. He induced Mr. Whiting to give him a hundred dollars for his claim, and then he disappeared and we did not see him again.

Mr. Whiting, being a rich man, did not live on the place to hold the claim, and it soon became vacant, so brother George filed on it and moved into the cabin. He filed on it as government land, afterward finding it was state land. While he was changing his filing, Mr. Whiting found out what was going on, got hold of some soldiers' scrip and filed it on all of the frontage, a narrow strip that extended along the coast line for about three-quarters of a mile. This discouraged George, and though he still had a good piece of land, he finally sold it for a small amount and left the land to its fate in the hands of absentee owners. This is the land that is now called the Three Arch Bay Tract.

PLEASANT MEMORIES

There was one thing we could always look forward to with pleasure, and this was watermelon time. We always tried to raise a small patch, and as there was no market for them, there was no limit to what we might have. The only drawback was that when I was herding cattle and needed them most, they were not within reach. One season, I was herding nearby and had to pass the watermelon patch. They were getting ripe, but I said nothing. I did not want father to ask me what I was doing over in the watermelon patch. They were being neglected, and some of them had begun to spoil, so I took one along with me. Now it happened that George came over to investigate on this same day. He picked one, sat down and ate half of it, and as I was not far away, he brought the balance to me. Now there are times when it is best to be polite, so I accepted it and ate some of it while he was still there, but it was hardly with the gusto that might have been due to the first melon of the season. Though I said nothing, I wished he had brought it the day before. I did not tell him that I had half of one about the same size lying in the shade a short distance away, which I was planning to eat in the middle of the afternoon. Now my plans had gone awry, and I was wondering how I would manage since it would not do to leave any of it out there where it would be destroyed.

I managed to do my full duty toward the watermelon, but my reluctance at giving information that would reveal that I had been first in the field was well grounded. There was no objection whatever to my having what I wanted, but children were not supposed to know when melons were ripe— this was a man's job, and children were not supposed to do anything except what they were told to do.

THE CALIFORNIA BOOM

People began to come to California. Its fame had spread over the East, and the railroad companies had acquired a lot of land in the West. It was good business to encourage travel—also it made it possible to sell land. Stories went abroad telling how people had bought land and resold it, making much money, and the temperature of the California fever began to rise. Soon everybody wanted to come to the Golden State.

Already, people had been coming from the surrounding country to Laguna Beach because it was an attractive place to spend a vacation. Now they were

coming in increasing numbers. Some of the people at the beach began to bake bread and others to sell milk, while others built up quite a business by peddling water. Henry Goff, who was the older brother of the three who had settled near us, built some rooms on his house and began to do a hotel business. Ammon Goff, his son, who was then a young man, started a store in a tent on the beach for the benefit of the campers. The boom gained momentum, and we began to hear of land being sold two or three times before the first transaction had been completed. We heard of subdivisions being put on the market in outlandish places, where people would come in buses, wagons, buggies on horseback and on foot, where land would sell like hotcakes regardless of its value. Finally, Henry Goff subdivided some of his land. It was understood that he sold lots for twenty-five dollars, but I doubt that this was on the ocean front.

We did not expect the boom to affect us, while evidently our neighbors felt the same, for I heard Frank Goff tell father one day that if anyone would give him fifty cents a day for the time he had spent on the place, he could have the property. As he had been there less than seven years at the time, it is easy to see that the price of his land would not have been much.

Hub had taken the precaution of acquiring a piece of government land that was to the north of where he was living, and had built on it a small hotel. Nate Brooks had run a tunnel high up in the hills and developed a little water, which he had piped down, and as his land adjoined that of Hub Goff's, they went in together and started the town of Arch Beach (which takes its name from an arch that is formed by the rocks on the beach). Arch Beach now had the advantage of running water, and many people liked it better over there on account of the uneven land and the rocky coast. Quite a number of houses were built; there was a branch post office and store and a daily stage that carried passengers and mail from Santa Ana.

One day, there was a group of men who drove over to see Frank Goff. They liked the looks of his place and thought it would make a good town site. When it came to the matter of price, in some mysterious way, it had been raised. He asked them $27,000. They seemed agreeable, and the bargain was closed, though I was told later that the closing price was $25,000. The men spoke of going down to see Lee. They were railroad men from the East and wanted to do things in a big way.

Frank told his son, Leon, to slip down to the beach and make his way to where he would not be observed, and tell his Uncle Lee what had been done. Before the men arrived, Lee had bolstered his courage up to $14,000. The deal was closed, and the men had gained control of nearly two miles of

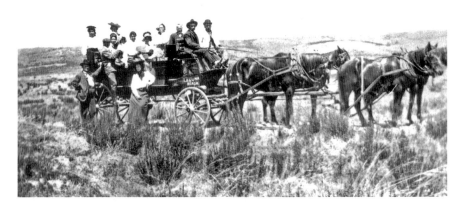

Daily stage to and from Laguna and Santa Ana. *Historical Collection, First American Financial Corporation.*

coastline. Frank had entertained the men while word was being sent down to post Lee, to keep him from asking such a small price that it might queer the whole deal. This land had inspired the imagination of those men from the East, as they could see unlimited possibilities, but they had acted on the spur of the moment, without taking into consideration the question of water. However, two families that had been struggling to make a living were now on easy street. As our land on the coast lay between these two places, they wanted our land, too, and came to father prepared to make a deal, with $15,000 in mind, but I was told that father made some remark about "some people having more money than brains," and the men naturally decided they could get along without it.

BROKEN BUBBLES

The men put surveyors on the Frank Goff property and started to lay out the streets. A great many stakes had been set when something happened. The banks stopped loaning money on real estate and undertook to collect

on what was already loaned. The next day, there was about as much chance to sell land in California as there would be to reconstruct a bubble. Everybody wanted to sell, but the buyers had mysteriously disappeared. Many subdivisions were turned back into acreage. He was lucky who had provided himself with a return ticket.

The men wanted the Goffs to take back the land for the unpaid balance, but they refused. They were still responsible, and the money was eventually collected. The stakes were removed, and a man was put on the land to farm it, but he raised hay and there was no market for it. Years later, some of it was used to fill in the roads.

Old man Hemenway brought his cattle over and pastured them a few times, but the land was finally allowed to return to nature.

The leading man in this deal died a few years later, and the land was left to his heirs. No doubt these heirs got tired of paying taxes on it while they knew nothing of conditions or potential values. It was perhaps fifteen years later when an old man who was camping on the beach asked me who owned it, and I directed him to an attorney in Santa Ana, who was acting as agent. This old farmer, who happened to have a little money in the bank, went into the office of the agent one day and offered $600 for the property, and it was accepted. Now there was no excuse whatever for taking this price. As far as I know, there had never been an effort made to sell it, and it was worth many times that amount. This was just one of the things that happened that cannot be accounted for. Some time later, however, the Lee Goff property was sold for $700. While there was not much difference between the real value of the two properties, Frank Goff's was much closer to where people were living.

BACK TO THE PRIMITIVE

Our neighbors were gone. Frank and Lee went into the grocery business in Santa Ana. Hub sold his hotel, or in reality, he traded one mortgage for another. Henry Goff, who had sold much of his property, got rid of the balance and went back to Missouri. George Rogers, who had also put on a subdivision (which had been done too late to meet with success) moved away, and several other families who had lived in Laguna Canyon were gone.

There were three members of our family who were at the age where they were entitled to a little social activity, and we went to Capistrano a few times

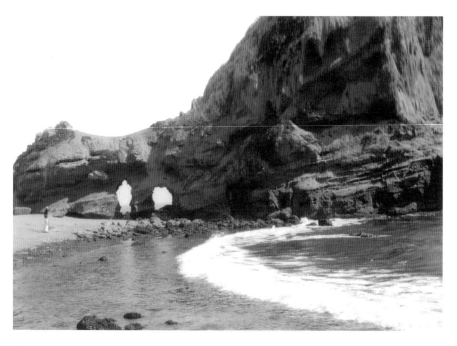

Three Arch Bay, Three Arches. *Historical Collection, First American Financial Corporation.*

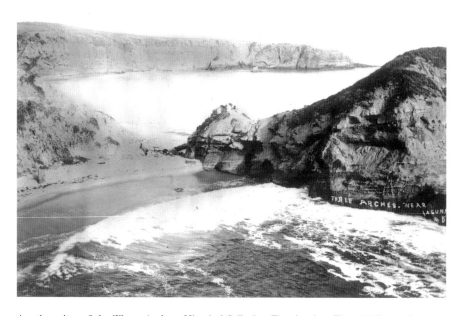

Another view of the Three Arches. *Historical Collection, First American Financial Corporation.*

each year to enjoy a social dance. Between the Congdons, Fullers, Cooks, Haydons and a few others, there were about eight couples. We had Spanish music (a guitar and a violin), which cost eight dollars, making it one dollar per couple. It was beautiful music and the people were fine, but it was a long way (fifteen miles) after a hard day's work. Coming home in the wee small hours, it was impossible to keep awake. The girls would both be sound asleep, and when we came to a smooth stretch of road I would take a nap but never failed to put on the brake when we came to a hill, and the girls thought I was wide awake all the time.

We also met some of these people on the beach two or three times a year and had a picnic. We either met at Shell Beach, where there is an autograph cave, or at Three Arches, the famous rock that photographs as a great turtle with three arches under his neck. We sometimes ate our delightful picnic lunch in a little cave that was formed under his jaw, but this protecting jaw has since broken off and left him with a snub nose. The names of all these people were carved in the sand rock of Autograph Cave, but the rock was too soft to endure. A little farther up the coast was Dragon's Cave, which in reality was another great arch rather than a cave, but we seldom went there because it was more difficult to reach.

THE WIND AND THE WAVES

There were some people stopping in a house at Arch Beach, and we went over one evening to see them. While there, a strong wind came up from the west, and it rained a little. On the way home, when we reached the mouth of the canyon at the top of the hill where we went down to cross over on the sandy beach, it was very dark, but we could hear the ocean making a terrible fuss, so I walked down the hill to see what was the matter. I found the sand had all been washed away, and the waves were beating against a reef of solid rock. There was no way to continue the journey, so we turned back to seek shelter in what was left of the Frank Goff house. The windows and doors were gone, but it furnished shelter from the rain. Someone asked for a match, but no one had any. The wind howled through the building, but we walked around to keep our joints limber and when it came daylight walked home with the horses, leaving the wagon until the ocean was kind enough to return the sand that it had so suddenly taken away.

We had too much to do to feel desolate over the loss of our neighbors. There had been no great love affair, and no marriage had materialized between members of our family and any of these early settlers.

FAMILY LIFE

George had reached his majority and had gone out to shift for himself. This gave Lafe an opportunity to take the little rifle and go out into the hills occasionally to see if he could kill a deer. It was some years before he came down the hill one morning in high glee, having killed a fine buck at the top of the hill east of the house. Father went up with us to help bring him down. He was a fine specimen and had been hit between the eyes, though this reflected no credit on the marksman, for he had aimed at the shoulder, and his head, which was held high in the air, just happened to be in the way.

Thus encouraged, Lafe got a secondhand Winchester, and it was not long before he succeeded in bagging another buck. Now this deer was not in as good condition as the other, and his antlers (or horns, as we called them) were not perfect. Father said it was a different kind of a deer. Lafe said he didn't think so but that there was something wrong with the horns. Now father had said it was a different kind of deer; therefore, Lafe had no right to have a contrary opinion and was severely reprimanded for this impertinence. We had a book showing a group of deer of different kinds, and the next day, Lafe showed father this picture of the various types. Now to have an opinion of his own was bad, but to try to prove that he was right was carrying matters too far, and he was promptly given a beating for it. He was nearly seventeen years of age, and told me he was not going to take any more of this kind of treatment. He was going to leave home. He had a little saddle horse and would go up the canyon in the evening (that was the plan), leaving it to be inferred that he wanted to be on the ground in the morning for another hunt. We had talked over this contingency and decided that if one of us left, we would both leave; but this was his grievance, and if we both left, it would be hard on the rest of the family, so I stayed behind.

The next morning, I took the gun and went out to look for a rabbit. When I returned, father was at the door. I think he had a good idea of what had been going on. He said, "Where is Lafe?" I replied, "He has left home."

"And you knew it?"

"Yes."

"Why didn't you tell me?"

"Because I didn't want to."

"I'll show you," he said, and going out to a peach tree he cut a limb, and when that was worn out, he cut another. When that was worn out, he was still not satisfied. He had failed to provoke the slightest demonstration from me; as he took hold of my collar with his left hand, his right being clenched tightly, he said, "And you told him you were going too, did you?"

"No."

He hesitated a second as if thinking what to say and then shouted, "Why didn't you?"

"Because I didn't know whether I would or not," I snapped. He looked at me, his hands began to relax, his arms went down by his side and he turned and walked away. He evidently realized that his plan of handling domestic affairs was not working.

For about six months I was treated better than I had ever been treated before. He tended to his own business and let me work in peace, but then he began to drift back into his old ways. He saw Lafe, who had gone to Downey, about forty miles away, where we had some friends. He gave him his time and did not ask him to come back.

This brought my cattle herding to a close, and this job was turned over to Frank, who was about six years my junior, but for some reason it was not necessary for him to stay out with them. He merely turned them out on the range and brought them back in the evening. Frank liked to ride a horse, and I have seen him walk past the cattle and go a quarter of a mile to get a horse with which to drive them into the corral.

Boys on the Farm

In the early days, when there was one-horse cultivating to be done, one of the boys had to sit on his back all day to guide him. This, in spite of the fact that the horses knew their business and would have done a good job without any guiding whatever. Lafe, being older, handled the cultivator, and I rode the horse. When we boys were working together it was a simple matter, but if father took the cultivator, it was a different thing. With him, it was vitally necessary to give orders, so presently it

would be "Gee a little." In a few seconds it would be "Haw a little." These orders would soon be shortened to "Gee!" "Haw!" The more the horse was pulled from one side to the other, the more he became unable to keep in the right track and the more he lost his own sense of responsibility. After a reasonable amount of confusion had been created, the fireworks began; the swearing and calling of names would grow in intensity until someone called for dinner. One day, this was going on when the line came loose from where it was fastened to the harness. He said, "Tie that line up!" As he gave no order to stop, and I could not tie it up without stopping, I picked it up and held it in my hand until I might have a chance to tie it. Presently, he yelled "Whoa!" I stopped the horse and started to tie the line up when he hit me in the side with his fist and yelled, "Didn't I tell you to tie that line up?"

He never had any trouble with the horses when he went to market. It was only when he undertook to do farm work. If he was plowing, he would fasten the lines to the plow handles so tight that it was uncomfortable for the horses to walk, then he would have one a little tighter than the other, so it was constantly pulling them to one side. With this setup he could soon work himself into a rage, and the hills would resound to the sound of his voice. It seemed to me that he was always trying to make himself appear a martyr to circumstances, and there was no public opinion to chill this propensity.

THE TEST

After Lafe left home, father did more of the work on the farm. We had a small walnut grove. The limbs of the trees were left hanging low, and it made it very difficult to work around them. When either of us boys worked in the grove with the team, father would come down and look them all over to see if any limbs had been broken or any bark peeled off the larger limbs, so we had to be very careful, and if any limbs (be they ever so small) got caught in the harness we had to stop and loosen them. If by any chance a small limb should get broken, it would be taken to the edge of the field and carefully buried in the rubbish.

One day, father undertook to cultivate this grove. The setting was perfect, the trees were full of leaf and limbs were hanging low, the sap was running and the large limbs would bark easily. To make matters worse, he

had recently bought a contraption consisting of two wheels on which could be fastened either a plow or a cultivator and with a seat to ride on. Now it was a nuisance to have to stop the team to release a small limb, even for a boy who had nothing else to do. But for a man of his dignity to have to get down from a high seat to do this menial task, it just simply didn't work out that way. I was in another field and did not see what was going on, but as he was doing the work, it was my turn to do the inspecting. Now the orchard belonged to him, and it was his privilege to do as he liked, and what right had those limbs to get in his way anyway. I found the borders of the field lined with limbs that had hung onto the harness until he got to the end of the row. More bark had been knocked off the trees than in all the preceding years. At one place, three trees in succession had been hit, and the bark was gone from a place the size of my hand to a strip a foot long. This inspection showed what I had expected, but through the wisdom of experience, I made no report.

In this job, however, he found one thing to blame me for. He had broken the cultivator on a fig root. We had dug out every alternate tree in a small adjoining fig orchard, and he had hit one of these roots. I had been very careful, so went to look, and found that he had hit a root of a tree that he had dug out himself, but again there was no report.

In spite of this, it was this job that brought me the only approval that I ever received for doing any farm work. I had been instructed to dig out every other fig tree, but at the edge of the field there was a vacancy where there should have been a tree left, and by disregarding his orders and changing the plan, I left the trees well spaced, and he told me one day in a tone of approval that he had noticed it.

Also, I remember one other word of approval. He had brought a gun home. It was a single shot breech-loader and used a Winchester cartridge. The spring that held the trigger in place had been broken, and for this reason, he had got it for two dollars. One day he was showing it to a man and cautioned him about the broken spring. I told him I had fixed it. He pulled the hammer back and found it was working perfectly. He looked at me and said, "You'll be making a gun next." I had taken an old table knife and with a very dull cold chisel had cut a narrow strip from the blade and with a file and hammer had brought it to shape and bent it so that it fit in place and was doing the work of the original spring.

From these little incidents I knew that he had a real respect for me, but he tried hard not to show it.

The Last Straw

One Saturday evening, I came into the house, and at the table the girls were dressing a chicken. Presently, father came in and asked who had killed it. He was told that Frank had done so. He began to scold Frank for killing the wrong one. Mother took Frank's part and said it was a small matter to make a fuss about, but mother had no right to enter into the matter, and he told her so. Other words followed, and presently he went over and slapped her in the face. I had heard of such doings before but had never seen anything of the kind. I was eighteen years of age now and did not feel that it was my place to stand by and let such things happen without a protest so stepped over and told him this had gone far enough. He turned and struck me over the left eye three times, then went and sat down at the end of the room. I had not attempted to strike back because I knew it would only make matters worse. Presently, the argument started all over again. Mother still thought it was a very small thing to start a fuss about and, woman-like, could not keep this to herself. I could see there was no stopping place, so to sidetrack the argument I told him she was right. Of course I had no right to say anything either, so he came over, and as I rose from my chair, he kicked me.

This missed doing serious harm by a narrow margin, and my attitude changed. I looked him in the eye and said, "She was right, and you'll be sorry for this!" He looked at me as if he realized that he had overstepped himself. Once more his hands relaxed; they went down by his side, and he turned and went back and sat down in the chair from which he had just arisen. His authority in his own household—where he had ruled as a dictator and a tyrant—had departed from him, never to be regained.

The Cause and the Effect

Saturday morning, in preparation for Sunday dinner, two cockerels had been caught—one of them to grace the dinner table—but father was unable to tell which was the larger so they were both put in a coop to await a further decision. Father went out on an inspection tour. The girls wanted to prepare the chicken, and Frank, who did not realize the gravity of his actions, had killed one of the chickens without permission. This was what set off the fireworks.

George happened to be in the neighborhood and was determined that mother should get a divorce, but she seemed to think father was a necessary factor and the lesser of two evils. It therefore seemed impossible to reach a conclusion.

On Monday evening, George asked me if I wanted to go with him to Santa Ana. We rode all night in his buggy, behind his pokey horse. He went to see a number of people and finally called on an attorney. He seemed to avoid letting me in on any of his conferences, so I knew nothing of what was said. His conference with the attorney was short, and when he came out, we started home, reaching there late in the evening.

The next day at about noon father asked me about the people George had seen, then asked if he went to see an attorney. I replied, "Yes." Then he asked what he intended to do, and I told him I would not tell. He said earnestly, "Won't you tell me what he intends to do?" I replied "No."

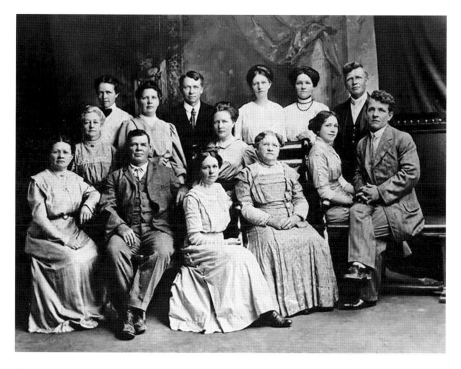

Thurston family photo. Pictured here are, from left to right: (*seated*) Sarah (Sadie), Artimesia, George Washington Thurston (father), Joan, Charlotte, Sarah Snow Thurston (mother), Luella and Frank; (*standing*) Harriet, Hulda, Lafayette (Lafe), Clara, Annie and Joseph (the author). Rosetta, about three years old in 1868, is not in the picture; she was stolen by the Indians while at play. *Thurston-Boyd family collection.*

As a matter of fact, I did not know that he intended to do anything. The only thing that gave me an idea of what was in his mind was that on the way home he made the remark that father "ought to be prosecuted for wife-beating." Two things were required in order to secure a divorce—one was money and the other was mother's consent—neither of which he had. I could not have given father the information he asked for, but inspiration often comes to the rescue, and the answer proved to be the right one, for he began to gather his things together, and in about two hours, he had driven away.

At this time, he had a good team and a spring wagon, also several hundred dollars in cash, all of which he took with him. We still had the old team.

From Los Angeles, he sent mother a deed to the property, but it was not signed. As this could not easily be an oversight, we felt it was to be the means of keeping the door open. Grandfather sent mother a hundred dollars to defray the expense of a divorce, and we had produced enough to keep us in groceries. Things went along smoothly, and in about two years, we heard from him. In a carefully written letter, he was informed that through some oversight the deed had not been signed, and he agreed to sign it. While he could not easily have claimed his home with us, we felt relieved when this had been accomplished.

The relief was so great when he was gone that the youngest child, who was less than four years old, did not even ask where he had gone or when he was coming back.

Responsibility

It is one thing to work under orders and another thing to take responsibility. I soon found that I was responsible for all the work but had no authority whatever. The rest of the family knew pretty well what was to be done but were under no obligation to do anything because I wanted it to be done.

I had never done any arguing with anyone and refused to start in now. I soon found myself doing all the leading work and letting the others do what they thought best. Frank would start after the cattle about four o'clock and frequently bring them in at about nine. He always had tall tales to tell mother about how he had been hunting for them. The fact was that they never went more than two miles from home, and there were no places where it would be possible for them to hide; also, while

he was unable to find them in broad daylight, he could always find them when it was dark. There was a sheep herder up the canyon with whom he liked to play cards, but there would be nothing gained by my giving out this information.

Tree Pruning

We had many trees on the place besides a small vineyard. There were apples, peaches, walnuts, olives, figs and some other kinds, and I had never pruned a tree. George volunteered to tell me how to do it. Shortly after this, Lafe also told me how they should be pruned, but they did not agree, so I figured the matter out for myself. I decided that there were two primary things to be done: cut off the limbs that were in the way, those that interfered with each other, and keep the tree as well balanced as possible. I have never had to vary from this plan. I also found that when the trees were well pruned, they bore more and better fruit.

We raised a colt almost every year, and when one of them became old enough to use, Frank would offer mother about half what it was worth, then take it and sell it, pocketing the difference. In this way, a team that would have been very valuable to us was broken up. I was never consulted in the matter and had too much to do to take such things in hand, while with the way I felt about it, if I had said anything, it would probably have ended in a row.

After six years, I told the folks one morning at the breakfast table that I was going to stay one more year and then was going out for myself. No one said anything. Presently, I said, "The longer I stay here, the more obligation I am under to stay and the less thanks I get for it." No one said anything, and presently, I got up and went to work.

Shortly after this, Frank left home. He wandered around for a good part of a year and came back apparently a little wiser for his experience. As Lafe was living nearby, with nothing particular in view, I prepared to leave, thinking he might come and take my place. At any rate, it was up to them to do what they thought best.

THE TRUNDLE BED

In the early days, there was a bed in the house that was called the trundle bed. This was where the children were put when they were old enough to be out of the direct care of their mother or when this place was occupied by another child that was still younger. The bed was wide enough to accommodate four or five when they were lying side by side. It was nearly square and was supplied with a straw tick. When the bed became full from the side by side arrangement, someone had to sleep sideways across the foot. Now this was not so good, although the children were very quiet. I, being the oldest of the group, it was up to me to find another place. We had a barn by this time that was well filled with hay, so I took a couple of quilts and laid them on top of the hay. They were simply folded together. When night came, I found I was not supposed to have a lantern, so when it came time to go to bed I just walked out into the dark. We used no greetings—there was no "Goodnight" or "Good morning"—so I just opened the door and went out. On the way, I heard noises in the weeds and wondered what was rattling them. I stopped; then it occurred to me that if it was light it would probably look the same as it did in the daytime, so I went on to the barn, which was about 150 yards from the house. Inside was total blackness. I went up the ladder and walked over to my bed. This was really a fine place to sleep, and it was mine for several years, though sometimes the haymow would be torn to pieces and then I would have to move out when it was being refilled. I once made my bed on the ears of corn in the crib, but one night of this was enough to last a lifetime. I made it on some boards in the shed, which were about eight feet from the ground. This would have done fairly well had it not been for the fact that about a million fleas had recently hatched out right where I had to walk, and most of them it seemed were able to get on and go up to bed with me. They are wise little devils and were very hungry, so they distributed themselves as evenly as possible, so as not to get in the way of each other while they settled down to the feast. Then, if they had all got on one side, it might have been the means of making me turn over in my sleep and fall off the boards. However, I managed to stick this out for over a month but was glad to get back to the hay.

Lafe had a cot by himself, but apparently it did not occur to father that he could have made me one also. Relief came when he built a room over the cistern that had been built to catch rainwater from the barn, and after Lafe left home, I had this room to myself. I made a desk and fastened it

to the wall. This was provided with a lock and key. The lock was made from a piece of steel wire and the key from a piece of baling wire. I had a box under the bed, and inside of this was another strongbox, each of which was provided with a similar lock and key. This is where I kept my treasure.

THE HOUSE THAT GREW

When we first arrived, we had one room and a tent. Finally, father got lumber and built a room at the end of the tent. When the tent finally gave out, this space was also enclosed, the partition was removed and this room together with the old cabin was used as a kitchen, dining room, living room and dance hall. Another room was built at the side of the old cabin that was called the girls' room; then there was a porch that led to the north end of the house, where there was a platform on which the water barrels were kept. Beside the stove was a platform where we kept a bucket of cold water, and in the back of the stove was a reservoir where we had hot water. Hanging from a rafter in the kitchen there were a couple of boards about six inches wide and thirty inches long, which were fastened together at one end with a leather hinge. The lower ends hung about four inches apart,

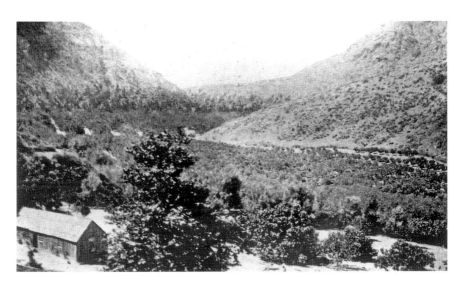

This is the only picture of the old house, taken a short time before it was replaced. *Historical Collection, First American Financial Corporation.*

71

and between them was smeared a little honey. When a goodly number of flies would settle on this honey, someone would come along and clap the boards together. This was dispensed with, however, when we got some fly traps made of wire screening.

Father and mother slept in this north room, the trundle bed being kept in the corner of the room. Here thirteen children were raised, seven of whom were born here. There were four boys and nine girls. We were never all at home at the same time, but after father was gone, we who were left gathered at one time and had our picture taken.

PART II

HERE AND THERE

We knew that the Fourth of July was supposed to be a holiday but did not know what it stood for and had never been able to celebrate it. The neighbors were coming down for one Fourth of July, however, and we were going up to the sycamore trees for a picnic. We had heard of firecrackers, and as they were in order for this day, Lafe and I pooled twenty-five cents and sent for three packages. After the day was over, we were scolded for wasting our money.

History was to me a blank. I finally got hold of a small book about six inches long, five inches wide and three-quarters of an inch thick—a history of the Revolution. This was interesting, but it was a little island of information dumped into the ocean of history and therefore could not be connected with the history of the world and lost much of its vitality.

THE FREEZE-OUT

During the time when we and our neighbors were hauling all our domestic water, there was a clever trick pulled by Mr. Rawson, the man who owned the large ranch adjoining us. There can be little doubt that the wheat spoken of before had been planted in the hopes that our cattle would get in it and give him an excuse for a damage suit, which would have been ruinous for

us at the time. There could be no valid excuse for going nearly seven miles to raise wheat when he had better land right at home, so he discontinued raising wheat or any other crop at this place. A few years later, he let it be known that he was going to build a fence across the canyon a short distance farther up. Father went to all the neighbors and advised them not to take a key, as he had also let it be known that everybody would be furnished with a key. This was at the time a public road, and by allowing him to put a locked gate across it we might lose the rights that had been gained by about ten years of use. To make this more apparent, he sent a crew of men down who did a little work on the road along the coast, evidently intending to show that there was another way for us to travel. This road was not only very poor, but part of the time there was no way that we could get to it. Father said that if everyone accepted a key, they would acknowledge his right to close the road, and all that would be necessary then would be for him to change the lock and we would be out.

The fence was built, but for some time there was no lock. Finally, father and mother both went to Los Angeles, and while they were gone a man was sent down to distribute the keys. Each one of the Goffs took their key, and then the man drove into our place and showed us children how the key worked. He offered us the key, but no one took it so he threw it on the ground and hit the horse with his whip. George picked up the key, ran and threw it into the wagon before it could gain speed.

Father came back late in the evening a few days later, and the gate was locked, but he lifted it off its hinges and came through. The next time one of the hinges had been reversed, and it could not be lifted off, but every time anyone went that way they were provided with a hammer and hatchet, and the locks were smashed. As we hauled water about every two weeks and father went to town every month, this made three locks per month. I went up with George one day. A man appeared on the hill behind a sheep cabin where he could see the gate. When we came back with the water, there was a new lock on it, and George started to hammer it to pieces. Two men came up and said, "Now we have caught you at it." George replied, "You've caught hell," got in the wagon and drove on. Shortly after this, father and George were both arrested, charged with malicious mischief and taken to Los Angeles (this being before the formation of Orange County).

At this time, mother was ill with erysipelas. She was afflicted with this; it would attack her face, and her eyes would swell shut. As a last resort in sickness of any kind, father would give the patient a steam bath. This was administered by having the patient sit in a chair and then covering everything

but the patient's head with a blanket. Under the edge of the blanket there would be a pan partly filled with water, and in this he would put a hot rock. When this cooled, it was taken out and replaced by another. This would be repeated until the patient yelled for mercy, then he would take the blanket off and dash a bucket of cold water over her shoulders. After this treatment and a good rub-down, recovery was only a matter of time.

As the law does not take such things into account, this task was left to the girls when father was taken to Los Angeles, and they performed it faithfully, with the usual results.

This malicious mischief was a serious charge, and two trips were made to Los Angeles. Rawson tried to show that he had built the fence to protect his cattle. Although he did not dare make a direct charge, he endeavored to make it appear that some of his cattle had been killed and that he had reason to believe that father was connected with it. However, Mr. Rawson's case was so weak that the lawyer advised father to start suit against him, charging malicious persecution. He was advised to sue for $10,000, but this was never done. It was not long after this that Mr. Rawson left the country. He leased the property to someone, and it finally came into the hands of Mr. L.F. Moulton, who was a gentleman in every sense of the word. We did not hear of Mr. Rawson any more.

THE OLD SWIMMING HOLE

We had a piece of land on the coast that it took just three days to plow. One Sunday, father sent me down to plow in that field, and the plow was left in the field until the following Sunday. On the third Sunday, I finished it. Each day, the neighbor boys were playing on the beach, swimming or fishing. Evidently there was nothing to be gained by taking three weeks to plow that little field, unless it was to find out whether I would do as much work on Sunday as I was able to do on a weekday. In spite of this, we were able to get to the beach occasionally and had many a good swim in the clear cool water.

Our neighbors found they could catch crawfish at night by tying a piece of fish or meat on a line and dropping it in the water. The crawfish would hold onto it until they could be landed on the rocks, and in this way, we would sometimes be able to take quite a number in an evening. This furnished us with sport as well as a new kind of food; it also furnished us boys with another excuse for getting out in the evening.

INDIANS

I am often asked if there were any Indians here when we came. No, there were no Indians or anyone else, but Frank Goff built his house on a little knoll where there had evidently been an Indian village many years before. This was attested by the fact that there were mortars and pestles found here and nearby and also by the fact that the ground was covered with seashells. The soil was full of shells. While many of them were in perfect shape, they had disintegrated to the extent that they would easily crumble up in the hand, and their bright shiny flakes could be rubbed into dust.

Frank Goff said he found a mortar that had been inlaid around the top with round disks of abalone shell. It had probably belonged to the chief. Many years later, I found a pestle in this same land that was of a very unusual type. It was about a foot long and was made from a very fine grade of rock; it tapered to a point at one end, and at the other there was a well defined knob; back of this knob there were three rows of bone that had been set in asphalt (which can be found in little gobs along the beach). The bones looked as though they might have been small pieces cut from the legs of rabbits. There were many flat rocks that showed the Indians' handicraft, but whether they had been used to grind food with or to play games remains with the Indians.

EMBARRASSED

In the early days, we boys had nothing outside of a rubber ball for amusement except bows and arrows. The bows were whittled out of such wood as we could find in the hills, and the arrows were made from a very heavy grass that is found in the country. They were not straight and had no feathers to guide them on the way. The arrowheads consisted of a piece of nail. They would not go anywhere in particular but furnished amusement. One day, I was going to the cornfield to keep the squirrels out and was shooting arrows on the way, always going toward the field but losing a few seconds of time. Father happened to see this and came over. He took the bow and broke it in two, then picked up my bundle of arrows and broke them over his knee. He had never told me not to do this but had apparently assumed that I would go straight to the field without

missing a step. I humiliated myself by asking him for the string, because string was hard to get, but he put it in his pocket. The arrows not only furnished amusement but were a help in scaring birds and squirrels away.

About three days after this, I killed a gopher with a bow and arrow. I told the children about it, and thinking to give me a boost, one of them told father in my presence. He looked off into the distance and made a very good effort to conceal a smile but said nothing. As far as I can recall, this is the only thing I ever killed with the bow and arrow, and this gopher came along just at the right time to embarrass him. The bow had been made from a small limb of scrub oak, and the string had been made by rolling enough strands of cotton twine together so it would stand the strain.

WORKING TOGETHER

After Lafe was gone, father and I frequently had occasion to work together, but there was never any conversation. In bringing in pumpkins and watermelons in the fall for the pigs, he would throw them out and I would catch them. He would sometimes try to throw them so fast that I would fail to catch them, but he never succeeded in this except when he got excited and threw two at once, in which case I would catch one and ease the fall of the other by letting it hit my arm. This was done in good-natured rivalry, but there was never a word spoken. One day we were out in the field, and he said, "I'll give you a quarter if you put that one in the wagon." He indicated a pumpkin that both he and Frank Goff had tried to lift and were unable to raise from the ground. As they were both large men, he had made bold to make me this offer. I said nothing but went over and knelt down beside it, putting my arms around it and rolling it up on my knee. I then managed to straighten my knee so that I could get a better hold under it. I managed to shove it up onto my shoulder, then arose, walked over to the wagon and dropped it in. I went on with my work. There was not another word spoken, and the quarter was never delivered. I always felt that he did not wish to remind himself that I had got the better of him.

HUMAN NATURE

"Everyone is a little queer." In spite of the fact that father paid homage to no religion whatever, he forbade any of the children to bring any fiction into the house. However, the Goff boys offered to bring Lafe and myself some stories. These were ten-cent novels at half price because they were secondhand. Most of these were "Blood and Thunder" stories based on the Civil War and early Indian fighting, as well as on the hero of the day, Jesse James. Daniel Boone, Kit Carson and Buffalo Bill were also included, also the story of three midgets who took a trip around the world. There were father, son and grandson, each generation smaller than the one before. These Katsenjammers were always playing tricks by way of keeping it lively, and the youngest was called "The Kid." It is wonderful how this name took root, for there are now as many "kids" as there are young people growing up.

Father also forbade a deck of cards on the place, but Lafe and I got a deck and we played with them until they were worn out, and some of them were replaced with marked cardboards, but we were never caught with them. Neither were we caught with any of the novels.

CHICKEN HAWKS

There were several kinds of hawks that would catch chickens, but there was one kind that gave us a great deal of trouble. They were known as the Blue Hawks of Scotland, though we had no knowledge that this was their real name. Their backs were blue and their breasts gray; they were very heavy and swift on the wing and lived among the rocks, making their nests in caves. They would never alight on a tree but would do so on the bluff above the house, and when they spotted a chicken would come down like a thunder-bolt, strike it on the head with a wing, turn, come back and pick it up. On account of their habits, they were difficult to shoot. One pair finally became so efficient in eluding the gun that they became a neighborhood menace, and there was a reward on their heads, but for years they continued to carry away young chickens. They lived in pairs, and there were never but two in the neighborhood at one time, but they lived in defiance of all efforts to get rid of them. Finally, I decided on a new method of attack. I took a rope and a steel trap up on the hill. Using

the rope I got down into their cave and set the trap. The next morning one of them could be seen dangling over the edge of the cave. I went up, and when the distracted mate came within range of my gun, he was brought down, and both of these destructive hawks were brought to their end. The reward, however, was never paid.

It was not long before there was another pair came to take over this good hunting ground. I made up my mind there would be no more educated hawks, so went up on the hill and bagged both of the unsuspecting newcomers. It was not long before another pair came and met the same fate. Another pair came, but they were a little less bold; one at a time was the best I could do, but the other one would go and get another mate. Each time, they would seem to be a little more aware of what was going on and would be a little more shy, but one by one they would get picked off. This hunting ground must have had a wide reputation, for they kept on coming, though they never caught any more chickens. They were very noisy at first, but they became so silent that they were heard no more and were seldom seen. Sometimes we would not see one in a month, and they were never within shotgun range. I had to resort to the Winchester. One alighted on the bluff north of the house and was brought down with a well-directed shot. The one that was left failed to get a mate. He was seen occasionally, but was always alone—though he refused to leave. Finally, this lone bird alighted on the same old bluff, and I sneaked up the creek bed with the Winchester. He flew away badly wounded. I followed with the shotgun and got a long shot as he flew again. He landed in a hole in the bottom of a bluff to the west, where I captured him alive, the side of his head being shot away and his brains exposed. One shot had pierced his body, but he was still fighting. Whether this was the last of the race I do not know, but I have never seen one since. I kept track of them, and this was the fourteenth bird, or seven pair.

THE OLD MISSION

Our nearest voting place was at San Juan Capistrano, the mission that was founded at the time of the signing of the Declaration of Independence. One day, father took me along when he went to vote. We found the tickets were in a store owned by a Jew by the name of Mendelson. This was a one-party ticket; where the other was kept, I did not find out. The ticket

consisted of a list of names that had been chosen by the delegates, and all one had to do was to vote for one party or the other. The man who handed out the tickets was free with advice if he wanted any name scratched out and another inserted in its place for any local office. The arrangement was open to corruption from top to bottom.

While there, we looked over the old mission, which at that time was probably in its worst state of ruin. The mud walls had been melting away for years, and all of the building, except one room, was open and most of the walls cracked and broken. In the front yard, there was a place where they ground olives in preparation for making olive oil. The equipment consisted of a vat containing two large wheels like grindstones; the largest must have been three feet high and six inches thick. In the center of the vat, there was a pillar to which a heavy pole was fastened with a bolt. This pole was worked by manpower, and the wheels were worked round and round in the vat to crush the olives, which were ground to a fine pulp. The pulp was then put in sacks. Inside an old building was the oil press. This consisted of a small platform on which a sack was laid containing some of the pulp; then a piece of heavy board was put on top of this and then another sack of pulp. When this was built up to the proper height, a very heavy timber was released to bear its weight down on top of the mass. This timber was perhaps fifteen feet long, and when most of the oil and water had been pressed out, weight could be added to the end of the timber and it was left until the pulp was pressed dry. The oil would rise to the surface and would be purified by turning from vessel to vessel until it came out the purest and best that could be made.

The Stray

There was a stray horse that came and made herself at home with our horses, which spent part of their time on the open range. She was very wild and had a piece of rope on her neck that was about an inch thick. We still had only the two old horses that we came with, and finally, father decided he would try to make her work. We eventually got her into a corner and put a rope around her neck. After a great deal of trouble, we got a harness on and got her hitched to the wagon. She went off with a bang, and by the time we had gone nearly a mile and had begun to get warmed up, father brought her to a stop, saying he wanted to teach her to stand as well as to

go. As soon as she stopped, she began to draw herself together like a great steel spring that is being set on a trigger. She looked around, and when she was ready, she plunged into the air. He drove her about five miles on the round trip and stopped three times on the way; each time the performance was the same. He turned her out for two weeks and then renewed the course of training.

She got this timing down to the second, and when the time came for the trigger to be pulled, all the steel in her body sprang forward with a mighty power. She was not very large but was certainly powerful. At one time, she pulled the wagon up a slight grade for some distance on the run, with the wheels locked and fairly dragging the other horse. Old Bill knew his business and was not helping her a bit.

In order to catch her, father tied one foot up and held it with a strap, so she went on three legs for two weeks. The two weeks' rest and the half hour's work became a routine, and each time, it was carried out in the same way. Each stop was timed to a given number of seconds. Finally, she was tied to a tree with an inch rope. I went up there one day with some of the smaller children, looking for birds' nests. She had wrapped her rope around the tree and was using her great strength in an effort to pull her head off, so I went over and cut the rope. She rolled over backward and finally got on her feet.

A short time after this, I was up in a sycamore tree when, on taking hold of a dead limb, it broke and gave me a fall of twenty feet onto the hard ground. When I got my breath, I was able to go home along with the children. After the incident of the fall had been told, one of the children said, "Yes, and he cut the rope and saved the horse's life; she was choking herself to death." Father looked at me and said, "Did you bring the rope home?" and when I replied in the negative, he said, "Well, you march up there and get it." I had felt fortunate to be able to come home, but though the rope was heavy, I went up and brought it back.

Not long after this, father decided he would make the horse do some useful work, so we drove over into the field with the plow, the handles being at the open end of the wagon. He handed me the lines and got down to take the plow out. However, by the time he got hold of the plow handles, the horse's waiting period had expired, and it was time for her to make a start as she had been trained to do. I soon got her stopped, and father came running up, cursing me as he came for permitting this to happen, but he unhitched the team from the wagon and I drove over to where the plow was lying. It was facing in the opposite direction from what it had been in the wagon, and there in the soft ground was the print of father's back, showing that the plow

had gone over his head. I kept my observations to myself, and after we had worked for about two or three hours, he decided he had given her enough of a workout for the day.

Fortunately, a short time after this, a man came over from Capistrano and claimed ownership. I heard later that she made a good saddle horse.

ALL IN A DAY'S WORK

Shortly after father left home, I had an opportunity to do a day's work on the county road. It was four miles up Laguna Canyon, thus making a trip of eight miles. It had rained, and there was a small flood in the creek. The ground was too wet to work, so I took this day to earn some money. In order to reach this place in time to do a ten-hour day's work, I had to have my team fed and be well on my way by five o'clock. Mr. C.D. Ambrose, who had traded for the Hub Goff Hotel, had asked mother to come and see them, so she took this opportunity to make the visit. It was not yet light when we reached the hotel. After doing my day's work and receiving my three dollars, which was the price for a man and team, it was well after dark when I came by for mother. They insisted on my taking a lantern (which I did not want), but as a lantern only makes shadows and blinds the eyes, I soon put it out. The road ran up the creek bed for some distance, and there was quicksand in places, but I could avoid that. However, the sand was stirred up, and the horses' feet, as well as the wagon wheels, sank deep into the soft sand. I stopped frequently to rest the team, but on the last lap, Birdie laid down in the water. Mother was going to get out, but I told her to sit still, for Birdie would get up when she had rested a while. Presently I spoke to her, and she got up and pulled us the balance of the distance. It was only then that I realized what a long day they had put in: over fifteen and a half hours, with only one hour of rest.

GOING TO MARKET

Harry Hughes and I were going to Santa Ana. Harry was on a visit and was going to Los Angeles on a little business, while I was taking our entire crop of walnuts to Santa Ana. The load was rather heavy, so we used the

hay rack—also we were driving four horses. All went well until we reached a distance of about four miles from home, then one of the tires rolled off. The old wagon had served us all these years and made no trouble, but rust had accumulated under the tires; the load had broken this loose, and it had let us down. Now, to put a tire on a wheel under a loaded wagon—with nothing to work with—is no ordinary job, but in time we got it on. Our gain was slight, however, for there was no way to make it stay on. We drove wedges under it and used what baling wire we had, but the wedges soon worked out and the wire was worn in two. One of us stood watch and also kept a sharp lookout for wire, but all the wire was rotten, so we worried along, stopping to drive the tire back on and pick up sticks to make wedges. The sun was going down, and we had just reached the halfway mark of our journey. I was on watch when the tire came off, and the rim of the wheel broke down. There was nothing else to do but get on the horses and ride to Santa Ana.

The next morning, Harry went on his way, and I went to a feeding place to see if I could get a wagon. They had a good one for fifty cents per day, and as I handed over the money, a man walked in looking for it but was informed there was no other to be had. I went out and transferred the load, including a box of eggs. Nothing had been disturbed. I took the wheel to a blacksmith shop and asked for a hurry-up job. He dropped all other work and started on it.

The next day, I had a new wheel, and the charge was $4.50. I borrowed a buggy, took the wheel back and brought the wagon in. The next day, Harry came back, and we went home.

As far as I could tell, no one had worried about what was keeping me, I having expected to return the next day after leaving. The best part of it was that we did not take things too seriously, and we had had a lot of fun out of it.

I Go to Los Angeles

A short time after father left home, I met a couple of boys from Anaheim whose name was Schmidt. They got a job in an upholstery shop in Los Angeles and wanted me to come up and see them. They wrote, giving me the name and number of their street and the right car to take, so combining a little business with the trip I went up to see them.

A new system of streetcars had been installed. They were run on a cable and would go up or down hill at the same speed, without horses, and made much better time.

It must have been some kind of a holiday; at least, there were many people on the streets. One of the first things I noticed was a young fellow standing on the sidewalk, calling, "Lemonade five a glass." He had a washtub about half full standing on a box. In this there was a large chunk of ice, and the top was covered with lemon rinds. I took a glass, as this seemed to be the only place to get a drink outside of a saloon. He took my nickel, squeezed another lemon, threw it in the tub rind and all, threw in a spoonful of sugar, looked up to see who was coming and called, "Lemonade five a glass."

A wonder had recently been wrought. Fire had been brought down from heaven, where it could be seen at night for fifty miles around, as it sparkled and sputtered on the top of a very tall pole. This was serving notice to Southern California as to what might be expected in the future in the lighting of cities.

I finally spotted the right car and requested the motorman to let me off at the nearest point to the proper street. I had to walk four or five blocks to reach the street and then go about an equal distance to reach the proper number in the 1300 block, but when I reached the place where this number should have been, there was only a vacant lot. This was an unexpected development. I went across the street—where there was a group of men—to get some information but could get nothing so went back to think it over. I decided that in order to number a street, they would have to start in the middle and number both ways, so started out on a walk of twenty-six blocks, and sure enough, they were at the right number. They had neglected to tell me on which end of the street they were. Their shop consisted of an old barn loft.

After dinner, they took me to the theater. It was a very good play, but I could see through it too easily. They took me through a certain notorious street that has since been outlawed in the city. After the show, we went to a saloon, and one of the boys ordered a glass of beer. We sat there for some time, and finally, another man came and was informed that we wanted beer. Right away, the first man came with the order, then presently the other man came, so we had six glasses. It was a clever trick. I tasted mine, but one taste was all I wanted, so the other boys had three glasses each.

I had seen Los Angeles, but the impression I have carried since is that it was a disjointed, rambling sort of a place, made up of buildings of every type that had been placed with no thought of order. There were unpainted wooden buildings of every kind and brick buildings two and three stories high. They were tearing down and building up, and they are still doing it.

Part II

A Trip to Colton

We met a young man at Capistrano by the name of Fred Pool. He liked my sister Hulda and came over Sundays to see her. His home was in Colton, and he asked me to come up and see him. I finally made plans to make this trip. George had a buggy but refused to lend it to me, so I rode to Santa Ana on Sally and borrowed a two-wheeled cart from Mr. Congdon, who had been one of our friends in Capistrano. They told me the way to reach the Santa Ana Canyon, and I started out. By the time I reached Riverside it was dark, and there were about ten miles to go. I did not have the slightest idea where Colton was, so I asked a man who drove by which road to take, and he said to follow him through town, as he lived on that road. Now it was so dark that I could not see his wagon more than thirty feet, but it had a distinctive rattle so I was able to follow it. Finally, he stopped and told me to keep right on and I would reach my destination. There was an electric light in sight, but as far as I could tell, it remained exactly the same distance away regardless of my traveling. When I finally reached it, there were several men standing on the sidewalk. I asked where there was a livery barn, and one of them said he would show me. This barn was about half a block away, and as I walked back with him, I asked where there was a hotel. He said, "Right here. This man has rooms upstairs." He stepped inside the building, where the balance of his group were still standing, and I realized that I was in a saloon (for the first time). As he went in, he told the rest to follow, that I was going to treat. I turned and went outside. He came after me saying, "Ain't you going to treat?" I replied, "No." He retorted, "You're no white man," and I said, "Neither are you," and proceeded to find another hotel, which was only half a block away. Here I got a room, and the man did not ask for pay in advance.

I was tired and slept soundly although I had a feeling that a lot of small company had been enjoying my presence, but I never had any proof. The next morning, I went into the lobby to pay for my room, but there was no one there. After waiting a while, as it was late enough so that the horse had been fed, I went to the bam and brought her back to the hitching post and went in to pay the bill (which was twenty-five cents). There was still no one there. I did not go into the dining room because Fred was coming over early to escort me to his place. Finally, I decided they did not want the room rent very badly anyway and went out just as Fred came over.

During the day we came back to town, and he treated me to a milkshake. This vender of a newfound luxury was found on the edge of the street, with an apple box for a counter. On a shelf inside the box he kept his flavoring in

a bottle, and in another bottle was the milk. After mixing the ingredients, he put a tin cap over the glass and shook it with his hands. It was good. Thus the beginning of the soda fountain.

The next day I drove over to Minifee, about twenty-odd miles, where we knew a family by the name of Walters. The following day was Sunday, and there was to be a ball game over at Elsinore. So I went over and watched my first game of baseball until the score had been run up to seventeen points, then I started on my weary way home. I had seen the country, but outside of that, the visit was of very little interest to me or to anyone else as far as I could see.

TO SAN JACINTO

George had bought some more or less worthless land at San Jacinto and wanted to move up there. He also wanted me to go along and drive one of the teams. It was about a hundred miles, and the journey took three days. When we arrived, there was nothing but his household goods and the bare ground, and it was getting ready to rain, so he wanted me to go over to Perris (about sixteen miles) and borrow a tent from his wife's cousin. When I got there, the tent was in use and could not be spared, so I went over to Minifee, about seven miles away, where Mr. Walters had a tent, but it was sheltering a stack of hay and could not be moved. I finally found a tent, but it was now getting dark and was raining a steady downpour.

I pulled part of the tent over my shoulders and started back by a different road. Along in the middle of the night I came to the little town of Winchester, and there was a light shining out of one window, so I went over and knocked. A man came to the door, and I asked if there was any place where I could get shelter. He said there was a barn nearby, that he had no right to tell me I could go in, but it was open. I drove in, unhitched the team, laid the tent on the ground and went to sleep. After a while I awakened, the rain had stopped, the clouds were gone and the moon was shining, so I was soon on my way. I guessed the right road, and as dawn began to break I could see the familiar hills where I had left George with his family. They had found shelter so did not get wet, but it apparently did not occur to him to tell me that he appreciated my going after the tent and the fact that I found one and brought it back through the mud, the rain and the night.

For this trip I got a ticket back to Santa Ana—my first ride on a train. When I got to Orange, where we were to meet a train on its way to Santa Ana, I was told that this train was three hours late. It was only three miles farther, and as I would rather walk than wait, I was soon on my way. I followed the rails, as this was the shortest way. Presently, I found myself walking over a bridge. Shortly, I heard a train whistle and looked back. Yes, there was the headlight. It was dark, and I could not see how far it was to the end of the bridge nor how far it was to the ground below, but thought I would be able to reach the end of the bridge if I did not try to go too fast and step between the ties. I could hear the train coming but did not think it prudent to look back to see how far it was to this thundering monster. The headlight lighted up the ties so that I was able to go a little faster; then the whole countryside was lighted up, and I could see the end of the bridge and the high bank of the approach. While I was going down the bank, the train passed. As I watched it go by I felt thankful that I had been permitted to come down under my own power but had felt no fear.

IN BUSINESS

When I was twelve years old, father told Lafe and myself that if we would clear a certain piece of land and plant it to corn, he would give us one cent per pound for the corn. There was about an acre of this land, and it was covered with heavy brush, but we were to work it only in our spare time. Most of this work fell to me, and my muscles were rather light to handle the heavy mattock, but finally it was cleared and planted. We raised five hundred pounds of corn, which brought us two dollars and fifty cents each. The next year, I planted it to watermelons and by so doing acquired a sort of proprietorship in it. It proved to be good watermelon land, and when they got ripe, I took a load over to Laguna. When I reached the camp, there was a row of tents along the beach, and the people were out on the sand. When they saw me, someone shouted, "Watermelons," and everyone was soon gathered around the wagon. I found they would not pay a high price (not more than fifteen cents). Probably most of them had watermelons spoiling at home. However, when we agreed on a price, the melons were soon gone, and I was on my way with four and a half dollars. The outstanding thing was that the people had been very kind and wanted me to come again.

Mabel Goff told me she saw some boys carrying melons toward Laguna in sacks, so when a boy came to the door early in the morning to ask for a drink of water, I figured he had come to see where the family were, and I followed him out at a respectful distance. They had a horse and little wagon tied in the creek bed and were grabbing melons as fast as they could. I went over, took their horse and started home. They came down pell-mell. They talked big at first but soon compromised by paying me a quarter for every melon they had picked. I went home with three dollars and let them have the melons, which were probably mostly green. This undoubtedly cured them of any idea of doing more of this kind of business.

This little field of watermelons brought me forty dollars, and out of it, I bought my first suit of clothes. I began selling fruit and other produce from the ranch but kept the watermelon money.

As the years went by, I accumulated $150. This I kept in my little strong box, mostly in gold. Finally, George realized that I had some money and would not rest until I put it in a bank. He now knew how much I had and was not content until he had borrowed it. I soon realized that my chances of getting it back were not good, as he was losing money. He wanted to sell me

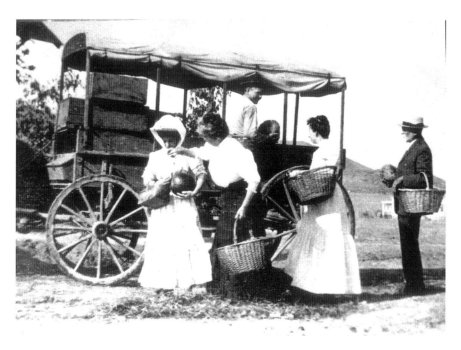

Joe selling watermelons from his produce wagon. *Historical Collection, First American Financial Corporation.*

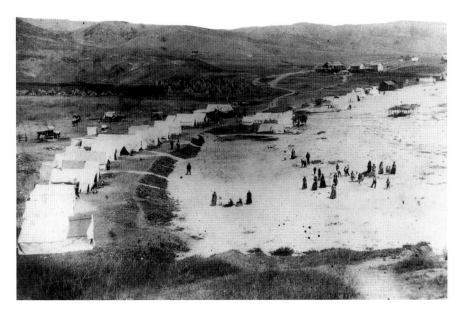

Rows of tent houses along the beach where water and produce were delivered. *Historical Collection, First American Financial Corporation.*

some land, and thinking I might have better security that way, I invested in some of this land and had finished paying for it only a short time before it came my time to start out for myself.

In the meantime, in addition to taking care of the ranch, I thought I would raise a few potatoes for myself, so I cleared the brush from some of our land on the coast and planted it. It was not potato land, and they were cheap. I saw Mendelson, the Jew at Capistrano, and he said he would take eight sacks at $.65 cents per sack of about 110 pounds. When I brought them over, he said he wanted to take some into the house and see how they would cook before he would accept them. I reached in between the twine and got out two or three that I knew would cook well and sat in the wagon while they were cooking. He gave me $2.50 for nearly 900 pounds of potatoes. However, this was better than I did with the balance of about twenty sacks, for I sold them to a hotel, and he did not pay for them at all. A short time afterward, he went bankrupt.

For Myself

I went out with fifteen dollars in my pocket and with no knowledge of the ways of the world. After stopping for a while with my sister Artie, who was living in Ontario with a small, growing family, I went to San Bernardino. The country had not recovered from the effect of the boom, and there was no work.

When Coxey's army was gathering in San Bernardino preparing for its famous march on Washington, I was taking orders for a cheap photographing outfit, who were taking large photographs at $1.25 per dozen, and I was getting the $.25 for taking the order.

I once helped dig a well near Santa Ana. The soil was underlaid with sand and rock to a depth of about fifty feet, and it was impossible to drill through this, so it had to be dug by hand. In order to keep the rocks from falling into the pit, it had to be made narrower as I went down. When I got to the bottom of the pit, there was just room to work, and if the bucket had touched the edge of the wall on the way up, it would have sent down a shower of rocks, but I got through without an accident. This work brought me one dollar per day, with board.

I got a job on a threshing machine as roustabout. That meant that besides my regular work I must be ready to relay anyone on the job except the sack sewers, the engineer and the boss. This job was from daylight until eight o'clock at night and paid $1.50 per day, with board.

The following summer, I got a job on another machine that was working exclusively on the Irvine ranch. The pay and the hours were the same. I worked over the same ground where I had worked on a mustard machine when I was a youngster. This machine was made by Hub Goff and could be described as a large box. It was supported by two wagon wheels. It was open in front, and there was a reel set a little forward of the opening. This reel was supplied with arms about two and one-half feet in length; this was turned by a chain that ran over homemade sprockets. The horses pushed this in front of them, and it was guided by a tiller wheel. The reel would force most of the seed, together with the broken sticks, back into the box, and the Goffs got forty dollars per ton for the seed. The Goffs had plenty of help among themselves, but evidently no one liked the dusty job of standing behind the reel to keep the mustard sticks out, and Frank came down to see if father would let me go. They gave me a pair of glasses to protect my eyes, and I stayed a week. I also was working one of our horses, but by the end of the week there were so many holes punched through his skin that the deal was

called off. This paid twelve, and father, after asking if I thought I should have part of it, gave me five dollars.

On this regular threshing machine job spoken of above we had a French cook. He was one of those men who try to avoid making work for themselves. Breakfast was served before daylight, and we stopped a few minutes at about ten for a bite. Ordinarily, a cup of coffee is the most important part of this light lunch, but if he had any coffee left, he would throw it out in the field, and no one was permitted in the cook house until the noon meal. What he had for us he would bring out in a pan. This was pretty dry picking. One day, he brought some corned beef. One of the boys took it and passed it around. Presently, he lifted it up and smelt it, then he threw it out in the field. This evidently made the cook mad, though nothing was said. A few days later, he sent out a pan containing bread and leftover meat. Now the meat was good, and everyone began to eat as it was passed around. When the bottom was reached, however, it was found to be full of worms, the fresher meat having been laid on top of the pile.

The boss was informed that he would have to get another cook or another crew, so in a few days we had a Chinese, and from then on, we had food that was fit for a king.

On this job there was a man by the name of Jim Stalker. He was well named, for he stood over six feet and weighed about 150 pounds. His bid for fame was a foul mouth. It was so foul that even the more hardened elements became tired of hearing it. In order to keep this going, he had to pick on someone, and finally, he started on me. I ignored his attentions, thinking he would get tired of it, but he kept it up. Finally, I began to cast around to see if there was anything I could do that would make him stop. One day, while coming back to the machine, I picked up a lizard. It occurred to me that this might be useful, for Jim was afraid of snakes. He had such a terror of them that when his own partner picked up a piece of dried snake skin, he was going to hit him with his fork. Now Jim was firing the engine, and as I came by his long neck was bent forward and his shirt collar formed a little basket that I thought would make a good place to put my lizard. I was always quick on my feet and was soon a safe distance away. He threw his fork at me, but his aim was poor. When I looked back, his head was nearly touching the ground as he frantically tried to get rid of his unwelcome caller. The air around him turned blue, then it began to be streaked with a lurid red and the vibrations that emanated from his vicinity were terrific. I kept at a safe distance, laughing at the comical performance.

That night at the dinner table everything was quiet. It was so quiet that someone made a remark about Jim not having anything to say. I was sitting nearby and said, "Jim will be all right when he gets his pants washed." He gave me one quick look, but I was smiling, so he quickly turned his face back to his plate and continued his eating in silence. That night, as I was making my bed, his partner came and told me I had better apologize to him. I told him he had it coming, and I had no apology to make. He said, "Jim will hold a grudge against you as long as he lives." I replied, "That's his look out," and I heard him apologizing to the boss a little while ago. His foul speech had lost its charm and was conspicuous by its absence thenceforward, and so matters stood until the end of the season when the crew disbanded. I shook hands with him and some remark was made about a snake, but I told him it was only a lizard.

In the Desert

I went to Santa Ana and found a man who had a few orange trees that he wanted dug up. He offered me $4.50 per cord for the wood if I would dig them up and cut them into firewood. After taking this job, I found the trees were just brush heaps, and it took $25.00 worth of the toughest kind of work to make a cord of wood. By working hard, I made about $.25 a day.

This was the means of getting me a job on the desert, in a so-called mine. We went some distance past Twenty-Nine Palms with a six-mule team, then the team went home. Water was carried several miles on the backs of donkeys. There was a tunnel 700 feet long in the side of the mountain, tapped by a shaft 150 feet deep from the top. Here I worked all winter at one dollar per day. I had been promised a raise if they should hire anyone else at better pay but said nothing when they hired a miner at two dollars because I could see no chance that the money would ever come out. I worked beside him and finished ahead of him every time because he was constantly sticking his drill. I would go to the top and send the powder down to him. One night, when I was getting the powder, one of the sticks of dynamite touched a candle that was hanging on the wall, and it started to burn. Knowing that it would not explode in this way, I tossed it down the tunnel about twenty feet and let it burn.

We were working a night shift at this time and slept in the tunnel. We were beyond the shaft—so had fresh air but no draft—and it was so dark that

there was no difference whatever between midnight and midday, and there was not a sound, the most wonderful place to sleep that could be found.

I was sent one day to drill an upper—that means to drill a hole in the top of the shaft above one's head. In doing this, the drill had to be hit from below while holding the full weight of it against the rock with the other hand, a job that no self-respecting miner would undertake unless from dire necessity. I finished the job only to find that someone had been watching to see if I would give it up.

Here I learned to sharpen tools and temper steel. Not that I did any of it, but I learned by watching others, and this knowledge came in very handy later.

BACK AT THE OLD STAND

After coming in from my work on the desert, I found the family had moved to Santa Ana. George had traded his land in San Jacinto for some property in Santa Ana, on which there was an empty house and a very active mortgage. He had invited mother to come and occupy this house, and they had moved out bag and baggage, leaving Frank on the ranch. They wanted me to go down and take charge, as Frank wanted to leave also. Under the circumstances, I thought it was the best thing to do.

There was a fellow we will call Will, who had been working on the place for some time, and I found that he and my sister Hulda wanted to get married and then for the three of us to handle the place together. As this would make a team that could handle the place to advantage, I agreed and went down to see the boys. I found them both in bed with measles. After I had taken care of them for a few days, they both got up and went to town. Fortunately, neither one of them had a relapse, and Frank did not return.

Neither Will nor my sister had any money, not even enough to buy a license. During this two and a half years that I had been away, I had saved a little over $300. I let them have $100 of this to get the few things they should have, and I stayed on the ranch while they were making their arrangements, and when they were married they returned. I had been told that they had a crop of beans on the coast, and when these were harvested, the money would be paid back.

I had not expected to find the place in the condition that I had left it but was not prepared to welcome what I actually found. In fact, I did not believe

such a transformation could take place in so short a time. The place was dotted with noxious weeds that had been completely destroyed many years before. Squirrels had been permitted to come and go at will and seemed quite at home, even under the walnut trees. There were several razorbacks ranging over the place, and between them and the squirrels, the harvesting of walnuts and what few other things might be growing had been reduced to the lowest effort imaginable and at the least profit. The fences were down, and there was only one cow left. We had been visited with a disease known as the "Texas Fever" some years before, and the small herd had been reduced to less than half of the original number, but now there was one cow. The harness that was new when I left was broken and in bad condition, the wagon, which was also new, showed hard usage and all other tools were in a like condition.

We had built a new house only a short time before I left, and all other things had been brought to a state so that they compared favorably with the new house, but in the short space of thirty months, they had gone back to the primitive. There was one thing in our favor, however: the country had not yet recovered from the boom, and groceries were cheap. I bought a case of corn, two dozen cans for $1.20, and a twenty-five-pound box of the finest dried prunes for $1.00.

I said nothing about my disappointment at the condition of things but took hold to build up. The bean crop that was spoken of was hardly worth harvesting. What we did not need for ourselves was traded for groceries.

In the course of a year or so things began to look better; we had hay in the barn (which was found empty), and the tools and fences were in better condition. I had provided myself with a secondhand set of blacksmiths' tools, and they came in very handy. In fact, they were the means of saving the situation, and the place had begun to be more cheerful and homelike.

Will was amiable and we got along very well, but unfortunately, he was by nature a horse trader. He had three skates that he used for trading stock. When a horse trader gets a horse in trade, he is not so much interested in the horse as he is in the boot. It is the few dollars that he gets out of the trade that he is interested in. In order to keep his horses handy, he wanted to do the work with them. This also was to show that they would work. They made lots of trouble, and each new one was a problem in himself. They often broke things up and caused considerable loss of time. They also were eating company hay, but when he made any money in a trade, it belonged to him. I had three good reliable horses that were standing idle most of the time, but we were feeding six horses when we only used three. I suggested that he

get rid of his horses and that we devote all of our efforts to the farming, but his horse trading nature could not see it that way. He was an ex-barber, said he had been run out of business by competitors and he frequently spoke of barbers as an "ornery" lot. One day, I asked him which were the worst, the ones who quit or the ones who stayed in business. He said he thought the ones who quit were the worst.

He had a brother by the name of Riley who came to see us once in a while. One day, he came unexpectedly. He had walked from Laguna. He said, "I'd uv brung your mail if I'd uv thunk of it." A few days after this visit, we were working in the field when, without any particular provocation, Will said, "I don't think we are going to get along here, and I think we had better quit." I replied "All right, if that's the way you feel about it." Then he added, "You tell me what you will give or take, and I'll buy or sell." I replied again, "You have made one proposition, and you can make the other." He agreed and started to town to see Riley. The next day, he came back with his proposition. This was about noon.

The three of us could do the work very well, but for me to undertake to do it all by myself was quite a different thing. I had taken this all into account, but mother was depending on us for her living, and to leave that to him was to leave her with nothing to live on. This was very evident.

When Will came in, he began to tell me what he would give me. He enumerated a number of things which are commonly called chips and wheat-stones, including about $15 in cash, the whole thing adding up to $125. I listened until he got through and then said, "I thought you were going to make a proposition to give or take." When he realized the position he had put himself in, he said quickly, "I'll give or take $135," and I said to him, "Come on upstairs, I have a contract ready for you to sign." He looked it over and signed it. Nothing had been said about returning the money he owed, nor the fact that it was my money that had seen us through to this point. He had evidently been so sure that I would not attempt to handle the place by myself that he had seen the proposition entirely from the point of what he had planned to do. I gave him a check for $135, and in a couple of hours, he had departed with all his belongings.

This was practically the last of the money I had, and from now on, there was not a thing that would be done except what I was able to do myself. Sister informed me that I had taken advantage of him in the amount of ten dollars, but this could have been only a shield for his disappointment.

This transaction represented but little material wealth, but it involved the eternal principles, and I had called his bluff.

Ever since I was a small boy, I had looked forward to the time when I might be free to work out my own destiny. Now events had shaped matters in their own way and given me the entire burden in such a way that there was no way to get from under it. Destiny had taken things in her own hands.

Alone

On the following morning, after I had done my chores, cooked my breakfast and washed the dishes, I took my lunch and went out into the field for the day. When I came back in the evening, I came up the path in front of the house and stopped for a moment. The house stood there as usual. The trees were standing back of it. I had seen this picture before thousands of times, but it was not the same—a change had come over it. The whole place had been transformed. There was no one there, and it was silent. The realization that there was no one in the house, and that there would be no one in it except when I was in it myself, was borne out much stronger than it had been the night before.

After a moment I started on my way to the barn, and after taking care of the horses, milking the cow and gathering the few eggs, I cooked two eggs and with these and a bowl of bread and milk had a good meal. I spent the balance of the evening in contemplation. I was not thinking of the farm work or the problems that might arise; neither was I thinking of the lonely situation. In fact, I almost forgot all these things. There were no conflicting emotions or thoughts; I simply got into a trail of thought and traveled. I traveled into a land of harmony such as I had never known. This evening is one of two that stand out in my memory; the other was to come a few years later.

The First Year

The following year was one of the driest that had been known to the country. A field of hay that I had planted on the coast came up nicely, but that is about as far as it ever got. When it came time to harvest, there were a few scattered spears of grain that stood about a foot high. If it was cut and allowed to fall on the ground it was lost, for no rake could pick it up, and I

must save every spear. I rigged a pan made from coal oil cans and fastened it so that it would drag behind the cycle bar of the machine. Then I made a reel that stood above the bar, which was turned by a sprocket chain. This would push every straw back onto the pan, and when a small pile of hay was accumulated in this way, I would stop the team and poke it off in a little pile. By saving everything in this way, I harvested about one ton of hay from about thirty acres of land. At one time, I passed a large yellow rattlesnake. He was just out of reach of the knives, so I turned the team around and passed the knives over him. He raised his head just high enough to get it neatly cut off, and I kept on going, not even paying him the honor of stopping to count his rattles.

Nate Brooks had planted about twice this amount on the Frank Goff place to the north and did not consider it worth cutting. I told him I would cut it and leave half of it in the field for him. I estimated that I got a little over two tons. Thus, after leaving his part, I had for myself a little more than two tons of hay after cutting over about ninety acres of land.

The walnuts that had been our best source of income yielded me just fifteen dollars this year. There was little chance of their improving, and they occupied the best land, so it was evident that they would have to come out. This in itself was a thankless job.

I had carried water out of the creek to keep a few melons alive, hoping that it might rain and keep them growing, but the rain did not come.

There were a few people still coming to Laguna in the summertime, and they would buy produce if there was any to be had, but produce depended on rain.

With the little hay I had salvaged, there was enough to keep the horses through the following year, but this did not bring in money. I kept track of all the money I took in that year, and it amounted to a little less than $325. After giving mother $200 of this and paying the taxes, it left me about $105 for food and clothing, besides upkeep and wear and tear of the ranch.

One morning in the fall of this year, I went down to the little field where the cow was pastured. She had been dry for some time, and I was expecting her to come fresh very soon. She was lying behind a rock, and as I came near, I could see she was dead. She was rolling fat, but she was just as dead as if she had starved to death. It is quite common when cattle are eating dry feed for their stomachs to become clogged. It soon causes fever and death and is called dry murrain. Lady Luck was not giving me any help. Fortunately, I had bought a young calf, but it would be more than a year before she could be of any help to me, and milk was more than half of my living.

THE BEGINNING OF A CITY

The first cottages built by summer visitors were along the bluff, south of the present hotel site, and were put up mostly by Riverside people. I believe the first was built by a banker by the name of Dyer. Then there was Edwards from Santa Ana, Richards, Moulton, Norton, Streeter and Handy. Captain Handy was a retired sea captain. This was on part of the subdivision laid out by Henry Goff. George Rogers subdivided later on the north side of Park Avenue, which was the line that divided the two properties. Someone has said that Rogers was the first to subdivide, but the fact that it is called Rogers Addition to Laguna Beach makes it self-evident that this is not true.

The collapse of the boom had left the country in a desolate condition. For many years, there were only about fifteen voters in the entire district, while as a summer resort it was almost deserted. The people who had built at Arch Beach tried for some years to keep the place alive, but the branch post office finally disappeared, and the store room followed. One by one, a number of houses were moved away. The pipes that had supplied water rusted out and were not replaced. Laguna, being the best place to camp and being nearer to population, managed to survive and support a post office and store. The little hotel that had been built by Henry Goff back among the trees was bought by a man named Spencer and moved over to the ocean front. Finally, Mr. Yoch bought both hotels, together with the land they were on. It was understood that the one at Arch Beach, which had been lost under a mortgage of $3,000, brought $500. This was moved over in three sections. As there were no roads and the gulches were very steep, this was quite a task, but it was added to the other hotel and made a considerable building.

Nate Brooks had invested in some land, including the school grounds. This had put him in the hole, and he never did get out. In an effort to extract himself from this predicament, he laid out a subdivision of several hundred lots, and attempted to sell them at $25 each. He was to sell these on a lottery basis. People were to subscribe for a number of lots and then draw the numbers out of a hat and take the good with the bad. While there were a good many people subscribed for lots, there were not enough to make the scheme a success, and it was called off, though he had spent about $400 in advertising. I had subscribed for one lot, and by doubling the amount, I got a choice lot on the ocean front, this being the only one sold. I disposed of this later for $350. For many years, there were many lots on the market that could have been bought for $10 each, but no one wanted them. There were too many of them, and there were no buyers.

This was the condition of the country when I found myself back on the ranch, where I would have to cook my own meals or eat them uncooked; where I would have to wash my own dishes and bake my own bread; where I would have to care for the chickens, the horses, the cow and any other chores that might be necessary; where I would have to be a blacksmith, carpenter and handy man; where I would have to be business manager and chore man; where I would have to fight coyotes, wildcats, skunks, coons and ravens, also squirrels, gophers, mice, worms and bugs; where I would have to wash my own clothes and repair barbed wire fences; where there was one thing of more importance than all of these things put together, and that was the uncertainty of being able to raise a crop even after all of these other things had been taken care of.

WATER FOR LAGUNA

In the heyday of camping along the coast of Laguna Beach, the job of furnishing water to these people was a business that brought in a little ready money for the use of what would otherwise have been an idle team. When we consider that three dollars per day was the established price for a man and team, and in hauling this water one could make four or five dollars per day, it is easy to see that there was always someone who was glad to take this job.

Old man Hemenway (as he was commonly known) was the most picturesque character. He stood about six feet, four inches; he was the rawboned type but was broad shouldered and weighed well over two hundred pounds. He wore a beard that was still black even after he was well along in years. In those days, no one ever patronized the barber, and according to appearances, neither he nor his family took the trouble to perform the duties that are now reserved for the barber. The old man could be seen almost any day as he maneuvered around among the tents, calling the people to water. His voice was pleasant, but it carried well, and he could be heard far and wide as he entreated people to bring their purses along. Water was five cents a bucket or fifty to those who were able to take a barrel. This job of hauling water lasted for many years, almost to modern times. It passed through the hands of many people and finally became so modernized that it was hauled in a tank with a faucet and didn't even have to be put into the tank with a bucket.

There were other things that people engaged in. Mrs. Rogers went into the business of baking bread, and during the summer, she did a rushing business. Others made pies and such things. Then the milk business was quite important, and those who had milk picked up a little easy money by delivering it at five cents a quart.

Political and Otherwise

One evening, there was to be a lecture far up Laguna Canyon by a couple of young fellows from Santa Ana. This was a political campaign, and they were to speak for themselves. Though the distance was eight miles, I came over to hear what they had to say. During their talk, one of them stressed the majesty of the law. He was for the enforcement of law, and in order to demonstrate the far-reaching effect of the law, he said, "Why, the law even forces you to wear clothes!" After the meeting was over, we were standing outside exchanging a few comments when, in order to drive his point home, he turned to Mr. Hemenway and said, "Why do you wear clothes?" The old man answered, in a drawl that he had, "To keep me w-a-r-m." I do not remember whether the boys were elected or not, but they did learn why people wear clothes.

Old man Hemenway was always on the school board and also served on the election board. The first time the Australian ballot was used (that is the ballot that we are using at the present time), I was old enough to vote, and hearing that one member of the board would not be able to be present, I came over early so as to be at the schoolhouse at sunrise and was put in his place. When we got through in the evening, Mr. Hemenway thanked me for the help I had given. He and all the rest of the crew were veterans on the board, but this new-fangled ballot had them bothered.

Scandal

Nate Brooks had a brother. He was not at all like Nate, but that is nothing new, for brothers are never alike except when they are twins. Will was a very large man, and he was a blacksmith. He weighed well over two hundred pounds, and it was solid muscle. He did not take any land of his own but

lived on Nate's place, where he farmed and kept cows and horses the same as others, while his shop brought in a little ready money; however, he was not satisfied and always had lots of trouble. He did not like his neighbors, and his feet hurt. He spent a great deal of time telling how his neighbors had treated him. They had never been as good to him as they should have been—that is, by comparison with what he had done for them. His feet were constantly hurting, although this did not seem to be apparent except when he had a chance to sit down and there was someone to listen. He was really a martyr, and even his wife was inferior. She raised his family and cooked good meals, but that was only fulfilling her duty and was not important (according to him). He was prosperous, as prosperity was known in those days. He did not like the country because it did not rain. He was going to a country where it rained. He was going to shake the dust of Laguna Beach from his feet and go to Oregon where he could get some rain. Finally, the time came. He sold what he could not put on two wagons and draw with two pairs of horses and made ready to go to a country where it rained. We bought some of the delicious canned fruit that his wife had put up in two-quart jars, paying twenty-five cents each; and he was on his way.

It so happened that within about two years he came back. His load was not so heavy, and his coming back was unheralded. He did not seem to have any particular reason for returning but took up his abode on his brother's place as before. Not long after this there was an election, and he went to the polls to vote. His vote was challenged on the ground that he had not been in the state for a year or in the precinct for thirty days, but he swore his vote in, declaring that he had not lost his residence rights, as he had gone away with no intention of staying.

He went to work as usual and began to build himself up in a material way and, in time, had accumulated a little property, but the grass was still greener over on the other side of the hills. Someone came who had alfalfa in Arizona. They had a good story about alfalfa and lots of water, and they liked Laguna Beach. This fellow, whoever he was, gave him the Arizona land and took what he had (except what could be loaded on two wagons), and once more, Will started out on a long trek with visions of plenty. They drove for a number of days and came to where there was lots of sand; also, the weather was disagreeable. The farther they went, the deeper became the sand. The hotter and more disagreeable became the weather. This was not to his liking, and without reaching his destination, he turned and came back, but he did not come to Laguna Beach; he went to another part of the country.

OLD JOE LUCAS

In the very early days, shortly after people had settled in the canyon and along the coast of Laguna Beach, there was an old man known as Joe Lucas. He had a gray beard and was a native of Portugal. He spoke very broken English. He did a little fishing and apparently made most of his living that way. If he ever earned any money either by fishing or working, I never became aware of the fact. He became known as Uncle Joe. George Rogers furnished him a place to live, and later, the county furnished him with eight dollars per month, which assured him of something to eat besides fish. Everyone liked the old man and had a good word for him, but his great popularity came about the time of the school election. The only honor within the gift of the people was to be elected to the school board. I do not believe that Uncle Joe was a citizen, but nevertheless, he voted at such times, while the vote among the rest of the people was so nearly equal that sometimes his vote was very important. The voters were very few, and at such times, the honors bestowed upon Uncle Joe, were entirely out of proportion to his deserts. He was an old man when he came, and he lived here for many, many years but did not know his own age. When the camp was flourishing, people liked to be kind to him and would give him the clothes they did not care to take home with them, and one day I happened to be in front of his cabin when he came out. The door being open, I could see that the entire inside around the top of the wall was a solid mass of clothes of all kinds, while he continued to wear the same old greasy overalls that he always wore. I presume he changed his shirt and overalls when they were worn out, but they always looked about the same.

He went fishing regularly, carrying a little spear and a very heavy line. I asked him one day if he didn't get tired of fishing, and he replied, "Business is business by God," so he evidently was not fishing just for fun, although I never happened to see him bring anything home.

BILLIE WILLIS

There was a little man of English extraction who came to Laguna Beach. He was rather odd looking, and his face was a little awry. He must have weighed but very little over a hundred pounds. There were a number of

Old Joe Lucas. *Historical Collection, First American Financial Corporation.*

houses built at that time that had running water, and some of these people had planted some shrubbery and started little gardens, so Billie took up gardening for a livelihood and would take care of these places through the winter as well as in the summer. Though his face was a little twisted, Billie was straight. People could depend on his doing what he agreed to do. He had married a girl at El Toro who had been born in Laguna Canyon, but they had separated. He lived in a very small place that was covered with flowers. Finally, he met a girl from Pasadena who had curvature of the spine. She had experienced a rather hard life, and perhaps for this reason, they took to each other and were soon married. Billie kept on with his gardening, and they moved into better quarters, but it was still small and was soon covered with flowers. They were a queer little couple, but he made a good living and they seemed to be very happy. They were both very small and both a little queer, but they lived their own lives in their own way amid their flowers, while most of the first gardens in Laguna Beach were planted and cared for by Billie Willis.

Finally, the little woman's frail body could stand it no longer, and she passed on to her reward. Billie lost heart; things were not the same. He kept on with his work, but his body was too frail. I went to his cabin one day, and there was a little pile of dirt swept neatly into one corner of the room where it made a convenient place to throw burnt matches, eggshells and such things. This is the last time I saw him. He soon followed the girl who had gone before. These little people had done their part and done it well.

DIVIDING OF THE WAYS

When people first began camping at Laguna, they came principally from Santa Ana and Riverside. They camped at the most convenient place along the shore. As the crowd grew, a few houses were built; they required more room. Then there was a little difference between the people. The ones from Riverside were a little more sedate, while the ones from Santa Ana were a little more jolly and lively, so they started another place, which became known as the Santa Ana camp. Their headquarters were at Boat Canyon where there was a good landing place. People would come in relays; that is, they would pitch a tent, and part of the family would occupy it while the rest stayed home and took care of things. In this way, the camp would flourish at top speed until it came time for the schools to open.

There would be a store at each camp, and one season, a saloon made its appearance in the Riverside Camp, but we had local option at the time and it was voted out. This was the only saloon that appeared in Laguna until the repeal of the Eighteenth Amendment.

One season, a man paid Irvine $100, so he told me, for the exclusive right to run a store at the Santa Ana camp, but, acting under the impression that prevailed at the time, that everything within sixty feet of high water belonged to the public domain. Another man started a store at the nearest point he could get on the edge of the bluff and kept it open through the season, though he did not do much business.

The man who rented this land put up a dance floor in connection with his store and did a big business. I went to this place one evening and found a new enterprise had made its appearance. This enterprise consisted of serving what was called ice cream. It was made at the premises and was served in a saucer at twenty cents a dish. It was not very hard, but it was good and was something new, so he did a big business. If he ran short, he would give some youngster a dish for turning the crank to make another lot. It was my impression that the dance floor was put in to help business, and there was no charge for the use of it.

As I had established myself in the sale of produce at this time, I was in this camp a great deal. While I made no effort to sell to the store, I came along one day with a large load of very fine watermelons, and he told me he would give me twenty-five cents each for a number of them if I would not sell any for less. I agreed and made the sale, for I had an overload, but I soon found I had made a bad bargain, for there were many small ones in the load. I told someone of this, and they suggested that I sell one and throw one in free. This offered a way out, and there was no bargain covering it, so I disposed of the load and it was a good bargain after all. I heard the storekeeper was going to give me a leather medal, but this did not materialize.

Boat Canyon was thus named because it was the best boat landing place along the coast. There was a man who had a shack at this place and who made his living fishing. He was from Chile and was known as the Chilean. There were several boats that were owned by the campers. These were freely used, both for fishing and for pleasure. The Chilean sold fish, and one that weighed ten or fifteen pounds would bring twenty-five cents. But I came over one day after there had been a heavy run, and there was a great string of them hanging in front of his place that were offered at ten cents each, so I bought my first fish. Everyone was full of fish, and they were not selling.

Making Wine

We had practically been forced to make wine out of our grapes. Father had been hauling them to a winery in Santa Ana, and one year, all he could get was ten dollars per ton. It took us one day to pick a load and two days to take it to market, so it was taking four man days and three for the team to get a load to market, and that is saying nothing of taking care of the vineyard. A ton was about all we could haul.

Father rigged up some vats for making the grapes into wine. This was only a few years before he left home, and when he was gone, I continued the business. But it was only a short time before a disease swept the country, killing our vines together with most of those in the county.

Later, the question arose: should we plant more grapes? I did not want the place to be known as a winery and told mother that as we had a large family, most of them girls, their reputation was worth more than we could make out of wine. I could sell this wine only in one place; so as long as it lasted, I took orders and would take a few bottles with my other produce. One day, a fellow came to the wagon and asked if I had any wine. I told him I was not peddling it, but a man had ordered a bottle and had not come to claim it, so he might have it. He took it and paid for it, then said, "I am an Internal Revenue officer, and you are not permitted to sell it except in one place." I told him I knew this. He evidently knew my reputation and, being a gentleman, said no more about it.

Before this wine was gone, mother saved up a two-gallon jug full, and more than thirty years later, I was allowed to have a small sample of the little that was left. I am no authority on wines, though I have tasted it occasionally. However, this little sip stands out in my memory. The taste lingers as nothing else has ever done.

Transportation

From the time the post office was first established in Laguna Beach, it has never been discontinued. During the boom, Lorain Thrall ran a daily stage from Santa Ana to Arch Beach. He carried the mail, which included that for the branch office at Arch Beach. Passenger traffic was important at this time, but it did not last, though there was always some during the summer.

The carrying of the mail was let by contract to various people. Finally, Mr. Farman came and took this work upon himself. He was an old stage driver and had a regular old-time stagecoach, swung on leather straps. He did a little farming, kept a few cows and sold milk. He appeared to be making a good living. He liked to talk about his experiences. He once said to me, "I'll tell you, Joe, if you had all I know in a book, it would be a big one." So I told him, "If you had all I don't know in a book, it would be a bigger one." He said, "There ain't no balky horses, but there are plenty of balky drivers." And he was about right.

Transportation shifted into high gear with varying fortunes for a few years. A man by the name of France, who operated under the name of the France Investment Company, got hold of some land in the steep hills at Arch Beach. This was laid out as a subdivision, the same as if it had been level land. Streets were laid out on straight lines over all kinds of steep places, with no thought whatever as to whether they could be used or not. Nothing was of importance except that they looked well on paper. It would have been as foolish for one to think of using these streets for driveways, as it would be to think of going out on the ocean in a boat to shoot quail. However, these lots were put on the market under high-pressure salesmanship rules, and were all sold. The bulk of them were sold for ten dollars each, and many were bought by people who came down to look and who were carried away by the view. It is possible that he made a little money on the venture, but it could not have been much. He ran free transportation during the campaign and a great many people came down, but one of the principal things that he accomplished was to ruin what otherwise might have been a very valuable piece of land.

A man by the name of Bill Nye drove his stage for him, and for a time after the campaign was over, he drove the stage for himself. In coming to Laguna there was a place known as Red Hill. In coming up this hill when it rained, it was very much like trying to climb a greased pole. One night, he had difficulty in getting up the grade and did not make it until the wee small hours. The worst of it was that he had a lady passenger in the car.

FRED TREFERN

A man by the name of Fred Trefern came from the middle west. He got a group of lots on the south side of Park Avenue. He kept a cow and some

chickens, finding enough work so that he appeared to be making a good living. Finally, he decided to go into the transportation business. He traded what he had for two passenger cars and a truck and started to haul passengers and freight from Santa Ana, while he would also meet certain trains at El Toro. He was a familiar sight along these roads for a number of years, where he gained quite a reputation as an Irish wit.

The roads were bad, and the demands for repair of his rolling stock were numerous. One at a time, his two cars fell by the wayside and found their way to the inevitable boneyard. But the old truck, which was capable of making about ten miles per hour, managed to stay on the road for some time. The seat of this truck was constructed in such a way that it was easy to get out and walk around the flat bed. Then there was a trapdoor made in a place where it was convenient to open it and look at the gears, which as time went on became more of a necessity.

Traffic in both passengers and freight was light, but if he happened to have a passenger on one of these trips, there was room on the seat. However, if he happened to have two passengers, there was room on the platform. If one of the wheels dropped into a chuck hole, it might throw the passenger off into the street, but this did not matter much because no one would undertake the trip if they had on good clothes. Even if there had been a railing around the platform, it would not make much difference as far as the clothes were concerned.

This old truck could be seen on the road even after its usefulness had vanished, but finally it came to the end of the journey. There was no money or credit for new equipment for transportation, and Fred had to seek other work.

CARRYING ON

After the horse had been virtually put off the road and automobiles had not fully taken their place, getting places was sometimes quite inconvenient. Mr. Yoch was doing business in the summer, and transportation was something of a problem, so he bought a vehicle to help out with his business. This vehicle was of a type that it is difficult to determine just what it should be called. To say it was a bus, a stage or a passenger car would not convey a clear idea as to what it really was. It would seat about ten passengers, and they sat on the side lines facing each other. There was an engine under it somewhere, and it

was cranked over on the right-hand side, a little back of the middle. While I do not know what speed it was capable of making, I think it sometimes made twenty miles per hour, but this speed was very uncertain.

Then there was another drawback, and this was that when a passenger got a seat, he could not tell how long he would be able to keep it. Some places where the road was rough it was not safe to travel at such high speed, for the passengers might be injured or the vehicle break down. Then there was a sandy spot on the way, and it was not built for sand. Some of the passengers might have to get out and push. It had been built for use in Chicago but for some reason had been offered for sale, and this happened to be the place where it made its next run. In addition to the sandy place, there was a hill to climb, and it was not built for hill climbing. However, when it reached the top of the hill, it was safe and its troubles were over. The balance of the way it did not make much difference whether the engine would run or not.

This machine could be seen on the road for some time. In fact, it spent more time on the road than it should have spent for the service rendered. However, it succeeded in making one more link in the transportation business of Laguna Beach before it reached its unknown destination.

Finally, the road was paved. A paving campaign had been started, and a bond issue of $18 million had been voted to build a highway from Sacramento to San Diego. A paved road was to be built to connect Laguna Beach with this great highway. While this work was being done, traffic was turned down through Aliso Canyon. Traffic was heavier by this time, and this road was a streak of chuck holes connected by dust. The traffic was routed by Capistrano and up over the terrible roads along the coast. This was more than twice the distance, but people came regardless of inconvenience or distance if the reward was to be a paved road to the beach they loved so well.

School Days

Shortly after our neighbors began settling along the coast, there was a demand for a school. As the various settlers came within a comparatively short time, and most of them had large families, the demand came very soon. The first school was held in a private building. It was my impression—from what I heard—that it was held in a room belonging to Henry Goff. But Levy Hemenway, who was about fourteen years old when he came and was therefore a charter member, came to see me one day recently. He said it was

a room put up by George Rogers (presumably for this purpose), the room later occupied by Uncle Joe Lucas.

The first teacher was a man named Twombly. I saw him once when he came to our place, probably to see if father would let some of us children come to school. My impression of him was that he was about six feet tall and weighed about 160 pounds, that he wore a short sandy beard and his hair was red. I think he taught just one season, and the next year there was a young man by the name of Taylor. By this time, there was a regular school building, which was located on the land that has always been used for school purposes.

It is my impression that this room was about fourteen by twenty feet, but it might have been a little larger. Mr. Taylor also came to our place once, and I was permitted to visit the school for half a day while he was teaching, walking the four miles each way by myself. Mr. Taylor told me he walked ten miles to go to school, but he did not say that this was a regular thing. He was conspicuous in the neighborhood because he was always well dressed.

There was a man in the class by the name of Jimmie Vinard who was twenty-three years old. Something was said about "nothing," and the teacher asked, "What is 'nothing'?" Jimmie could not give a satisfactory answer, and so he asked, "Which would you rather have, one nothing or four nothings?" He said, "Four." The teacher said, "I would rather have one, because it would be easier to get rid of."

Another thing that stands out in my memory is this: he said, "If you say 'do this please,' the please does not modify the fact that it is an order, but if you say 'will you do this,' it is a request." For some reason, modern teaching seems to imply that to say please modifies an order into a request that must be obeyed. To me, however, it seems like an insult against the English language.

As the families increased in size, the people up the canyon complained that their children had to go too far to school, and they started an agitation to divide the district and build a new school house up the canyon. They finally succeeded in this, and a new building was put up on Mr. Hemenway's property. This was built under a bond issue and was a much better building than the old one, but it was not long before the boom broke and most of the families had moved away. There were not enough children to support two schools, and it became necessary to consolidate the district, so the new building was left out in the cold while what children were left had to come back to the old building.

This little building served for many years after this, but finally, there was a demand for a new one. Originally, the children came from about

The 1913 schoolhouse, which exists today, situated on Legion Street, now known as the American Legion Hall. *Historical Collection, First American Financial Corporation.*

four miles from each direction, but now they were more centrally located. When the new building was contemplated, a question arose: should it be a one-room building or should there be two rooms? There were just enough children in the eight grades to make one fairly good class, and many of the people contended that it would be a waste of money to build more than one room. This entered into the campaign and became the vital issue.

Mr. E.E. Jahraus, who had recently come to Laguna, was a cigar maker who had established his factory and place of business underneath the old hotel. His entire force of manufacturers and salesmen consisted of himself, but he had begun to visualize something more than a summer resort for Laguna Beach and had gone into the real estate business.

There were plenty of vacant lots waiting for buyers, and he undertook to find some of these buyers. He was always ready to drop his cigar business to try and sell a lot, whether or not his commission would amount to more than one dollar. He told everyone that Laguna was going to grow and that they should have a two-roomed schoolhouse. When the campaign came to

Schoolhouse situated in Laguna canyon. *Historical Collection, First American Financial Corporation.*

a close, it was found that he had won his point, and the little old shack was soon replaced by a two-room building. It was some years before the extra room was used, but finally, people began to come to make this their permanent home. The school began to grow.

Finally, between the eight grades there were enough children so that it became necessary to divide them into two classes and to hire another teacher. This marked the breaking up of the old conditions, as the town had really started to grow. It marked the change from a summer resort to a city of homes.

Action

In 1921, the town really began to grow. For some years, there had been about seventeen houses on the cliffs, and enough building was going on to keep one carpenter fairly busy. He sometimes employed a helper. Now there was a crew of carpenters who were kept busy all the time, while

more of them began to make their appearance. It was not long before it became necessary to build another room on the school grounds and to hire an extra teacher. After this, for a number of years, there was another room added almost every year, and there soon was a group of one-room buildings. Finally, plans were submitted for a class "A" building, estimated to cost $124,000. This was voted for by the community and was supposed to provide room for all school requirements for a number of years to come, but by the time it was ready for use, it was completely occupied and the demand for more room was beginning to be felt. Soon there was a four-room building erected, which has since been devoted to workshops. Also, a campaign was started to convert the class "A" building into a high school and build a new grade school. This was done and has been added to since, together with a gym.

PRISONERS

We will have to look back once more into early times and view an incident when father was excavating for a cellar, over which was to be built a honey house. In digging, he came upon a small cavity in which three toads were imprisoned. They were three ordinary warty toads. One was full grown, while the others were about half grown. They were all alive but died as soon as they were exposed to the air. They were in a cavity about six inches in diameter and between eighteen inches and two feet below the surface. Although they were alive, they were just skin and bone. How long they had been imprisoned, there is no way to tell, but inasmuch as there is only one practical way that they could have been buried, it must have been a long time.

Toads burrow in the soft earth in the daytime for protection. In this way, they simply get beneath the surface. While thus buried, there must have been a flood of water that came over and carried soil enough to seal them in, and while the soil was still wet, they could have pushed it back in their effort to get out and thus made the little cavity—though having no claws it was impossible for them to dig out. Our experience showed that the water came down from the hill after heavy rains, about once in ten years, but there is no assurance that it carried soil over this particular place every time this happened, for as soon as it built up a little in one place, it was free to run into some other place, while it was just as free to carry soil away as

it was to build. Thus it might have taken many hundreds of years to build the soil up to the depth that we found it. The length of time the toads spent in that little prison is anybody's guess, but it must have been hundreds of years and dry most of the time.

Only a Bluff

Upon the steep side of the hill (to the east of the house) from where the water flowed when there was a heavy storm, there was a long overhanging bluff. We children used to go and play in the soft sand that covered the bottom of this long cave. One evening, as I came to the house from doing the chores, there was suddenly a terrible crash and roar. I looked up but could see nothing but a great cloud of dust as this great body of rock came crashing down the hill. Father was working in the shed, making beehives, and Joan (the child that was a babe in arms when we came) was playing among the hives. Father grabbed her and started to run to the south as I ran toward the creek, while all the rest of the family began to find their way to the south, out of range of the rocks. As soon as the noise had stopped, I went up and joined them and counted noses. The two older boys were up the canyon, but Hulda (the first child born on the place and who was now nearing the age of three years) was missing. A search was made through the house, but she was not there. By this time, the dust was so thick that one could hardly see, but out of the back door she was met as she came toward the house whimpering.

As the rocks had stopped rolling, we went up to the corn crib, where the milk and eggs were kept, to appraise the damage. A large rock that would perhaps weigh 1,200 pounds had made one last effort to get into mischief and was resting on the sill of the crib right at the point where these things were kept, and there was a lot of perfectly good omelet material scattered around. But as only a small part of the rock had come inside, the damage was not great. The next day there was a hole dug back of it, it was toppled back into it and the hole in the wall was patched up. The omelet was a total loss.

Two or three rods from the house there was a duck coop, and back of this coop there were three rocks that must have weighed about a thousand pounds each. They had hit the coop and moved it about six inches but had not broken it. They were lying tight together and looked as though they

might have been a single rock that had broken in three parts while on its way down the hill. They had come through the beehives at the point where Joan had been playing and had stopped about ten feet from where Hulda was still playing, she being directly in their path. Several beehives had been smashed, but otherwise, no damage had been done. Right in the path of the greatest of these rocks was a little cave where Artie, one of the older girls, had been but a short time before to see some kittens. They were lost, but the mother was saved.

The side of the hill that had been covered with heavy brush had been ground up until it was but a mass of dust and where a piece of wood the size of a match could hardly be found. This took place in May, and though it was just at the end of the rainy season, the ground was like powder. Most of the large rocks, many of which were as big as a good-sized room, were still standing on the steep side of the hill. Father was asked if he could account for their not coming down at least to the bottom of the hill, and he said he could not account for it unless it was because he was a good Tom Paine man. I have come to the conclusion since that it was on account of their great weight. This forced them deep into the ground, which slowed their speed. If the ground had been wet, it is quite possible that they would have gone much farther.

A strange coincidence connected with this was the fact that a man had been at the place the day before and had made the remark "I should think you would be afraid of a landslide here." Father looked up at the bluff and said, "I am not afraid of a landslide, but we might have a rock slide." The man looked up and said, "There is no danger of those rocks coming down; they have been there for thousands of years." He forgot that the land had also been there for the same length of time, but this took place just the day before they gave way to the inevitable, as there was a large root hanging over the place from where they had broken off, showing that there had been a crack there for ages.

The Hermit's Cave

There is a legend of a robbers' cave in Laguna Canyon, where horse thieves and bandits had their hideout and where they would go to elude officers when hard pressed. I have also read in local accounts how they would swoop down on the stage that plied between Los Angeles and San Diego. As the stage passed

about six miles from these hills and could not be seen from such a place, this is hardly possible. That they might have hidden out in this locality and waylaid the stage is quite probable, but there is no known cave in Laguna Canyon that could have served this purpose. However, there is a cave in a branch of Aliso Canyon, which is over the hills opposite Laguna Beach, that could have been the place that was supposed to be in Laguna Canyon. In coming down Laguna Canyon there is a place about four miles from the beach where bandits who were being pursued might turn off into a side canyon and pass over a small hill that would lead them down to this perfectly good hideout. This would throw pursuers off the track and give them a clean getaway.

When we came to the country, father found this cave and retrieved from it an old blacksmith's bellows and some pieces of iron, including part of a broken anvil. We called it the Hermit's Cave, not thinking that it might have been used by bandits and horse thieves. This cave is located at a point where the canyon widens out to about twice its width when entered from the aforementioned point. As a cave it is not much, but as a place of strategy and refuge, it is a wonder. It is located in a very narrow ravine that is solid rock on both sides, and the cave is parallel to the ravine. In front, there is an elder tree that makes it difficult to see into it from the outside and which acts as a screen for those on the inside. There being a solid wall in front of the cave, it is impossible for anyone to get in a position where they might see directly into it.

Also, there is a place on top of this little ridge where one might lie, having in front of him a commanding view of the entire country. A hole has been drilled in the rock at this point, evidently to give one something to hold onto in keeping his position, as there was a peg driven into this hole. The cave would shelter several men, although it is not what could be called comfortable. There were holes drilled in several places, each of which had a peg driven in. These were obviously used to hang things on.

By taking their horses a few rods up the canyon, they, too, would be protected and could hardly be seen from any direction. In addition to all these convenient arrangements, there were the ruins of an adobe house a short distance in front of the cave. It was within easy rifle range and might have been used in connection with it. Quite likely this was the case, for an accomplice might have lived there who could easily pose as an innocent party, while he might also be a great help to the bandits.

I have no way of knowing whether or not the cave has been used since we came to the country, and the last time I was there, the old house was nothing but a small mound of dirt.

THE LITTLE OAK

When I was herding cattle, I noticed a little oak tree was growing in a pocket of dirt that had collected in a small indentation that had been left in a great rock at the point of the hill where the road made a sharp turn. There was no crack where the roots of this tree might find a way through to other feeding grounds. The rock was very large and solid, and the tree was confined entirely to the little pocket of soil where it happened to find itself.

In winter, it would get water and start to grow, but throughout the dry summer, all it could do was to try and keep alive. Sometimes, in spring, it would send out two little branches (as a rule it would be only one), but it could not keep these limbs alive through the long dry summer. They would wither, though a spark of life remained in the root, and next spring, it would try once more. If there was plenty of rain through the winter, this branch would grow a little taller, but as a rule, it attained only about one foot in height. I watched the struggles of this little tree for about fifteen or eighteen years. It would grow a little in the spring and lose that growth in the summer, but it kept up the fight. I used to glance up at it every time I passed that way.

When I came back after my two and a half years' absence, I looked to see if my old friend was still there, but it was gone. It had given up the hopeless struggle. There was a little grass and other plants that bore seed that were still carrying on. They had kept it company through all these years, but now they were carrying on by themselves.

Some distance away, on the side of the hill, there was a large oak tree. Its branches spread wide, and the cows would sometimes come and stand in its shade. Birds would build nests in its branches, and it bore fruit after the tradition of the oak. It had been placed where there was an abundance of good soil and had grown great. But my heart went out to the little oak that tried so hard but did not succeed in bearing fruit before it was forced to give up the fight.

BEGINNING OVER

After my first year alone, I began to cast around to see if there was any way I could raise water for irrigation. Without water, there was nothing I could depend on. To be able to irrigate had always been a dream. Father had once attempted to raise water for this purpose with a homemade windmill—but

there was not much wind—and when he did get a little reservoir full, all the land he could water was about what could be covered by a small house. This went on the alfalfa but brought no results and so was given up.

There was still no way of raising water that would meet the situation. I dug a well near the creek and got water at ten feet, trying to raise it with an endless belt made out of canvas on which I had riveted some cups made by a tinsmith. This belt was run by a wheel that was turned by a horsepower that I bought for fifteen dollars. I succeeded in raising water with this outfit, but it reminded me of trying to eat soup with a fork, so I gave it up. I had put a tank up on a platform ten feet high. This tank was one in which we used to crush grapes, and I could lift only one side of it. But I leaned it up against a ladder, then shoved it up until I could get beneath it and then shoved it up a little at a time with my back until I could tip it over onto the platform. I undertook to put water into this tank by another scheme, patterned after one that was in use by the county. This was to raise water through a wooden tube, through which wooden blocks were drawn by an endless chain made from strips of steel. I put in all the time I could spare for eight months, making this outfit, only to find that the vibration was so great that it was not a success. As a matter of fact, it was not practical anyway for the situation.

About this time, advertisements began to appear for a new kind of pump. It was called a centrifugal pump. It would throw a steady stream and had no valves to wear out. There was a small two-inch one that would suit my purpose that sold for forty dollars, so I sent to San Francisco for one of them. This pump finally came, and I drove to the station ten miles away and brought it home. I set it up according to instructions and got it primed. I started the horsepower, but no water came. I worked with it for two or three days, figuring it all out as to how and why it worked. I did not take it to pieces but prodded in it with a wire and decided it had been put together wrong. I wrote to the company, and in due time, they replied, telling me to send it back. In two weeks, I got notice that it was being returned and that the runner had been put in backward (as I had suspected). Now I did not mind the man who was stupid enough to put the runner in backward, but I did think it was a dirty trick to pick out that particular pump and send it down to me where it would make so much trouble, in addition to three round trips to El Toro, which added up to sixty miles.

Part II

Interference

I was working to get the pump set up once more when Elvin Hemenway came down and said that Frank was wandering around at Laguna, out of his head. I dropped my work and went over to see if there was anything I could do. I found Frank on his horse, and when I tried to approach him, he made a crazy remark, turned his horse and galloped away. There was nothing I could do, so I went to see some of the boys in town. Oscar Warding, who had had some experience with a rope, said he would rope the horse. A number of us went out, including Nick Isch, Elvin Hemenway and Fred Trefern. Oscar Warding went out on his horse, and pretty soon they came down the road as fast as the two horses could go. Oscar had thrown the rope over the horse's head, but with insane cunning, Frank had jerked it off before it could be drawn tight. He was trying to throw it a second time when they passed the rest of us who were standing at the edge of a small bridge. We all stepped to one side to let them pass, but something happened. The next I knew, I was walking along the road with Fred Trefern, and there was no one else in sight. I told him my neck hurt. Pretty soon, he left me sitting on a bank and went to get a horse and cart. When it came, I managed to get in, and he drove down to the hotel. Nick was in charge through the winter, and he gave me a room. Dr. Bellows, who happened to be near, came to see me but said there was nothing he could do. I asked Nick what happened, and he said the horse hit me. As I had stepped out of the way, I could not understand this and told him there was no evidence of it. I added that a horse going at that speed could not strike a person without leaving some mark, but he replied, "There were about a half dozen of us standing within arm's length and saw it." As I remembered nothing from the time when the horse was several feet in front of me, I could say nothing against eyewitnesses, except that there was no proof. He said I had landed about fifteen feet away—on my face. There was plenty of evidence of this but no proof of how it had happened.

Finally, I noticed that my left shoulder was wrenched and told him that I knew how it had happened. I had unwittingly and unintentionally reached up and caught my fingers on the rope around the horse's neck. The wrench had almost unjointed my neck, which was so sensitive that I could not touch my chin with my finger without causing severe pain. The shock had been so sudden that I did not even feel it. I asked Nick to bring some stimulating liniment from the store, and after three days, I was able to go to Santa Ana, where I stayed at mother's for a week. No one there appeared to realize that it was anything serious, and at the end of a week, I went back to the ranch.

It was impossible to move my head sidewise, and very little in any way, but there was work to do. Fortunately, I had a good man on the place by the name of Frank Stone. He was engaged in digging up walnut trees, but he had overstayed his time, and when I came back, he had to leave. It was lucky that he was there, for there was a cow to milk, as well as other chores to be done. After he left, I was once more alone.

TROUBLE

As I finished installing the pump, I had to be extremely careful, for to make a misstep over an open well, in the condition I was in, might be very serious. However, I finally got the pump in position and put things together. I started the horse, and water came. The supply was very small at the depth I was able to go. It was only about what would pass through a one-inch pipe under good pressure, but it was water: the thing we had been dreaming about for so many years. I moved this from place to place in a canvas hose, but all of this took too much time. If I went to move the end of the hose or to stop up a hole, the horse would slow down, and the water would stop. I had a boy for a while who had been taken out of school at El Toro, but he did not last.

The thirteen children who had been raised on the place, together with mother and father, all felt that they had been working, and now I was trying to do all this by myself. In some ways, there was less work, and in other ways, I was taking on more—but above all things, I must have water. I had to bake my own bread, for there was none on the market even though I might have the money with which to buy it. Baking day and wash day always came at the same time, so there was no time lost, and I baked enough to last for two weeks and kept it dry so there was none that ever spoiled. I avoided as many chores as possible, but it was impossible to get into the field by eight o'clock even though I got up at five every morning, winter and summer, except Sundays.

One thing I refused to do, and that was to worry. The work might be done, or it might be untouched; things might go wrong and I might get angry, but when I went into the house at night I released my mind entirely from the duties of the day. There was plenty of time to think of the work when I got out in the field. I stuck to this rule knowing that no possible good can come from worrying, that it not only brings harm but can be likened to three things: murder, suicide and insanity. It is only the degrees of the worry that will determine what the result will be. I could put my efforts to better

use. Also, if I had fifteen minutes to spare I would go to sleep, always waking up on the dot very much refreshed. Rest is not complete, except in sleep.

Frank had undertaken to raise barley but had worried about the lack of rain and unpaid bills.

When the cow was giving a good flow of milk, I had to be on hand night and morning, and at one time, I did not get to Santa Ana—where I could get a haircut—for eight months. One year, I did not have a calendar of any kind but always knew the day of the week and the date of the month.

THE ENGINE

I finally got a gasoline engine from Charley Butterfield, who later went on a musical tour, starring himself and family. I paid him one hundred dollars for it and soon found I had deliberately brought onto the place more trouble than I had before. I would sometimes work for two or three hours to get it started and then would have to watch it every minute to keep it going. This was particularly exasperating on account of the other things that I should be doing at the same time, but I must have water at any cost.

My regrets were that when my good old Bossy was giving five or six gallons of milk a day, I could not use even all the cream; I made what butter I could use but could not spare the time to make any to sell. My lunch was invariably a bowl of milk and a chunk of bread or a bottle of milk if I was out in the field. Often, dinner was the same. I must confess that I haven't got weaned yet, and I often think of that rich cream.

NECESSITY

The only way now left open where I could make any money was to raise such stuff as could be sold to the few people who came in the summer, the season being just ten weeks (with a few relays that lasted for two weeks more), after which the town looked like a bush that had been vacated by a flock of migratory birds.

Everything I had to sell had to be brought in during this time.

The leading crops that I could raise were corn, watermelons, muskmelons and tomatoes, together with a little fruit that was still growing; a few string

beans, lima beans, cucumbers, squash; and perhaps a few things of less importance. The worst of it was that when I left home, there was no one there to look out for things until later on when I was able to take a load every day, and then I got someone to help in the summer who would be able to get a few things ready for the following day.

In order to have corn coming through the entire season, I had to plant at least ten different times. The first planting would be about the tenth of March, and the last would be the latter part of June. When the first corn was ready to sell, the last would just be coming through the ground, and all of these ten different patches would have to be cared for at the right time and irrigated with the little difficult stream of water if they were in a position where they could be reached by it. People expected their corn regularly but took what they could get. If the ears were good, there was a set price, but if they were poor or were nubbins, I gave them a few ears extra. I was the judge. Thus, a dozen might be twelve, fourteen, sixteen or eighteen, according to the quality.

Just how I managed to keep these things growing while I was also engaged in taking them to market, it would be difficult for me to explain. There were two things that no one could pick but myself: one was the corn, and the other was watermelons. I was hardly ever able to get home before dark.

One bad feature about the situation was that I had to raise my hay on the coast, and just at the time when it should have been hauled to the barn, I had to start in the entire summer job of selling produce, the hay having to lie cut for it was impossible to get it baled. It would be greatly injured by this, but it could not be helped. By the time I was able to get it hauled in, it was time to start preparing for the next year's crop. I could not find time to repair fences to keep the creek bed free from cockleburs and young willows, which clogged up the channel.

In the meantime, I was constantly fighting wild animals. Having the only green stuff in the country, all these creatures thought I was raising this good stuff just for their benefit. There were the coons, coyotes, wildcats, squirrels, gophers and many other creatures that could not be convinced that they had no right to what I was growing. This was the more difficult when I was not there to teach them. Even the mice would come out in the night and start digging the muskmelon seeds up as soon as I put them in the ground. They had a "smeller" that could pick them out and would always dig in the right place. Then the birds would pick their heads off as soon as they came through the ground. The gophers worked night and day, while the squirrels worked only in the daytime. The cats did not keep union hours, while the

coyotes came after chickens in the daytime and for watermelons at night. They learnt to eat watermelons like a cow, and one evening, I came home and found places where four chickens had been caught, each one within one hundred feet from the house. A group of coyotes had entered, and the chickens had evidently run toward the house for protection, but there was no protection there. The coons would come at night and make little holes in the melons, then claw the inside out with their hands.

Then there were a couple of ravens who would come in the daytime and peck a hole in the watermelons, and they did not care how many they ruined in the process while they were hunting for the best. I could keep the animals out of the melons by sleeping in the patch, but this did not help in regard to the ravens. As they nested in a cave on the bluff, I watched to see when the young came from the nest and then would try to slip over before the old ones had a chance to train them in the ways of the world and pick one off—for the old ones are almost impossible to shoot. If I was able to get one, I would take him down and hang him up in the watermelon patch, and the rest of the ravens would keep away for the balance of the season. I would sometimes catch a coyote or coon and treat him in the same way, this furnishing perfect protection.

The irony of the situation was when someone asked, "What do you find to do down there in the wintertime?" The worst part of this was that this question was asked by someone who should have known better. I was asked this question two different times, and my answer was the same: "I don't need to find anything to do; it is staring me in the face all the time."

Don

I had some sad experience with dogs. I tried to keep wild animals out by the use of poison, but it was impossible to keep the dogs from getting it. Several times I was able to save a dog from strychnine poisoning by giving him oil. Any kind of lard or cooking oil would do the trick, and the next day he would act quite normal. But it was not often that I got a chance to do anything for them, and I lost several good dogs.

Don was a little fox terrier who was found lost in the city. He was brought to me by my brother-in-law, Charley Ward. Don was bright but he was city bred and did not know the ways of the country. He wanted to be helpful, but the first time he heard the crack of a gun, he put his tail between his

legs and ran like a scared wolf. Charley said, "The dog is gun shy and will never get over it."

I had to go out and sleep with the watermelons, so I took a couple of quilts and folded them over on the ground when it came time to go out. Don would not follow, being afraid of the dark. He crouched down near the house and refused to come, so I carried him. When we got to the field and I went to bed he kept awake all night, watching and barking in his strange surroundings. He barked until he was unable to make a sound. After that, he would go with me anywhere.

One moonlight night we started a coon, and he followed him up the hill about five hundred feet high and cornered him under a large green bush. It was so dark under the bush that it was impossible for me to see him though I was only a few feet away. If I fired where the flash of the gun would be right beside Don's head, I did not know what he would do, but finally, this seemed to be the only thing to do. So I fired, expecting it would frighten him almost to death, but he evidently understood the situation and dived after the coon and we soon had him headed down the hill. He climbed a tree, and I shot him out with my 22-caliber rifle, which I carried on all such occasions. This was a crowning victory for Don, and from then on, he was not afraid of anything, while he was also good at hunting anything that could be found in the country from quail to coyotes. He would even run and open the gate for me when I came with my hands full; he would stand up, trip the latch with one paw and shove it open with the other and then show how pleased he was to be able to help.

One moonlit evening, we routed a coon when I had no gun. I was satisfied that it was one that had got pretty smart and would come into the field in the early evening before I went to bed. He climbed a eucalyptus tree. I climbed up and threw him down, thinking we might be able to get the best of him, but he soon got up on the hill, with Don after him. Presently, I heard Don whining and went up to see what was the matter. He had chased him out over the lower part of a steep bluff and was in a spot where he could neither go forward or back. I managed to get out to him, and by lifting him down a little at a time, I worked my way to the bottom, about twenty feet.

One night, he woke me up, and I jumped out of bed to find that he had a coon up in an olive tree. I finally located him and pulled the trigger, but there was no fire. The gun had never before missed; I tried it again with the same result and so I looked, finding it entirely empty. As I kept the magazine full, I could not make it out for a minute. Then I remembered that two of

my nephews, Gilmore and Leland, had been down to the place the previous day, and this accounted for the difficulty.

I was satisfied that this was the coon that I had been trying to get for so long, and now—for the second time—I was losing out. My experience was that Don would not stay and hold him if I went to the house, though I thought later that had I laid the gun down and told him to stay, he would have understood. However, in desperation, I threw a rock at the coon, and he jumped down and started for the edge of the field nearby, with both Don and myself after him. As he was much larger than the dog, he paid no attention to him. As he jumped into the brush, I grabbed him by the hair of his back. He turned and sank his teeth through my wrist. I threw him on the ground and tried to get him by the throat, but he ducked his lower jaw and my thumb went into his mouth. He closed down, but I rammed it down his throat and got it out. When I finally got a grip on him, both wrists were pretty well chewed up.

However, when the fracas was over, this coon had gone to the place where he would have no use for watermelons, and while I did not get off without damage, it was still a victory. I went to the house and put some turpentine on the wounds and came back to finish my sleep in the field.

The next morning, I got my load ready as usual and went to market, but the rags on my hands and wrists attracted a great deal of attention. I counted thirty-six scratches on my legs, which had no protection from the coon's hind feet, but these were negligible. The principal thing was that the melons were quite safe for the balance of the season.

A Wildcat

One of the things that did me the most good was the killing of a wildcat. He, like the lion, had become too familiar. He had the advantage and had been making himself at home. One Sunday morning, I was awakened just at the break of day and went out very quickly, clad in nothing but a shirt. He had disturbed the chickens but went up the canyon without any. I followed, and finally, when he ran across the road, I fired at him. I made an effort to throw another shell into the gun, but the old one did not come out. The cat ran up the hill in plain sight, up over the bluff and then for more than a hundred yards was still in plain sight, but I might as well have been armed with a stick for all the good the gun was doing. It had never treated me that way before.

I presume I had jerked it too quickly, but that did not help. I had no knife with which to get the shell out, and there was not a tree nearby on which I might wreak vengeance, so I had to stand there in the road and watch the cat scramble away, while he was no doubt thinking, "You're not so dangerous as I thought you were."

It was not long before I again heard a disturbance. I jumped out of bed, deliberately put on my shoes and pants and went out where I could see the cat climbing up the steep side of the hill, with a chicken in his mouth. I had come out of the house with a feeling that I was going to kill him, though he was quite a distance away and the gun was small. I fired at him, and he dropped the chicken and started scratching gravel as the bullets spattered nearby, urging him to his best efforts. He climbed up over the steep bluff, and the shooting was still long distance. It began to look as though he was going to get away, but all at once he fell from his high place to the bottom of the cliff. I felt like shouting, but there was no one to hear. I went up and picked him up. He was big and fat. I looked him over to see where he had been hit, but there was only one little scratch on his body, and that was between the eyes. A little hair had been cut off and the skin was cut, the direction of the bullet showing that he had been looking at me at the time, though I had not been aware of the fact. The skin was hardly cut through. If the bullet had gone one-sixteenth of an inch higher, he would not have been hurt, but he had been slightly stunned and then undoubtedly killed by the fall.

MANUFACTURING

When I found myself on the ranch alone, I had three good horses and a one-horse cultivator. If I expected to get things done, I would have to have more effective tools. I picked up a couple of old sickle bars from worn-out mowing machines, then went around several blacksmith shops in Santa Ana and picked up short pieces of steel that had been discarded in making wagon tires. Out of this material and a few scraps I had at home, plus a pair of handles, I made a good thirteen-point cultivator. Out of the scrap steel I made shanks on which I could bolt regular cultivator teeth, so it did good work. It was formed in the shape of the letter *A*, and I did most of my work with it for many years. I still have the frame of it. I frequently had to make something for special work.

In addition to the farm work, there were several miles of road that I had to keep in passable condition: the road that went up the canyon and which led to the coast. There was a man appointed to take care of the road that went along the coast and belonged to the county, but the rest was up to me.

The work that was done on the county road depended very much on who happened to be appointed. There was a man who lived well up Laguna Canyon who had this job for a number of years, and his district came down to Aliso Canyon. He used to drive down that far in a buggy once every year, and if he could get by without any difficulty, that was all the attention the road would get for that year. He would come down after the spring rains so as to avoid the necessity of making two trips. It happened one time when there were three years in succession when the rains were very light. The hills were steep and the little water that ran down the wheel tracks would keep cutting a little deeper, thus destroying the path where the horses walked; then, in the course of time, the road would get very rough and extremely disagreeable, but there was no one who used it to amount to anything except myself, so there was no reason why it should receive much attention.

At the end of this three-year period, there was a light rain late in the spring that wet the surface of the ground, and I took advantage of this to do some repair work with a pick and shovel. I did not take a team and, at the end of two days, had smoothed down all the worst places in about three miles of road. This included one place near town where a rut had been cut about three feet wide and eighteen inches deep.

Some time after this, I happened to meet this road boss as I was passing his place and, by way of letting him know of this work, asked him what was the chance of getting paid for it. When doing the work, I had no intention of asking for pay, but he blurted out, "If you wanted to work on the road you ought to have come and asked me about it." I replied, "I might as well repair the road as to spend my time coming to ask you about it." Then he said, "I was down that way and didn't see that it needed repairing." So I asked him if he had noticed the rut that was washed across the road, and he replied, "Yes, I saw that but didn't see any dirt around there to fix it with." (As a matter of fact, there was no soft dirt that could be moved without the use of a pick.) As it was a waste of breath to talk to him, I went my way, but since he had offered such a brilliant argument, I decided to write a letter to the supervisors.

In this letter I explained the circumstances and told them the nature of the work. I told them what he said about the rut and that he did not see any dirt to fix it with and added that I did not see anything around there but dirt.

Then I told them that I had two reasons for repairing the road: one was to get it in condition so I could use it and the other was to find out whether the Laguna Beach road district came down to Aliso Canyon or stopped at the Laguna Beach Hotel. A short time after this, I found three dollars waiting for me at the store, this being the price of the work. But I never did hear of the merry "Ha ha" that I presume he got when he was confronted with my letter and did not learn whether it was his money or county money, as there was no receipt.

The Tables Are Turned

This, time the joke was on the supervisors. The little lake at the mouth of the canyon that furnished us with many a duck also furnished us with some problems. When there was a freshet, or when the water came in over the sandbar from the ocean, it would back the water up so we could not get through without going into deep water. One cold morning, George drove through, and when he reached the opposite bank, he looked back only to

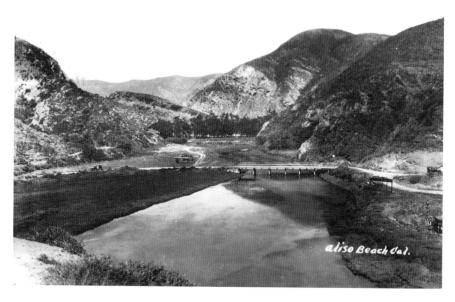

Aliso Canyon with bridge, looking toward the Thurston homestead, just beyond the row of trees in the distance. *Historical Collection, First American Financial Corporation.*

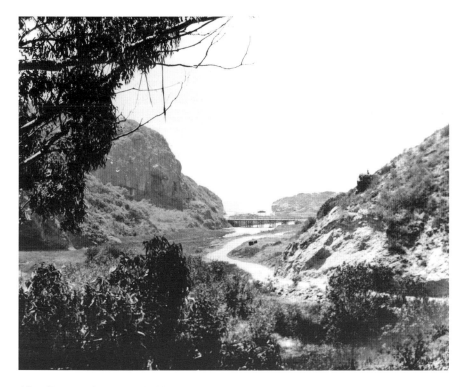

Aliso Canyon with bridge, looking toward the ocean. *Historical Collection, First American Financial Corporation.*

discover that his hind wheels had been left standing in the middle of the lake. Many a time I have crossed this water, morning and night, when it would run over the horse's back, while sometimes it was impossible to get to the coast at all except on foot.

The county supervisors had to go over the roads occasionally to determine what repairs might be required. One time, after a light rain, they drove down through Capistrano with a high-stepping livery team. There were four men in the light spring wagon, and they came up along the coast, as this road had now been accepted by the county.

Now the road was routed through the lake and was seldom used—except in fair weather—except by us. When they came to the water, it was high and was also filled with mud. There were wheel tracks, showing that it had been crossed recently, but they had no way of telling how deep it was. It was a long way back, while if they went back they would not have inspected all the road, so they ventured in. They had to go down a steep mud bank, and when

they once got started there was no turning back. The water came higher, and they lifted their feet up and put them over the dashboard as it filled the bed of the wagon, but it kept getting deeper and finally came up over the seat. They were in and there was nothing for them to do but to go on through. The horses had long legs and went through without swimming. I never did learn just what portion of the men was sticking out of the water when they got through.

It was not long after this that a crew of men was sent down to build a bridge over this water. It had now ceased to be an individual problem and become a county problem. This bridge served until the great state highway was built along the coast. Now the old bridge has no doubt been picked up along the shore as drift wood.

FINIS

Father had made several trips home at various times, and at one time, he stayed for two weeks. During this time, I was coming home one evening when I found him cutting the low limbs off an olive tree and then putting them in a little wash. As I passed, I said, "How is it you are cutting the lower limbs off? I thought you liked to leave them on." He flew into a rage, apparently at the thought that I should question what he was doing, although I had spoken in a good-natured way. After going about twenty feet, I stopped and looked back, saying, "You were running this place once, but I am running it now." Then I went on about my business, and next day he was pleasant.

George had married, and his wife thought that father had been misjudged. She wanted him to come and stay with them so she could judge for herself. I do not know how long he stayed, but when he left, she had been entirely disillusioned and was satisfied.

After about ten years of this sort of life, he wrote to George saying that he was tired of wandering and wanted to come back and live among his family, adding that he loved them and wanted to be near them where he could be useful. George was not only the oldest but was also the only member of the family who had shown any vindictiveness, and it must have been difficult for him to have written this letter. However, the letter went unanswered. George refused to answer it, and no one else offered to do so.

One day, when I went to town, I told the folks that the letter should be answered, and if they would give it to me, I would write a reply, sending it

on to them for their approval, after which they could forward it on to him if it met their approval. In the meantime, I knew that there was not one member of the family who would like to have him back, that his presence would upset the lives of everyone and would only furnish an excuse for disagreeable conversation. It made no difference how good his intentions might be; he could not change his ways. He had begged mother to say the word and he would leave and never bother her again. His challenge was accepted. Ten years or so had taught him a lesson, but he was responsible for his own position.

I wrote a letter as decently as possible but made it clear that his request could not be granted. I sent this to mother, and it was forwarded to him, no voice being raised against it.

We received one more letter from him, though it was not written to me. It was bitter, as might have been expected. He was in Texas at the time and was still in Texas at the time of the great Galveston storm. He had papers and letters that would have identified him if he had passed on under ordinary circumstances, and we would most certainly have been notified, but as we heard no more, there can hardly be a doubt that he was in Galveston and met the fate of many others in that storm.

As stated before, he had a brother who was shot and who died from his wound. He had a brother who later was killed by Indians in Arizona, and I heard him read a paragraph from a letter that brought this news, which said, "Are we all to die by violence?"

Here the curtain is rung down on a life, a life that strayed from the beaten path, not only physically but in some other ways, but kept steadfast in the path of honor. A nonconformist. A life that refused to be satisfied, a man who could not see with others. A stormy petrel.

He had been raised very strictly; had been sent on a mission and had spent four years spreading the gospel in England. What he had accomplished in those four years seemed to be the one bright spot in his life, the one place where he had been a success. He brought back a full set of chinaware that had been presented to him by the factory workers with whom he had spent some time on this mission. On each piece his name appeared in a broad band of burnished gold. This set was dissipated by much moving, and the remaining pieces have been distributed among other members of the family, though I have never seen but one piece.

He had lost one boy, the first born, who died when he was very young. He lost one girl, who was stolen by the Indians when she was about three years old. This was shortly before I was born. The little girl was playing a

short distance from the house when she disappeared, never to be seen again. Though the people from the entire countryside joined in the search, she was never seen or heard of. No one believed that the Indians would mistreat her, but it was a severe blow. Ordinarily, an experience of this sort would make one more kind and thoughtful of the others that were to follow, but it did not seem to have that effect in father's case. He was very emotional and appeared to let his emotions rule. His word was law, and he was quite sure that he could not be mistaken.

After ten years or more of wandering, he evidently came to the conclusion that he had made a mistake, and he humbled himself to acknowledge it. But it was too late.

A Paradox

In the early days, although we were very much isolated, someone would drop in once in a while. On such occasions, father would soon be talking either politics or religion. He had an undying hatred of tyranny in all its forms. He was the champion of the downtrodden, whether it might be the tyranny of religion, crooked politics or a despotic government. We heard a great deal of the injustice in Russia.

When he came back from his mission, the man he had left on his small farm refused to leave, and it was only with some difficulty that he secured half of it. He permitted such things to make him bitter.

He read Thomas Paine's *Age of Reason* and said he dropped the Bible like he would a hot egg, and we were taught that religion was the dying embers of superstition, that it throttled reason and hindered progress and that it was vanishing before the light of reason.

I used to wonder how a man of his general ability and with his particular ideals could be so unkind and thoughtless in the treatment of his own children, but there are many quirks in human nature that cannot be measured.

He consulted the old family doctor book and made some remedies from herbs, leaves and bark that were to be found in the neighborhood, and a doctor was never called to the house, neither for childbirth nor for any other reason. The thirteen children raised were very independent in taking care of themselves. When he decided that his teeth had served their purpose, he got some forceps and pulled them out himself, afterward getting a set of false teeth. I saw him sit down on a rock and brace himself

against a tree while he pulled out two teeth, one of which brought with it a piece of jawbone. When I see him in that light, and when I see men who are called gentlemen, who build up a fortune at the expense of others and at the expense of their own character, I realize that he was not so bad.

One of the things that father resented very much was the idea that a man with money could get away with things that a poor man would be punished for. While this is bound to be true to a certain extent, it is not the point that I wish to bring out.

One day, two young men drove down to the house in a livery rig from Santa Ana. They told father they had been arrested for housebreaking; they were members of a group of twenty young men from Santa Ana who had been to Newport Beach and had broken into a warehouse from which they took some walnuts that were stored there at the time. They represented many of the best families in the country and had all been charged with housebreaking, which is a very serious offense. This was a charge on which it was not sufficient merely to pay a fine, but the boys had only taken some walnuts to eat and the officers did not wish to be too harsh with them and had agreed that if they could make it right with father (who happened to be the owner), they would drop the case.

Now this was exactly the thing that father was so violent in condemning, that of favoring the rich man, the man who could pay his way out. Also, these men would be glad to pay a good price to clear themselves from the disgrace of being prosecuted for a criminal act. This was a chance where he might make a small fortune from these twenty young fellows, who would be glad to pay well for their freedom.

Father asked them how many they took, and the amount he figured was worth about four dollars. He took their word for it and gave them a clearance for the sum of four dollars.

MOTHER

When mother passed, which was at the age of eighty-seven, her children, grandchildren, in-laws and great-grandchildren numbered about sixty souls. Her father, who was not only a leading light in the church but a leading light in the state, had also been on a mission. He went to Denmark and learnt the Danish language. Then, at odd times and by the light of a candle, he translated the book of Mormon into the Danish language.

Mother had learnt to be very economical—she watched the pennies. When she was able to get a daily newspaper, she would read it through before discarding it. If a new one came before the old one had been read through, it would be laid to one side until she had got the full value of the old one. When she wrote a letter, she used a postal card. She wrote a full-sized letter, and it was legible if one's eyes were good, though her economy was not always appreciated.

Luella, the next to the youngest of the children, was the only one who succeeded in getting an education. She started in a country school in the mountains at the age of ten and graduated in due time, being valedictorian of the class at the Santa Ana High School, and when the First World War broke out, she was in Spain learning Spanish at first hand. She was all alone but came back through the war-torn country without mishap. She was in Berkeley during the San Francisco earthquake. For several days, we heard nothing; then a card came, which read, "Pajama party on the lawn at five o'clock in the morning. Bricks and live wires flying around promiscuously but nobody killed."

PART III

SELLING PRODUCE

When I started to sell produce, this business belonged almost exclusively to the Chinese. I felt a little humiliated coming into competition with him but consoled myself with the fact that I was not selling the same things.

As time went on and I increased my variety, the Chinese almost disappeared from the picture. This was partly due to the fact that I raised only the things that were required mostly in the summertime and partly due to their superior quality because they were fresh and brought to the market in the best possible condition—also that I sold cheap. I had to have the entire trade in order to make it a success. There was no argument about prices.

I really enjoyed this contact with people, who were very agreeable and were always ready with a joke. Mrs. Harper (a customer) told me about a new cucumber, said they were never bitter and were of superior quality. She had a few seeds and wanted me to try them. Partly to please her, I took the seeds. I raised two or three vines, and they proved to be so good that I planted an equal number with the old kinds the following season, and after that, I never raised any other kind. They were called lemon cucumbers and were about the size, shape and color of a lemon. They afforded a great deal of amusement. Someone would ask, "What are these things?" "They are cucumbers; didn't you ever see a cucumber?" They would ask for cucumbers, and I would show some and would hear some such remark,

"You don't call them things cucumbers?" I would reply, "Yes, don't you know what a cucumber looks like?" This would generally be followed by cutting one open and handing it out for them to taste and always resulted in a sale, and I was soon selling two or three times what would have been taken of the other kind. This was their first introduction in this part of the country, but they have not met with an equal success on the market, partly because of the price and partly because they do not reach the customer while they are fresh. Where these first seeds came from, I never have been able to find out, but the seeds that spread over Southern California came from my field.

I always believed in rubbing it in. Occasionally, someone would complain about prices just from force of habit. In such cases, I would at once raise the price. They would smile and say no more. A man once asked me how I was selling lima beans. I replied "Ten cents a bucket." He said, "What kind of a bucket?" I lifted up a ten-pound lard pail, and he exclaimed, "Oh, I thought you had a bucket," and I said, "You'd kick if I sold a washtub full for ten cents." He replied, "No, I wouldn't want that many." I replied, "No, you'd only want a nickel's worth." He took his beans and was always good after that.

I introduced casabas. One day, a girl came out and said, "That casaba was rotten, and I want another." "Now you're just trying to get another melon from me." She said, "No, it was rotten inside, and I want another just like it." I replied, "But if it was rotten, why do you want another just like it?" I brought them at the pink of perfection, but today you can hardly get a good one on the market because they are picked green.

One day, a man came to the wagon and said, "I want one of the best watermelons you have." I happened to have some very large ones that were of the finest quality and picked one up. He said, "Will you plug it?" I looked at him and said, "I see you are a tenderfoot." There was an old customer standing near, and he said, "You don't need to plug his melons," so he took it as it was. For several days following, he came out for one of the finest melons, and one day, he came and said, "I am going home tomorrow, and I want three of the best melons you have." Then he looked up at me with a twinkle in his eye and said, "You needn't plug 'em."

I was sometimes asked how I could tell when the melons were ripe. I replied, "When I find a watermelon that I think is ripe, I leave it on the vine. When I know it is ripe, I pick it."

One day, four girls bought a melon; they cut it and sat down on the porch and ate it. I had not gone far when they began to clamor for another melon, said it wasn't ripe and they wanted another. Nothing I could say would stop

them. I told them they had spoken too late, but there were four against one and logic did not count. Johnnie Hayward happened to be sitting on the railing of Nick's old store where the people always gathered about mail time to try their knives out on the railing or on the posts. Then the customers that came to the store while Nick was sorting the mail would have to wait on themselves and either leave the cash on the counter or leave an account on a slip of paper for future reference. Nick had the reputation of reading all the postal cards, although I doubt very much if he really earned it. However, Johnnie Hayward was sitting on the railing and noticed what was going on, so he called out, "Bring back the damaged goods." This was something different, but they renewed their demands, only to hear the voice from the railing, "Bring back the damaged goods." This was more than they could stand, and they had to give it up.

Johnnie Hayward was in the hardware business in Santa Ana. He was very small in stature but not in other ways. He was so small that he was made the object of many a joke. In the early days, he took part in some political campaign, during which there was a prominent attorney from Los Angeles who came down to tell the people how they should vote. They had a big political rally and hired one of the largest halls in the city, where the people gathered to hear the other side of the story. This attorney was not only prominent in his profession but was also prominent in size—and somewhat pompous. It happened during his speech that he referred to Johnnie Hayward, even speaking of him as a little runt, saying, "Why, I could eat him at one meal!" Now it happened that Johnnie was in the audience, and if he had just kept quiet, things would have gone off according to the rules and the big man might have got away with his point, but Johnnie spoke right up in meeting without even getting permission. He said, "Yes, and you have more brains in your belly than you ever had in your head." I do not know how the campaign came out, but believe what Johnnie said was all that survived.

THE OLD HOTEL

The hotel was one of my customers, and when I came in, the women folks—who did practically, if not all the work—would be very busy, so they told me to look in the place where they kept such things and bring what they should have. This saved them valuable time and was quite satisfactory. They only

took a few of the necessities, and there was never any question. This served for several years, but one day, the boss came out to the wagon. He had evidently made up his mind to economize, and he said, "If you'll sell your stuff cheap enough, we'll buy some." I replied, "All right." He came and picked up a small cantaloupe, the kind that I was selling three for a dime, saying, "Now, if you'll sell a melon like that for a nickel, we'll take some." I said, "All right." Then he picked over the other things and priced them but could not make up his mind to part with any money. We were just wasting time, so I told him that if he would pick out what he wanted, I would give him a 25 percent discount on the retail price. I told him that knowing that I would only be depriving other customers of what he took, but he could not make up his mind and finally told me to go on with my route and if I had anything left to stop on the way back. This suited me, and I started on, but he really wanted something and presently overtook me and attempted to drive a bargain. I reminded him of the offer I had made, and he said, "I ought to have more than that. I ought to have 50 percent!" I looked at him and said, "Do you think I am going to raise this stuff, then pick it and haul it over here and give you half of it?" I drove on and left him standing there, and when I went back in the evening, there was nothing to stop for.

Laguna Beach Hotel. *Historical Collection, First American Financial Corporation.*

This was really a help to me because I was having difficulty in keeping my regular customers supplied at this time, so I did not stop at the hotel any more, but people would come out at times and buy things to take to their rooms. At this time, I was selling as fine tomatoes as ever grew, at the rate of fifteen pounds for twenty-five cents, but the hotel could not afford such luxuries.

Shortly after this, the hotel management was turned over to Birdie. She would come out to the wagon with a smile and order stuff that would give me visions of a famine at the other end of the line. Sometimes it would include a dozen watermelons—something they had never indulged in before. She never asked the price, and I would carry things in and get my money. I believe that Birdie conducted the biggest business that the hotel ever enjoyed.

THE SEAMY SIDE

The following year, Birdie made the mistake of bringing a helpmeet. That is, she had a man who was to act as manager while she acted as help. I could see at once that she was to have no say in the management. They were to have a grand opening on the Fourth of July, and I came over to help out with my first load of the season, including a good supply of fine corn. This new hotel manager, who knew more about driving cattle than he did about the hotel business, was anxious to get corn, but he only wanted to pay ten cents a dozen, while I was asking fifteen cents. These were extra-large ears that were in their prime, but he hung to his price. Finally, I told him if he could not afford to pay more for the corn at the price he was getting from his customers, it made no difference to me. He replied that it was none of my business what he charged his customers for board, and I countered with the remark that it was some of my business what I got for my corn and went on my way.

I did not stop at the hotel any more. This pleased me, however, as I was still having difficulty in supplying my customers exclusive of the hotel. Several times people told me they had been paying twenty-five cents for corn where they came from, and they would sometimes say that one of the pleasures of coming to Laguna was in the good things that I brought over.

With the new management, the hotel soon went into a decline and was used only as a rooming house, until it was finally replaced by a modem hotel.

THE GUEST HOUSE

There was a building in the backyard of the old hotel. This means that it was on the side next to the road, as the front was toward the ocean. There were a few geraniums in the yard, but it took time to care for flowers. As the hotel was used only a short time during the year, most of the ground was open. The building was quite a large one-room structure with a small platform at one end and was not only for the use of the hotel guests but open for all comers. This building was pressed into service for everything from a town hall to a Sunday school.

It had been said that at times one or two babies could be seen sitting on top of the piano while their mothers were dancing. It was frequently used on a Saturday evening as a dance hall and the next morning would serve as a Sunday school, while if a minister happened along, it might also be used as a church. Then it might also serve on occasions as a theater where Shakespearean plays were produced or some other play that might be decided on.

Laguna Pavilion, later the town's art gallery. *Historical Collection, First American Financial Corporation.*

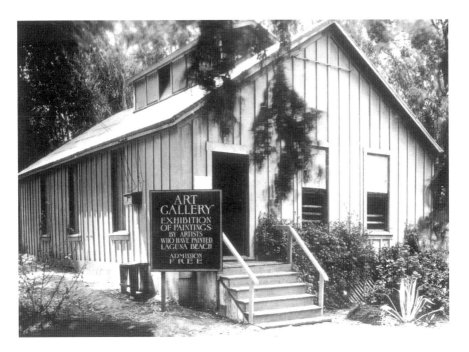

Art gallery. *Historical Collection, First American Financial Corporation.*

As time went on and conditions changed, it served as the art gallery and, in this capacity, was quite important for some time. Also, at this time when the Women's Club was organized, this was the place that served as clubhouse. Among other things, it was used occasionally as a polling place.

Personally, I did not mingle in many of these activities, but one day, I came over to vote. When I came in, there was a woman with a baby in her arms, and someone, thinking to have a good joke, suggested that she let me hold the baby. They all joined in, so I went over and took the baby out of her arms, and he seemed perfectly contented. This ruined the joke. Then I voted and went home.

This building was moved away when the new Hotel Laguna was built. It was moved onto the property of one who had taken part in many of the programs that had been presented within its walls, and was used for some time as a Little Theatre, but was finally transformed into a residence, for which purpose it is being used at the present time.

ADJUSTMENTS

After fighting with the old engine for a number of years—and at times when it was fortunate that there was not a sledgehammer lying around handy—I finally got a new engine. This engine would start in the morning, and the only way to stop it was to turn the gas off. The only trouble now was that I did not have water enough to keep it going, except at very low speed. I would sometimes leave it running and go down to shut it off only when I was ready to go to bed.

One morning, three young fellows stopped at the door and asked for a glass of water. One of them inquired why I had a handkerchief tied around my head. I told him I had hurt my neck and it was bothering me. He said, "I am a doctor, and perhaps I can help you." I told him I did not think so, but he insisted that I come in and lie on the bed. As soon as he touched me, I asked if he was an osteopath. This was a new breed of doctors at the time. I had seen a shingle in Santa Ana denoting the presence of such a doctor, but knew nothing of their skill. This doctor, whose name was Irvin, gave a few vigorous movements and snapped the joint loose from where it had been holding a nerve in a vise for over three years. During this time, I had been able to move my head only a very little, and most of the time there was a dull pain. While it was now very much relieved, it was far from normal. This condition, combined with the inability to use the muscles, had caused some swelling, and when I pressed this with my fingers, it was like breaking the grain of a ripe apple and would leave a dent in the flesh. The doctor gave me one more treatment, and after this, I finished the cure myself. But it was several years before it felt anything like normal and about ten years before the last effects disappeared. I would find it necessary sometimes to reach up and relax a nerve with my fingers, a nerve that had been unable to adjust itself without a little help. In doing this, I learned a lesson and have been able frequently to cure headaches in others by pressing carefully on the tired nerves and relaxing them so they were able to make adjustments.

THE LADY OF THE HOUSE AND LADY LUCK

There was a woman who would come to the wagon and spend about fifteen minutes of valuable time telling her troubles before making up her mind what she wanted. I used to avoid her place if possible and sometimes stopped on the way home but tried to avoid being rude.

One day, she came out with her usual line, then hesitated and said, "You don't have any troubles, do you? You don't have anyone to look out for." I looked up and glanced out over the broad expanse of the ocean and said, "I don't trouble other people with them." She made her purchases and did not tell me of her troubles any more.

After a number of years of hard work, I found myself in possession of $900. I thought a good way to invest this would be to build a concrete pipeline that would bring water to the land from the creek. In this way, when there was water in the creek in the spring, I could give the land a soaking, which would be a great help and save a lot of pumping. I made a survey with a carpenter's level to get the elevation and located the intake about a third of a mile up the creek. This work was done by contract, and the first year, it was a great success, so I thought the water problem was well in hand; but the following winter, there was a big flood that washed the bottom out of the creek bed and left the intake high and dry. The bed of the creek had not changed for more than fifteen years, and it had seemed quite safe, but Lady Luck had turned her face the other way. I could still use the lower end of the line for distribution, but the rest of it was useless.

WATERMELONS AND PEOPLE

When the automobile began to force the horse from the highway, people began to come to the beach in droves on holidays. As my hay was still in the field on the Fourth of July, it was quite an attraction for them. They used it as if they thought it had been left for their special benefit. Then I would have to clear the field of rocks and tin cans in the fall before I could plow. One day, someone went up to the hill, gathered a load of brushwood and dragged it through a twenty-acre field of beans that were in full growth, when they could easily have gone around the edge of the field or carried the brushwood. On the whole, I enjoyed their coming where they could have such a good time.

Sometimes, they would hunt the countryside for a place to camp or eat lunch. One day, I came into the orchard, and there was a young fellow who had driven out among the apple trees and had just got out of the car to examine a shady place at the edge of the field. I asked what was the idea of driving in there. He seemed a little confused for a second and then asked, "Is this private property?" By this time, I had come over and was standing in

front of the car in which there was a very fine-looking girl seated. He said, "If this is private property I'll leave." I turned and looked at him, saying, "Do you want me to think you haven't intelligence enough to know that this is private property?" At that, I turned and went back to the road but have always wished that I might have been in a position to hear what the young lady had to say to him or what kind of an excuse he had to offer.

I went my way and started up the hill when a car came along the road that ran through the orchard. They turned to one side and picked a couple of apples. Just then they saw me. I waved my hand and continued on my way, as they had only taken a couple to eat.

People frequently helped themselves to watermelons when I was not there. I encouraged it because I could not expect anything less. These were usually those who walked the distance from Laguna and were entitled to a melon. Then it was a cheap way to keep their goodwill, and even to this day, people will brag of stealing watermelons from me, whether they ever did or not. One day, a man came out from the hotel, and said "My name is ---, I am president of the Rabb Creamery Company in Los Angeles. I was down at your place yesterday, and as there was no one home, I took the liberty of picking five watermelons and would like to pay for them." I asked him the size, and he paid the regular price. I told him I was glad he had felt free to do this.

Not So Welcome

One day, a couple of girls and a small boy came up to the house, saying they had been picked up by a couple of strangers on the way who had stopped down by the creek. I started down and said I would bring them up and we would cut a melon, but when I came in sight of the car, the man was out and on his way to where the melons were growing. He saw me and got back into the car and started very slowly. Presently, another man came out of the field with three melons in his arms, and the machine was making the right time to intercept him, so I thought I would be at the reception, too, but the driver looked back and saw me so he slipped into high gear and passed the meeting place before his companion reached that point. While the other fellow hid in the willows, the car stopped down near the ocean, and I went up on higher ground where I had a good view. The girls came down, and the man in the willows decided that he might as well come out. I asked what he was doing with the melons. He said he didn't have any melons, that he was sickly and

could not carry them anyway, so I turned to the girls and asked if they did not see him with the melons. They said they saw someone but could not be sure who it was, so I turned to him and said, "He seems to be the only man around here, and he looks guilty." He then acknowledged that they took a couple of casabas from the place where they had stopped and asked what they were worth. I told him they were worth five dollars. He thought that was a little high, and I told him that I presumed they would have been worth about twenty-five cents if he had got them from me, but now they were worth five dollars. He handed me a gold piece, and then I invited him to help us eat the watermelon that was still lying on the ground where he had dropped it. He declined, saying he did not like watermelons, and went his way while the rest of us enjoyed the melon.

The girls said they did not like the looks of the men, that they were nervous and acted as though they might be evading the law. However, we all enjoyed the friendly encounter.

Embarrassing

One evening years later, a couple of fellows came to the house to try and sell a piano to the school, my wife being one of the trustees. During the conversation, something was said about watermelons, and one of them spoke of stealing watermelons from a fellow who was living down the coast. Then he added, "Whatever became of that old fellow who used to raise melons down there?" His partner, who was well acquainted with the situation, said, "He is sitting in that chair." The fellow became embarrassed and hardly knew what to say. He did not even succeed in making an apology, although we all took it as a good joke.

Our Western Boundary

The territory that joined our property to the west was sometimes explored to a limited extent, but we were always fortunate that this exploration did not extend to any great depth. I say fortunate, because it was not always on account of prudence or great judgment. They say familiarity breeds contempt, but it also breeds carelessness.

Lafe and I used to enjoy diving for white rocks. This made it necessary to keep our eyes open under water, which was good practice, but sometimes the ocean was not in a good mood. It was wise to be careful. Harry Hughes used to come once in a while. He came to see Joan, but whenever he came, we had to go fishing, and it made no difference whether the fishing was good or not. So we three started for the ocean one day. We were now fully grown and supposed to be in our right senses, but when we reached the ocean, we found it was on a rampage. The breakers were rolling in all along the beach and were mountain high, but there were calm spells between, and we went out on the rocks when it was fairly calm but kept an eye out for breakers. The lines were not much more than in the water when a swell could be seen forming nearby. My line was slightly tangled, and the boys were in front of me and got the start. They reached the high rocks in the rear where it was safe; I waited for this breaker to pass, but it left the rocks covered deep with water. The rocks were rough, and there were channels. It was not safe to attempt to cross unless the rocks could be seen, but by the time the rocks could be seen, the next breaker was dangerously near, being twice as large as the first one. Now if you happened to be caught between the devil and the deep blue sea, you could take your choice, but if you happened to be between the devil and a large curling breaker, you could ignore the devil but shouldn't trust the breaker. I managed to get my feet on a low shelf below where the boys were standing and put my pole against the rocks for a brace as the wall of water passed over. When it receded, I looked around, and there was no one else in sight. Pretty soon, as the boiling foam began to clear, I saw Harry down in a pool nearby. I reached him my pole, and he crawled out. He looked around and said "Where is Lafe?" and he came out laughing, thinking the joke was on him. Presently, Lafe's head came up through the foam some distance away. I ran over and offered him my pole, but he refused to take it, getting hold of a rock and crawling out himself. He went out on the sand and started to nurse his toes, which had been cut on the rocks. He was mad as a hornet and said he didn't think it was anything to laugh at. It was some time before we could convince him that we were not laughing at him and that he was not the only one who had gone overboard.

We decided that the fishing was not worthwhile on that occasion and went home minus one shoe and two hats.

At another time, I went down to take a swim by myself and found the ocean in the same mood. I went in, fully aware that I must keep a close watch for the large breakers. Presently, there was one forming nearby, but although I was standing on the sand, the water was deep enough so that it

was impossible for me to get out of the way, and there was nothing to do but go out and meet it. I got back of it and dropped in a trough. When it broke, the spray hid the entire range of hills. I was carried up over the sand, but the force was so great that there was no chance to get out. I had to swim hard to get behind the next one, which was still higher. I dove through the crest of this one, and after one more I got out, safe and sound, but not frightened, for I always feel in case of danger that to become frightened only increases the hazard.

At another time, some fellows from Azusa brought down a homemade boat. I went to the beach a few days later on a Sunday and found they had not launched it. These rough spells always come in the middle of summer and are brought about by some unknown cause. The water is very deep near the shore, and the waves break almost on the sand. As a breaker begins to turn when it reaches water that is the same depth below the surface, it gives these large breakers a chance to come almost to the shore. The ocean was wild, but I told the boys that if they wanted to launch the boat, I would help. So it was dragged over into position, but I found it had not been built for the surf. It had a deep keel and would not float except in deep water. If we got it down where it could be floated on the small waves, it would be sure to get caught by the big ones. After watching for some time, I said, "Let's shove it off on a big one," so presently we had it in the ocean. I was holding the oars, and when it was well in the water, the other fellow jumped into the stern. The boat was not only clumsy and not built for the surf, but the oars were made out of two-by-six pine planks, and one of them touched the water and lifted out of the rowlock. I had to take both hands to put it in place. By this time, it had turned sideways to the breakers, and I gave a couple of pulls to get it straight, then looked over my shoulder to see what my chances were and saw the bow just beginning to rise on the next breaker. The boat raised straight up and ended over as gracefully as you please. When it got settled, I put my hand against the seat and pushed myself out to one side; the other fellow had jumped out and was still holding the rope. No one was hurt, and we soon had it out on the sand; but the stern had been jammed into the sand and broken. We gathered a few things that were floating in the water and—just to show the ocean that we were not afraid of it—went over to the sand bar where I had an old boat tied and went out fishing.

The boys did not take the boat home, and that was all the service they ever got out of it. It was eighteen feet long, and heavy, but I repaired the stern where it had been broken and tried to see if it could be put to any use, but

it was hopeless. Finally, it was carried away by a rough sea, and I never saw it again. It was probably picked up along the shore somewhere as kindling wood, but one year later, one of the oars came back from its wanderings and landed on the same old beach, where I found it, with the same old piece of tin that was protecting the edge of the blade.

What Is a Mystery?

I was talking with a lady one day, and she spoke of a friend of long standing as being a baffling mystery. After thinking this over I wrote on a piece of paper these words: "The world holds no mysteries. Everything is a mystery to one who knows something about that particular thing, but does not understand it. When we understand a thing it is no longer a mystery."

I handed her this paper but made no attempt to solve the mystery. The fact is that we are all a mystery to some extent.

I stopped at a house with produce one day, and a lady came out. She took my hand and began to tell me things that no one knew but myself and some things that I did not know. I found she was a palmist and went and washed my hand so she could see the lines better. She was a beautiful woman who had passed middle life, and her hair was quite gray. If I remember rightly, she said her name was Mrs. Baldwin, and she was the president of the Palmist Society of California. Her telling me many things that were pertinent to my life, things that my best friends did not know, much less a stranger, furnished me with food for thought. What is it that makes a book out of the hand of a human being? A book that one can read when he has learnt the letters? What power is it that marks the human hand with hieroglyphics that show what he has done and point the way to what he is going to do? When a babe clenches his little fist, what is it that makes the lines form according to a definite pattern, a pattern that is full of meaning? You may say that this is not proven, but the evidence is against you.

The thing that is of the greatest interest to most people is the element of romance, and this entered into what I was told by this lady. She said, "You will meet a girl," and after looking carefully, she went on, "Oh, within a year." But she was more interested in what she said was the line of destiny.

The following winter, I came over to town and stopped in front of a certain house. A girl came out from the rear and stopped under a tree. She bowed and smiled. I had met many girls in my time—some of them had tried hard

to make an impression—but this one had the combination that opened the way, and she came right in.

She had been down to the place the preceding fall with her folks, and I knew they were coming back, but at that time they were just some more people. Now it was different. They spent a month, and I took time out to show them along the coast, where we had some very pleasant times. They were from a farm in the middle west, had retired and built a home in Long Beach.

I had dreamed of such a situation and wondered if fate was holding anything in store for me. In fact, at one time when I was in this mood, a picture was flashed on my mind. Later, when I recalled the picture, I realized that this was the fulfillment of it, even to the place being the same.

This situation brought out the painful fact that I was in no way equipped to participate in the social side of life. I never felt completely alone except when in a position that required the ordinary social conduct. I had not only been alone most of the time since I was five years old, but in order to avoid criticism or an argument, I had drawn back within myself to the point where I sometimes failed to respond to a question, and if I detected the slightest criticism in what anyone might say, I would shut up like a clam.

Twice I had engaged in a little talk with some of the younger children that was not confined to everyday events, but not even this much to father, mother anyone else. I did not realize the extent to which I had retired into my own world until I was in a position to see how difficult it would be for anyone else to enter into that world. My whole experience was a sealed book. I could not talk about it to anyone else; it would look like complaining, nothing more. I believed in keeping the sunny side up. In business, it was easy to do this, but social life was a blank.

I was dissatisfied with myself and with my position. I was not interested in farm work. I had been doing the work here because it had been put in my hands, and I could not leave it without deserting my post. I could see too much in life to be satisfied, but there was nothing else I could do.

I was thirty-six years old, and Frances was twenty-eight. She and her parents came to Laguna in the wintertime for several years and stayed a month each time. When we all went down to see the old mission at Capistrano, I turned the horses loose in the creek bed. The folks thought I might be bidding for a long walk home, but I knew the horses would not go home and leave us.

We had several long walks together, and there was nothing to prevent a perfectly fine romance, for I knew she reciprocated my feelings, but there was always the specter that made me feel that I could not make her happy under the circumstances, while I am sure she thought I was just dumb.

It would be futile even to attempt to define the effect that the particular isolated position that had fallen to my lot—together with the fact that I never heard an encouraging word or met with an encouraging attitude that would lead to self-expression, together with the final seven years that I had spent on the place by myself—would naturally have on anyone.

When I was growing up, I could look forward to the time when I could be free to do as I liked, but when I went out into the world, there was no opening except hard work. When I came back, I soon found myself confronted with the fact that wherever I looked, there was no consolation to be found except that I was holding the fort.

It is true, I loved my animals and was master of all I surveyed, but it was much like being a king without a subject.

At one time, while at the table after father had left home, one of the children remarked in a critical way about my not having much to say. Mother answered this by saying "Still waters run deep." This furnished assurance that there was at least a little appreciation, but self-expression is the important thing. There are two ways in which this can be done. One way is to be able to do what one wants to do, and the other is to be able to say what one wants to say. Both of these avenues were now closed.

She once wrote "Few ring true," I replied, "Yes, few ring true. There is much dross to a little gold, and it has to go through the retort and the crucible to be separated, but when it does ring true, it rings the same every time, but you cannot get the true ring with a stick. It takes metal to metal."

She married an old flame, who previously had been rejected.

Whether she thought me unfair or just stupid, I do not know. If she gave me credit for both, she was justified, for I felt the same way. I refrain from saying "It might have been," for we never know the pitfalls that may be found along the path we did not take.

Mrs. Baldwin did not say I would marry this girl, though this would seem to have been implied. She said I would have two children, which would also seem that this was to be the case. Future events brought the two children, though they were adopted.

She said I had something for the world, that she did not know what it was, but it was something. This was a very unusual statement to make and could not have been made for any idle purpose. Whether this is to be fulfilled or not remains to be seen.

Events have been shaped so it has been made possible for me to do a little writing, of which this is a part. I have tried to write what was taking place in my mind all the time.

It is with reluctance that I mention this, but it is a part of my experience.

If the human hand is an open book, then destiny is a big word and marks a goal that is worth keeping in mind.

A Study

I was working in the field one day when I was almost startled by hearing someone speak. My mind had been following a train of thought, and I had almost forgotten that I was alone until my train of thought was broken and I was brought back to my surroundings.

During these years, I undertook to study law. I took a course with a correspondence school and passed three very fair examinations. I waded through Blackstone and several other books. After my day's work, however, I found it impossible to study without first taking a nap, after which I was able to study for a while, but the effort was too great and I had to give it up.

As a matter of fact, one of the reasons for taking this up was that it might at some time be of service in the matter of self-expression. My experience had taught me to keep my eyes and ears open and my mouth shut. While this is a good policy to a certain extent, it can be overdone, and my experience had made self-expression practically impossible.

I could talk business, but that which is purely social is a different thing. I could talk to my horses, for they were always good listeners, and they never started an argument, which is a very rare thing among humans. However, they did not care whether I studied law or not. They never asked any foolish questions or assumed that I ought to get married. They expected to be well fed and were glad when I was around with them. When I felt lonely and discouraged, or when I felt as though I had been left stranded out on the outer rim of nowhere and then had been forgotten, their kindly eyes, sincere friendship, caressing touch, lack of self-seeking and willingness to be helpful made me realize that there was something worthwhile after all. They were genuine, and I was the law to them. They might have sometimes thought that I was a little severe, but they liked me just the same for what I was, and I liked them for what they were. The friendship was real and was shared alike. They were not only good listeners but also learned to understand.

THE DAWN OF A CENTURY

One evening, after the day's work was done, the horses had been fed, the cow had been milked, the few chickens that still remained had been fed and the eggs gathered, I went into the kitchen and made a fire. Then I put a few spoonfuls of tapioca on to cook. When it was done, I broke an egg into a bowl and added a pinch of salt, a pinch of sugar and a little nutmeg. I beat these together and added milk together with the tapioca. This, with a slice or two of bread, made me a very satisfactory dinner.

This was a special evening; there would never be another just like it, for it was not only the last day of the year but also the last day of the century—the century that I had been living in for over thirty-two years. The morning dawn would show us the beginning of the twentieth century and the present century would have passed into history.

I sat by the kitchen table in contemplation, just thinking, riding on a train of thought; the subject was interesting, and the time passed quickly. Some people cannot endure their own company, but I enjoyed mine. I had no book, and the air was not disturbed by a sound, not even a cricket. Occasionally, I would put another stick of wood on the fire, but outside of this, there was only silence. I picked up a pencil and wrote a few verses that had been running in my mind, finishing just after the midnight hour had rounded the corner, then went to bed to get some needed rest.

The next day, the papers came out with screaming headlines. The people of San Francisco and Los Angeles had been turned loose. They had swarmed out on the streets with every noise-making instrument that could be found, and pandemonium had reigned without hindrance. The new century had been received and ushered in with a rousing welcome.

THE PLACE

I am standing under a sycamore tree near the house. This is a tree that George had planted shortly after we came to this place. I am in a little cove. To the left is a point of the hill that runs down to the creek and completes the effect of being in a cove. This is where the early flowers used to bloom, the lamp chimneys (shooting stars), the Johnny-jump-ups and the straw flowers (buttercups). There were many others that were very interesting. Down by the edge of the hill there were some little poppies; they were real poppies

with the pepper-box pod but were hardly an inch across and the pod was a tiny thing. I have not seen them for years and believe they are lost. Across the valley is where we saw the first orange flowers (California poppies). Every spring, they would come and ornament this little hill. From where I stand, I cannot see land that is a mile away, and I appear to be in a pocket among the hills. Though I can go to the north and reach the open country without going over a hill of any kind, toward the ocean the valley seems to be closed, yet I can go to the shore without passing over any hill.

In front of me to the west across the little valley is a point of the hill that runs down into the midst of the field. This hill used to border the vineyard where the first poppies bloomed. It also has the appearance of a great elephant's head—the long trunk reaching down into the field, a broad forehead cut back at the top, a cave for an ear (although it is not exactly in the right place)—the likeness being apparent from any direction. It has been chiseled out by the great sculptor who has done so many wonderful things. It has been content to stay there all these many years. Whenever I look, it is still watching to see what goes on in the valley.

At my right, to the north, on the sharp edge of the hill there is a lion's head. This head has been carved out of solid rock. It is the most remarkable image. The eye, the lip and the nose all have been carved with the most meticulous care, and there is a tuft of mane on the top of the head though it has been singed by a fire. It has been keeping vigil at this place for ages, guarding my place from the north, though keeping its own counsel and never revealing what passes before it.

At the mouth of the canyon, down by the seashore on a point that juts out into the sand, there is a man's face. He is somewhat shy and does not reveal himself except in the glow of the setting sun. He has been watching at the entrance of the little valley for time that has not been revealed. He knows who goes and who comes, both up the canyon and along the sandy beach, but like the lion on guard at the north and the elephant in the midst of things, his secrets are sealed between the noise of the ocean and the silence of the valley.

On my left, to the south, there is a semicircular hill with some sharp peaks that rise up from its crest. These peaks are the ones that I used to watch when I was herding cattle and from which I could judge by the shadows that formed just when it was time to start home. In these peaks there are several small caves. This is one of the places where the hawks used to live, until I exterminated them. Now there is a pair of great American eagles who have come to make it their home. They build their nest each year and raise a pair

of young eaglets to carry on the traditions of the eagles. These great birds will sometimes light in the trees back of the house. They watch me as I go about my work, but they never take any chickens. For fourteen years they have been my neighbors, and I like to see them around.

On the side of this sloping hill, my faithful old Bossy found her food for many years, and when I called her, she would come home, it making no difference where she might happen to be. When I called her in the evening, she would start home and would be at her place when it came time to milk.

On the other side of the canyon, just back of the elephant's head, there is a little nook in which are three caves a short distance from one another, while each one is fitted for a different purpose. One is the parlor, another would serve as a kitchen and dining room and the third is fitted only for a bedroom. In the kitchen and dining room there are a few shelves and knobs for convenience and a little cubbyhole that would be suitable for storing things. It is long, attractive and quite comfortable. The parlor has a high ceiling and a few knobs that serve as ornaments. There is a chimney that stands up over this parlor room, but this also is purely an ornamental arrangement. For years, there was a pair of beautiful owls who lived in this cave, sitting on some of the knobs during the day but flying away on their silent wings when anyone approached. They are now gone, and the place is deserted. By the side of this cave there are some beautiful rose geraniums. They have been growing there since a short time after we came, and although they have had no care for many years, they are still flourishing.

Back of me on the steep side of the hill are the great rocks that fell so many years ago. They are still standing on the steep side of the hill where they stopped in their headlong crash, but the hill is once more covered with native brush. The steep bluff whence they fell makes a great sounding board that sends the vibrations all over the valley, and sometime in the future it may serve to send sweet music where it may be heard by throngs of people.

Across the valley, at various places in the soft soil there are some beautiful white plants growing. These plants are able to store up enough moisture in the winter and spring, so they are able to grow through the hot dry summer, when they slowly raise their white arms to heaven and put forth their delicate fingers that are decked with jewels, jewels that are not only a delight to the eye but also laden with nectar. The hummingbirds come each day seeking this nectar that has been prepared for them. One of these tiny birds built her nest in a large fishhook that happened to be left hanging under the porch by the washstand. When I came near, she would fly away, but it was not because she was frightened—for she would come right back to her nest where it hung

almost in my way. She would tilt her head sideways as if to say "I am not afraid, but don't try to touch me or I'll fly away." For years, this hook was left hanging where she came each spring to raise her young.

These beautiful birds are the most independent creatures that we have on earth. They seem to be subject only to their own will. Watch as they go from flower to flower. Where they will to go, there their wings take them, without any apparent change in motion; where they will to be, there they are, just at the right spot. Up, down, back or sidewise, it makes no difference. Away in the twinkling of an eye to a new feeding ground. No enemy can catch them; they are too quick and small. This most beautiful and interesting of creatures.

What's in a Number?

I used to hear that the seventh one born to a family was the lucky one. I remember making the remark at one time, that there must be something to it because I was lucky to have any sense. However, besides being the seventh son born to the family, I herded cattle for seven years. I took care of the place for seven years after father was gone and the family was still there; then I took care of it for seven years all by myself. Also, I sold produce from the place for thirty-five years, which is five times seven, and it was forty-nine years from the time we settled on the place before I moved away, which is seven times seven.

The number three is also a magic number, and the first thrashing I ever got was for telling the truth and staying with it. The last one was for refusing to betray a brother and the only time I ever carried a black eye was for defending my mother. Three times I answered father in such a way that it baffled him and changed the course of events. It was not altogether what I said that disarmed him but what was implied that made him afraid to carry out his purpose. In addition to this, I have had three serious accidents, each one of which might easily have proved fatal. Three times I might have had a serious accident with my first automobile, each of which for some reason was passed over. One time, I was coming home empty after taking a load to Santa Ana and had slowed down to make a sharp turn at the bottom of a gulch, when one of the front wheels broke off and the axle dropped on the ground.

Not long after this, I was going up a little sandy bank and the other broke off. Later, I was hauling a load and turned around in the street in Tustin, and

as the car was coming to a stop at the curb, it refused to respond to the wheel. I got out and looked, and the steering knuckle had broken in two. Driving over rough roads at the time had crystallized the steel in these cases, but just why they did not break when I was going down some steep hill instead of waiting until the car had almost come to a stop is not easy to understand.

I have already mentioned the three outstanding encounters I have had with the ocean but have wondered why these experiences have always come in threes and sevens.

The number seven is unique because it is the number that has been used for the dividing of time. Three is the number that represents the Creator, the Trinity, whence we not only receive life but we have also received the code of life and our guidance.

If there is any significance to these numbers as they appear in life, some numerologist may be able to tell, but it is at least a coincidence.

I Buy Some Land

There was a piece of land that came down past the house and into the field. It went across the creek, and there was about an acre that we had always farmed, but it was not included in our homestead. Lafe had preempted this land and got title to it. However, it had cost him $200. He had borrowed the money and never paid it back, so lost the property. Father had attempted to take this land under the Timber Culture Act. He had required George to clear off spots of ground on the side of the hill with an old mattock. We then planted trees there, but enough of them did not grow to fill the requirements of the law, so this attempt to get title to the land was a failure.

I did not know to whom the land belonged, but it was a vital factor in connection with the property, and I wanted to get it.

I finally found out to whom it belonged; he lived in Missouri, and I wrote to him. He wrote back and asked me to make an offer. He signed his name "George N. Chase, First Lieutenant U.S. Army, Retired." I made him an offer. He wrote back and informed me that the land had cost him about three times that amount in a trade, but he had never seen it and wanted me to give him a description of it. I told him that there was about an acre of land in the valley that I was farming, a few acres on the side of the hill that I was using as a pasture, and the rest (which I could not use) went up on top of the hill, which was a thousand feet high. He wrote back and said he had

been told that there were three acres of damp land and sixty-five acres of barley land and asked me if this was not true. He also asked me to pay rent for the past year and to continue to pay rent.

I sat down and wrote these words: "You ask me to pay rent both for the past and for the future but do not give me credit for being truthful."

He replied and asked how he had failed to give me credit for being truthful, and I had to explain that I had given him a description of the land and that he had virtually implied that I had given him a false description.

He then wrote that he was coming out to California and would come down and see me before going to Santa Barbara, where his wife was living, in what I believe he said was a sixteen-room house.

At a time appointed, I met him at El Toro. He said there was another train going back in a few hours, and he would stay only long enough to see the property and then wanted to get back so as to catch the next train. I showed him the property, and he said he would like to go up on the hill, so we climbed to the top. We went south along the ridge for half a mile the full length of it, then came down through Coast Royal and home. When we reached home, it was evening, and his train had passed through hours before. I was talking on a philosophical subject that was uppermost in my mind. He was the first man I had ever really talked with in this manner. He appeared interested and was a good listener. As we entered the house he said, "You're a philosopher; why don't you write a book?" My reaction was that it would give anybody the jim-jams to read it, for I was not qualified to write a book, and as my emotions were uppermost, it would not make good reading.

I have forgotten just what his answer was, but after I had done my few chores and got a bite to eat, we sat and talked until midnight.

By paying him one hundred dollars more than I had offered in the first place, he gave me a deed to the land. This deed did not go through the hands of any title company. He said he would be disgraced and lose his pension if he did anything that was not right, and I took his word for it.

TIMBER CULTURE

In the hills around Laguna Beach there are a number of groups of eucalyptus trees. Each one of these groups represents a Timber Culture, which in turn, represents 160 acres of land to some of the early settlers. The grove in Aliso

Canyon where the Girl Scouts have their camp, represents a claim taken by Leon Goff, the boy who was looking after four cows up on the side of the hill.

We had been farming this land for years and considered it part of our place. Father might have taken it in the same way, but it had never been surveyed and we did not know where the lines were.

BUSINESS COLLEGE

One day a couple came up to the house who had been camping on the beach, and they offered to work for me. By this time, there was enough money to be made, so I figured that between us we could make enough to pay their wages, and I engaged them.

This ended my seven years of taking care of the place almost entirely by myself.

I told my friend Judge Cheney about my attempt at the study of law. He discouraged the idea but said it might be a good thing if I would take a course in business college. He said that if I wanted to do this, he and Mrs. Cheney would let me have a room at a nominal price in their home. I was sorely in need of a change, and as soon as my new hands got the run of things, I made plans to go to Los Angeles for three months, although they could not take my place.

On the way, I spoke to a young man, Harry Lewis, who was clerking in Santa Ana, and told him where I was going. He said he had a brother who was about forty years old and who had been in one institution of learning or another most of his time and was still studying. I told him I had not spent one day in school and would not trade my education for his. I mention this merely to show that I realized that there were valuable things that could be learnt without kneeling at the feet of any man; that the value of an education is measured only by what is done with it; that one may get in the habit of digging for knowledge and fail in his quest for wisdom; that the storehouse of nature is not confined to books.

The three months that I spent in business college was a vacation, the first real vacation that I had ever taken. Judge and Mrs. Cheney took me several times to hear Sousa's Band, which happened to be in the city at that time. They sometimes asked me to be present when some of their philosophical friends were coming. Their place was like home. It would have been unbearable to have been there entirely among strangers.

It was very awkward at first getting accustomed to studying, but I managed it. One of the things that jarred on me was the maxim "Get a better education and earn more money." The entire attitude seemed to be to turn an education into money.

What I could learn in such a place in three months is not of much importance, but I improved my writing and learnt a little about figures. Examples in arithmetic were half finished before I began to use a pencil, but the answer was what I was after. I increased my vocabulary by a few words, among which were "maximum" and "minimum." One time, the faculty offered a prize for the best page of capital letters, and I actually won the prize. This consisted of a small tablet of writing paper, but the surprise of winning it was worth something.

The business college was on Eighth Street, and around the corner on Seventh Street was a shack of a building where they served meals for fifteen to twenty-five cents. One day, two men came in who were very noisy. When the little girl brought their order, they began to make remarks about it, and they attracted a lot of attention by their loud talk. One of the men took his knife and made several passes over his steak and said, "I wonder if I can get anything off of this." Presently, before he had touched it, he said, "I might put it on the floor and put my foot on it." I was sitting at the next table, and said, "That's the way dogs do." They gave me a quick glance and started to eat, while the silence that fell over the room was just as conspicuous as the noise had been.

ANOTHER EXPERIENCE

One evening, I was on the streetcar when someone touched my elbow from outside the car. The car was in the middle of the block and moving at an ordinary speed, while I was sitting in the front compartment with my elbow resting on the windowsill. I looked out and there was Frank, my brother, on a bicycle. He was turning around, and so I got off at the next stop. He had ridden his wheel from Colton, a distance of about fifty miles, and apparently had come to see me. I was surprised that he should do this because we had nothing in common. We never had anything in common. When he was six or seven years old, if he got hold of anything of mine, he would take it to a rock where we pounded bones for the chickens, and there he would smash it to pieces, so I had to hide things from him. He had always been of a

taciturn type and preferred the company of others rather than members of the family. He had recovered from his difficulty, which had been brought about by worry, and had a little place in Colton.

I had never heard him attempt to carry on what might be called a conversation with any member of the family. Now he made this trip, apparently to talk with me. Furthermore, as far as I know, he did not know where I was stopping in the city, which at that time was estimated to contain 200,000 inhabitants. He not only came into the street where I happened to be on the street car but also saw and recognized me while he was riding on a bicycle. Furthermore, it happened at a time when I had been asked to stay at Harvey Cheney's place for a week while he was on a vacation, so it was possible for him to stay overnight. This is a set of incidents that hardly any sane person would undertake, much less would be able to accomplish.

It was quite a long way to where I was going, but as he had a wheel and could not take it on the streetcar, we walked the balance of the way. After we had a bite to eat and were comfortable, he talked freely. He was not interested in anything I might wish to say but talked until late in the evening. His talk was rational, but his attitude was that of one who had just returned from a journey among the stars to have a visit with a long-lost brother, after wandering through the universe. What he said was not so important, except that he warned of impending disaster, said I would not understand now, but would know later. He implored me not to be disturbed by anything that might happen. This was ten years before the First World War, and plenty has happened since then, although I am unable to say whether or not it was this to which he was referring.

The next morning, he was himself again, and as I started for the car to return to business college, he mounted his wheel and started back to Colton.

Whether or not he had any deep convictions concerning life, or whether he had any philosophy of life, I do not know, but I mention this incident because it is quite unusual.

A Coincidence

A man came to the place one day, saying his name was Henry Simon, that he was writing a book and would like to know if he could have a place to pitch a tent. I located him on a sandy spot, where he stayed for several months. This was shortly after the Spanish-American War, and he was trying to show that

it would be impossible for nations to carry on a modern war, that it would not only bankrupt nations, but that it would be impossible to produce the materials that would be necessary to carry on such a conflict. The book was published and his point proved to his own satisfaction.

At the time that he was working on his book, there was another man known as General Homer Lee who was stopping at Arch Beach, working on a book that has since become well known, wherein he was pointing out the vulnerability of the Pacific coast to an attack from the west.

Henry helped me load the wagon for little accommodations that I could do for him. He once asked me to bring him three cans of canned corn. I replied that I would be glad to and then asked if he would like me to bring a few cans of corn that were not canned.

We were loading some very large luscious muskmelons, and he was handing them up fast. I laid one on the edge of the wagon 'til I could find a good place for it. He said, "If that remains there, it will fall off." I said, "No it won't. I'll bet you ten cents." He was a great hand to bet ten cents, nothing more and nothing less, but he always lost. After taking the bet, I told him why—"Because if it falls off, it will not remain there." I picked up five fairly good-sized watermelons, raised up on my feet, turned around and laid them down, and said, "I'll bet you can't do that." He said, "I can do anything you can do," accompanied by the usual bet. He got four in place, but the fifth one was unruly. If he got this one in place, another would get out of line. After working with the unruly bunch for some time, one fell over and broke, and as usual, he lost his money.

He was highly educated and spoke four languages fluently, but like many highly educated people, he was a materialist. One day, we happened to be talking about life, and he said, "When a man dies, his body disintegrates and goes back to the elements of which it is composed, and that is all there is to it." I had long since realized that the great forces of nature are the things we do not see. These were the permanent and endurable things, while the visible things are subject to change. I also realized that if life came to an end, it was a failure. If life was a failure, all the created universe was a failure, and I could not conceive of the greatness of creation coming to an end, a failure.

I told him that when a man dies, something has already left his body. Physically, he is still there. His weight is the same, but he does not see, he does not talk, he does not move. Something has gone from him. What has become of that? He replied, "It disintegrates and goes back into the elements of which it is composed, the same as the body." Now while I did not agree with him, it was only one man's opinion against another, and there was no

use to argue. I was ready to drop the subject when he continued and made the fatal mistake of saying "I don't believe a thing unless it can be proven." I said, "That is fair enough, now let us hear you prove your own statement." He had nothing to say, no comeback. The tables were turned; the proof was not where he thought it was. His argument had snapped back, and he was hopelessly caught.

Another man came one day and stayed overnight. He appeared to be well educated and well read. I judged that he had some position but was now restless, though I learnt little about him. He had some very peculiar ideas that appeared to come from the study of science, which according to his understanding proved that things can be reversed. He said we were living on the inside of the world instead of the outside. I tried to get his point of view and determine how a man of apparently sound mind could take known facts of measured distance into outer space and think that it was on the inside of the earth. How we could take the proven fact that the earth revolves around the sun and measure the day by turning on its own axis and think that all this was taking place on the inside of the earth instead of the outside. But he always had some answer; either the measurements were taken in reverse or were the result of some sort of an illusion. The fact that we could travel around the earth and measure the distance did not mean anything. His knowledge of space was great, and his answers were satisfactory to himself, so I gave it up. However, as a parting shot I said, "Conceding that we are living on the inside of the earth, then what is there on the outside?" I had finally asked him a question for which he had no answer.

DENIZENS OF THE AIR

In the early days, Frank Goff drew our attention to the fact that there was a flock of birds flying over the ocean. They appeared to be loons and were flying about a mile from shore. They were stretched out over the ocean like a great rope, as far as the eye could see in either direction, and were flying in close formation so that several birds were passing a given point at the same time. Whether they continued this flight at night, we could not tell, but from morning until night, the flight kept up for several days. They were flying north, but where they were going and whether they ever came back is anyone's guess.

When I was herding cattle I was on top of the hill back of Laguna one day and counted fourteen California condors. They had been roosting on the sand rock cliffs below where I was standing and had come out to enjoy the weather, as there was a light misty rain falling. We called them vultures. They were black with a large white stripe under each wing, and at no other time did we ever see more than three or four at a time. They are one of the largest birds that fly and are now almost, if not quite, extinct.

The last one of these birds that I ever saw, I caught with a rope. He flew across the canyon and attempted to light on top of a cave but slipped off and landed on the ground. Noting that he was weak, I picked up a rope and went over to investigate. After making several short flights, he alighted on a small ledge of rock. It was getting dusk, and realizing that he could not see very well, I waited a few minutes and slipped up under cover of the rocks. I was within throwing distance of my little rope, and there was a step just at the right place. I put my foot on it and raised up suddenly, throwing the rope. I am not good at throwing a rope, but as he raised his wings to fly, it settled down over one wing and his head, and I had caught one of the largest birds that fly over the North American continent. It is true that I had caught something for which I had no use, and I do not imagine that he could have found another place in Southern California to alight that would have given me an equal advantage. The next morning, I tried to throw a rope over his head, but it was impossible, as he would catch it in his beak. He measured eleven feet from tip to tip. If I remember rightly, I sent him to a park in Riverside, but do not think he lived very long.

DENIZENS OF THE EARTH

It would seem that the rattlesnakes have had their full share of publicity already, but none of us were ever bitten. Therefore, in order to give them their just dues in keeping with their reputation, I must give them a little more attention.

These little creeping things have been held up as a symbol of treachery, but while I would not advise anyone to trust them very far, I never knew one to go out of his way in order to do any harm. They never strike unless they have reason to think they are in danger themselves, and then they will attempt to give warning. That is more than I can say for the Japanese or the Germans and even some of the people in our own country.

They know they have no friends, that the world is against them, even many wild animals. They are especially anxious to keep out of the way of human beings, because human beings are inclined to take an unfair advantage; then their chances of escape when discovered are not very good, for they are slow in their movements, except when they strike. Contrary to general belief, they cannot jump. They can only strike, and that is limited to about one-third of their length; so much of the fear they have created in the world is due to the fact that they have a deadly weapon and are not afraid to use it.

I know of but two people in this part of the country who have ever been bitten. One was a man who was driving down Laguna Canyon in a buggy when he saw a large yellow rattlesnake and thought he would have some fun. He got out and gave him a chastising with his buggy whip. Now he had no reason for this except that he was a man and had the advantage. The snake tried to get away, but he was slow and there was no place to hide, while he had no chance to fight back on equal terms on account of the vicious buggy whip. Eventually, the man decided he had his share of fun and would kill the snake with a final blow, so he reached over and made an attempt to strike him on the head with the stiff part of the whip, for a slight blow on the head will render them helpless.

Now if he had done this in the first place, he might have succeeded, but the snake was now angry and alert. He dodged and struck the man on the back of the hand. The man left the battlefield in defeat, and the snake went his way having suffered no serious harm. There was a farmhouse nearby, and the woman at the place cut a chicken open and put it over his hand so that it might absorb some of the poison. I saw him a few days later. He was in bed, a sick man, but he recovered.

At another time, there was a woman walking up the coast on her way to the beach when she saw a small rattlesnake near a hole. Before he disappeared, she noticed that he had a set of rattles that she would like to have as a souvenir, so, as she had a knife in her hand, she thought she would cut them off as his head was safely down in the hole where he could not help himself. Now these snakes are a little peculiar; they even think they have some rights, one of these rights being that they should be allowed to carry their own rattles. If they get tapped on the head, or if it should be cut neatly off, there is no argument, it is just one of those things that cannot be helped. But there are some circumstances under which they think they have the right of self-defense. Then, also, these rattles might be useful at some future time to sound a warning to some thoughtless person, in addition to which they were worth more to him than they were to her,

so he turned his head back to where she was holding him by the tail and struck her on the finger.

Yes, she lived, but she was much wiser. It is possible to gather wisdom from very humble sources.

Billie Schutes

There was a man by the name of Billie Schutes who made his living fishing. There had always been some question about the title to the large Irvine holdings. Several schemes had been tried by various individuals, in an attempt to get this land under the land laws of the United States, so Billie Schutes also thought he would try his hand, and he filed on the land that is now known as Laguna Cliffs. Whether his filing had any merit or not was not the only question, for he had built a little cabin and had possession. In order to remove him by court action, it would be necessary to prove the title. Whether this would be easy to do or not, it was an extremely undesirable procedure and one they wished to avoid.

Now Billie, like most men who ply the waves, was fond of his liquor, and one day, a friend of his came down with a goodly supply. They proceeded to enjoy themselves, and when they reached the point where they were quite happy, Billie was invited to come downtown, where the entertainment was prolonged. The sad part of it was that when he was able to make his way back, all his possessions had been removed from the little cabin and someone else was in possession.

Coast Royal

A short time after the Lee Goff property had been sold for $700, a man by the name of Pullen became enthusiastic about the possibilities of this coast, and after making a careful study of the situation, he contacted a man who had acquired an interest in it from the fact that he was the means of making the sale. They reached an agreement whereby he was to pay the sum of $100,000 for this same tract of land.

This agreement had been reached without consulting the other owner, Miss Blanche Dolph, thinking there would be no question but that she would

be delighted to turn this investment at such a profit. He found she was on her way to Europe and had left her affairs in the hands of a sister.

This agreement had been made on the basis of paying the purchase price out of future sales, which was quite common and was considered fair, and also he was dealing in behalf of a friend of good standing. The deal was made in good faith, and there was no thought that something might happen to interfere. Mr. Pullen had made plans for a beautiful subdivision, and he had named it Coast Royal.

When this proposition reached the sister, she filed proceedings in court to kill it, on the grounds that no money had been paid. The next morning, the *Los Angeles Times* came out with screaming headlines, giving the nature of the deal, while it appeared to the public to be exposing a deal that was crooked.

This, of course, destroyed any possibility of carrying on and also destroyed what had been a very fine friendship.

While there was nothing left of the friendship, the name, Coast Royal, survived, though the property was divided and this name applies to only one of the parts.

HIRED HELP

Being out in the country where I was completely isolated, and being in a position where the cooking was a problem as well as getting the farm work done, I found it necessary to take whatever help I could find. Sometimes this help was good and sometimes anything but good.

One day, a man drove into the yard. He had been recommended, and I had sent a team to bring him down. He had red hair, his wife had red hair and they had three redheaded boys. Now, according to my experience, redheads have nothing to do with temper, so temper is not under discussion. It is only a matter of discipline and what is commonly known as horse sense. Before he had set foot on the ground, he said, "Now if the boys don't mind you, give them a whipping." The youngest boy was in his mother's arms, and the oldest was about seven years old. They were out first, rushed over and turned on a faucet and started to play in the water. I told them to close the faucet, and I might just as well have spoken to the wind. The parents were getting out of the wagon, I went down near the boys and said, "Did you hear what I said?" They looked up in surprise as though they had heard a new sound and turned off the water. They had heard a sound that had a meaning to it.

PART III

Some months after this, I went up the canyon to repair a fence. Fred stayed with me, and Raymond, who was somewhat of a monkey, was climbing willows. We went to another place, and finally, I started for the house and told Fred he had better go and get Raymond. He said Raymond had gone home. I replied, "No, he did not," but he insisted, "I saw him go home." The mother came to me very much excited and said, "I thought Raymond was with you." I told her he had been, and she replied, "Fred said he didn't know where he was." I assured her that he did know, and she went back much relieved, but there was no reprimand whatever. I went back to the barn, having a buggy whip in my hand. I said, "Fred, why did you tell your mother you didn't know where Raymond was?" He maintained that he didn't know where he was, but I insisted that he did. He then said, "I didn't tell her I didn't know where he was." Just at that time, the buggy whip wrapped itself around his bare legs, and he started to howl, "I'll tell my pa." I said, "That's what I want you to do, and he will give you a real whipping." Presently, I said, "Shut up! Shut right up and go and get Raymond." He knew right where to go, and the lesson did him a lot of good.

There was another tribe who came down; they were equal in numbers and also redheads. I always tried to put up with what help I could get. The youngest boy in this family was two years old, and he had a fit every time he was told to do anything, so his mother humored him. Both parents went away for a few days and left a woman friend in charge, who had been cautioned not to cross Kenneth. When she told him to come to dinner, he started to throw a fit. He was clawing at his hair, and she did not know what to do. Presently, I said, "Kenneth!" He looked up, and I said, "Go and get in your chair!" He forgot about his fit and went and climbed into his high chair, then said, "I ain't agoing to eat." I said, "I don't care whether you eat or not, but you sit in that chair." Presently, he asked for a piece of pie, and I said, "No pie unless you eat your dinner." As far as I know, he did not have any more fits.

I had to go away and leave this man to handle the produce for a few days, and when I came back, I found he had gathered up some fallen apples from under the trees that were absolutely worthless, had mixed these with good apples, had reduced the price by half and sold this stuff to my customers. I asked him what was the object, and he said, "Think what I was getting for that junk."

There was another couple came from Los Angeles one time, they seemed to be very nice and appeared to be making good, but when I came home to lunch one day, I found the wife, who was considerably the younger of the

two, had a note in her hand. Her husband had disappeared and left this note to tell her she could have what there was coming. This was very generous, but from my viewpoint, he had also left me his wife. I told her she was welcome to stay until the following day, but she preferred to leave at once, so I took her to the station at El Toro. He was a carpenter and had a very fair set of tools, which I bought from her. Later, I heard they were living together, and he wanted his tools. She said they had never had any fuss.

The second year after I found myself alone, I was looking at the hayrack one morning. It was on the ground, and it was a two-man job to put it on the running gears. I was trying to see if there was any way whereby I could get it on the running gears by myself, when a man came walking up the path. Being off the highway, this was something that seldom happened, and it seemed like a godsend. He kindly helped put it on, and then we had breakfast. I asked him if he would like to work for a while, so we went down into the field and I set him to hoeing weeds from a row of watermelons while I was working with the team nearby. Presently, he came over and asked me to show him which were the weeds and which were the melons. He said he was a sailor. I went back to my work, but soon he had disappeared, and when I came to the house, I found a shirt missing. He had evidently taken pay for his work, which I thought was very fair.

DIFFERENT

Mr. Green came from New York for his health. He had a wife and two small children, the girl being about nine years old and the boy six. It appeared to be their first experience out in the country, but there was no difficulty with the work. One day, the little girl wrote a very attractive poem, inspired by her surroundings.

One day, as we were coming up for lunch, we noticed a snake trail across the road. It was very crooked and looked as though it might have been made by a rattlesnake that had just swallowed a toad. We looked in the weeds but, seeing nothing, proceeded toward the house. Presently, there was another trail that was very similar. This looked very odd, and we spoke of it at the lunch table. The children smiled. They had taken a large snake and held it by the tail while it made these tracks across the road. The snake was harmless, but it would be difficult to convince some grownups of this fact, and we had not discovered that the children were on such friendly terms with them.

I was out in the field plowing one day, and Mrs. Green said this was the picture she saw when she looked out. I was following the team, while behind me in the furrow was a colt; behind the colt there was the boy, Barton; following Barton was a dog; while a little farther back in the furrow was a cat bringing up the rear.

Barton was a natural wit, and would say many funny things that would make us laugh. Sometimes, he would repeat one of these sayings, and his dad would say, "That was funny once, but it is not funny anymore." One day, Mr. Green repeated something he had said. Barton waited until he had finished and, with a perfectly sober face, said, "That was funny once."

One day, we were hauling string beans for shipment. I had one wagon, and Mr. Green had the other, while Barton went along for the ride. A few miles from home, after wriggling a little on the hard seat, he said, "This makes my botambula sore" (whatever that means). On the way, Barton's face got somewhat sunburned, and the next day, it was red. Mr. Green started to tease him about his red face. He kept this up rather persistently. Every time he saw him during the first part of the day, he would try to tease him, but Barton said nothing. At lunch he kept it up, and as we were about through, he said, "Barton's got a red face." Without cracking a smile, Barton said, "My behind ain't sore."

Mrs. Green kept her seat, but Mr. Green and I had to get up and go outside.

LOST AND FOUND

Some people who were camping on the beach were seen hunting diligently along the sandy road. I found that when they were coming up to water their horses, one of the men had taken out his purse to count some change and twenty dollars in gold had slipped out of another compartment. They hunted in vain, for they had no idea where it had fallen. I told the man to leave me his address, and if I found it, I would return it.

That winter there was a heavy rain, and it made a flood that went over part of the road. I went down to see what damage had been done, and there where a little sand had been washed away was a ten-dollar gold piece; nearby was a five, but though I sifted the sand for some distance around, I could not find the other. Now it happened that I needed fifteen dollars to pay my taxes at this time, and it came in very handy. When I began to get some more money coming in, I wrote to the man to be sure that his address

was the same. He wrote that he would be pleased to get the ten, and I could keep the rest.

I used to carry with me whatever money I had, because I felt it was safer than it would be to leave it at home and then I could always make change. One day, I changed three twenty-dollar gold pieces in a short time, but I always kept the gold separate. I would frequently still be doing business when it got dark, and one night, I had been around my own camp and made several sales after it was so dark that change was made by feeling. When I got home, I took out a handful of change, and there was a five-dollar gold piece. I thought it was odd but took the rest out, and there was another one. I looked where I kept the gold, and it was all there. I had two extras. I began to think how I had got them. There were just two men (both old friends) who had given me what was supposed to be a quarter after dark. I could think of no other chance where I could have taken them. The next morning, I asked Bob Shaw if he had missed any change, and he said he thought he was a little short, so I told him what had happened but mentioned only one of the gold pieces. He accepted it with thanks, and as he put it in his pocket, I said, "Hold on, you owe me twenty-five cents." Then I went to Dick Thompson, who had handed me the other quarter. He looked through his purse and said he did not miss anything, so I was unable to find the owner of the other five.

AN ERRAND

A man from Riverside came to Arch Beach and built a small summer cottage. I used to haul water in barrels to water a few trees that he planted around this cottage. We became quite friendly, and he and his wife asked me to come up to their home in Riverside. He also wanted me to see the man who had bought the Frank Goff property (spoken of before). He lived in the Downey country, and as I had an invitation to come up to see a girl who lived nearby, I dropped her a line telling what train I would come on.

I met some of the leading people in Riverside, including Mr. Frank Miller, owner of the famous Mission Inn that has made Riverside known to the tourists of the world. I felt about as much at home with these people as a turtle in a birdcage, but it was nice to know them, and was never forgotten.

The next day, I started on my errand, with money in my pocket to make a payment on the property, if it could be purchased on the terms offered by my friend.

As I got off the train at Downey station, a buggy was driven in with three girls in it. The one who had given me the invitation was driving. As the buggy would hold only two comfortably, it was evident that it was not intended that I should get in. The fact that someone was coming had evidently been noised around, and these other two girls wanted to see what this Romeo looked like. Then, perhaps, it would have been improper for her to come out all by herself to meet a man under any circumstances. To have done this would probably have started all the other feminine tongues in the neighborhood to wagging; hence, the other two girls had been picked up, not for company but for protection, as well as to satisfy their curiosity.

As there was room in the back of the buggy, I put my grip in and started to walk, as the distance was only about two miles. Fortunately, a man came along with a wagon, and I got a ride.

We arrived a little before noon, and the mother was preparing a Sunday dinner. The man I wanted to see had been invited. It was a rich farming country, and chickens and cows were in evidence. The house was old and of the ordinary farm type; the floor had been swept, and the dirt had been neatly brushed into the fireplace. As it was late summer, no doubt it was to stay there until such time as ashes might accumulate, when it could be carried out with the ashes. When we came to dinner, the principal dish was boiled potatoes and milk gravy.

My errand with the man was not a success, because he had doubled the price offered, and as I must get home and would have to walk ten miles, I made it known that I must catch the next train, so the old lady volunteered to see that I got to the station. She drove a farm horse that much preferred to walk. If he was urged into greater activity, he would soon come back to his old gait. We had plenty of time, and there was no reason for hurrying, but the old lady was busy telling me how carefully she had raised her girls. I frequently expressed my anxiety about getting to the station on time, so she would shake the lines over the horse's back and hit him with the whip, but he still persisted in walking. Finally, I heard the train whistle, grabbed my grip and said goodbye. We were just reaching the tracks, and when I reached the station, I found it was only a switching engine and I still had a half hour to wait. This half hour passed very quickly, however, for it was such a relief.

I wrote to my friends in Riverside that the land was low and damp, but it was wonderful how the people had adapted themselves to the country.

THE CLIFFS

About the turn of the century there was a group of men who bought a piece of land north of the original subdivision known as Rogers Addition to Laguna Beach, which included what is now known as Broadway. This was quite a large tract of land and was bought from the Irvine Ranch Company. The land was subdivided and called "The Cliffs," as it was mostly elevated land bordered by cliffs along the ocean.

Up the canyon about four miles there was a fair supply of good water that also belonged to the Irvine Ranch. This water was piped down and used to furnish this tract of land but was not permitted to be used on any other land. This encouraged the building of permanent homes, but the time was not ready for permanent homes, although a few houses were built for summer use. Gradually, these houses increased until they reached the number of seventeen, and there they stayed for a long time. They were pretty well scattered, and it took considerable driving to get around to them all. But the people were good customers as long as they stayed, and I managed to make the rounds. However, it made me late in getting home, which would almost always be long after dark.

This property moved so slowly that it came near to breaking the men who were backing it, but it finally pulled out with a fair margin of profit when the town began to grow about twenty years later, under the management of Mr. Howard G. Heisler.

A HAY RIDE

Regardless of how much work I had to do, I would sometimes find time to take people out for picnic. I once took some friends down to Three Arches. There were two sisters in the party; one was eighty and the other eighty-six years old. They climbed down the steep hill to the beach with very little help, and while we men were looking around, they went bathing in a pool. When we came back they were floating in the water, sticking their toes out and having a great time.

The last excursion I had of this kind was when I took some people for a real hayride. I had the hay rack, plenty of hay and four horses. This time we went down to Eagle Rock. We called it Eagle Rock because a fish eagle had her nest on it when we came. We drove to the ranch and got some

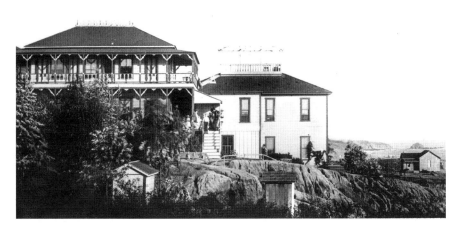

Arch Beach Hotel. *Historical Collection, First American Financial Corporation.*

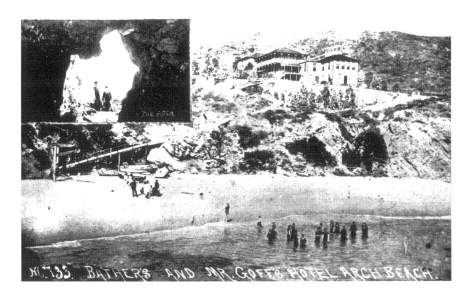

The Arch Beach Hotel with bathers and Arch inset. *Historical Collection, First American Financial Corporation.*

watermelons and plenty of green corn. Most of these people were well past middle life. There were Mr. and Mrs. Martin, Mr. and Mrs. Cayting, Miss Cathrin Edwards and her mother, who was about ninety years of age at the time and lived to be over a hundred; there were Ben Handy and his sister, several members of the Norton family and I believe some of the Moultons. If there were others, I am unable to recall, but we spent the entire time in this interesting spot, which is hemmed in on three sides by great rock walls, there being only a few hundred feet between these walls. We found a small devilfish, or octopus, and a few shells and had an interesting time.

Ben Handy acted as chief cook and boiled the corn in a coal oil can. It was stripped and cleaned, then the husks were replaced, and it was cooked in sea water. The water salted it just right, and the husks gave it a flavor. When I think of good corn I always think of that time. Corn loses its flavor rapidly, and this was not only fresh but also cooked to the queen's taste.

SALLY

A man came to the place one day, bringing a two-year-old colt. Father traded two cows for the colt and ten dollars. For some unknown reason, he gave her to me. I never used a horse to herd cattle with, but when she grew up, I would ride her down to the neighbors occasionally. She would go like a streak, especially on the way home when I found it impossible to hold her back. She did all kinds of work but liked the saddle or something on wheels best. I taught her to follow me, not only from work to the barn but also from the barn back to work again. She seemed to enjoy the fact that I trusted her and let her walk with me without being led with a rope.

I was riding her one day when she stepped in a bed of quicksand. In a second, she could have become hopelessly mired down, but she was too clever for that and beat the quicksand by doubling up her legs and dropping on her belly. The quicksand soon settled and she was up and on her way. That decision was made in a split second and demonstrates the resourceful mind of animals, whereby they are able to save themselves.

I was running down a steep rocky hill one day when a stick flew up and caught my foot. Now the proper thing for me to do was to take a header among the rocks, but one foot was still on the ground, and with this I gave a small leap in the air, kicked loose and continued on my way.

Some people are unwilling to give animals their just dues by saying that animals use instinct while man uses reason. I have never been able to tell the difference between these two instances. Also, if one was instinct and the other reason, they at least served the same purpose.

When Sally had a colt, we called her Birdie. Now Birdie had her own individuality the same as people, and when her mother was taken away for any purpose, she would not follow. She would come a little way, then say goodbye and run back to the other horses. Even if her mother went to Santa Ana and stayed two days and I had to milk her, neither one of them seemed to worry about the other. This is the only colt I ever knew that would not leave home.

Birdie had wonderful self control. When she was about two years old, another horse made a pass at her, and she whirled and landed on top of a barbed wire fence. I was nearby and ran over to her and put my shoulder under her neck. She was trembling violently but did not struggle. The wire was pricking her under the belly, but she knew that to struggle would ruin her. Frank was coming some distance away, and I called to him to run to the house and get the wire pliers. He had to go at least three hundred yards round trip, but she stood until he came and cut the wire. Many human beings would not be able to exercise the same degree of self control. Birdie lived up to this reputation in everything she did, and I could write a lot about her, but it is not my purpose to write a horse story but only to give them their just dues.

I was plowing a little field down by the lake and had to go up a steep mud bank, so I cut some weeds and laid them on top of the mud before going home. When I came down in the morning I found the water had risen and the weeds were floating. In going up the bank, the weeds instead of being a help served to entangle the horses' feet when they pulled them out of the deep mud. Finally, Birdie fell over in the deep water and went entirely under. I jumped out and held her head up so she did not breathe any water, and she finally got on her feet. After things were quiet, I undertook to take the team down to where I could hitch on to the pole and pull the wagon out, but Sally was afraid and refused to go. Birdie reasoned differently. She said, "I got out of there once and I think I can do it again," so she pulled it out by herself.

When I found myself on the place alone, I undertook to teach all the horses to follow me. This was quite a different task than teaching just one to follow, for one is influenced by the actions of another and they will sometimes play tricks.

BONNIE

Bonnie was a beautiful animal with a coat that looked like spun gold as it scintillated in the sunshine. I gave her a little extra attention and taught her to shake hands with me when I came to the barn in the morning. One morning, Dandy, who stood beside her and who worked with her, raised his head and looked me over. He gave me a look that said, "I don't think you are hardly fair," then he raised his right foot as much as to say "Shake hands with me, too." After this, I had to shake with both of them every morning.

Bonnie had a colt, and I called her Fadie. This was for Florence Dolph, who said her baby name was Fadie.

Fadie was nervous and afraid of people. If I touched her she would jump as though she was afraid for her life. One day, she stopped with her head in front of her mother so she could not see me, and I walked over and picked her up. She kicked and struggled but could do nothing. I laid her down on the ground and lay down with her. When she was quiet, I got up and left her lying there. She hardly knew what to make of this, as she had not been hurt. The next morning, she came up and smelled of my hand but was still shy.

Bonnie died. She was sick for several days, and Fadie tried hard to get her nourishment, which finally failed altogether, and she went over to the manger and started to eat hay with the old horses. I had too much to do to play nursemaid to a colt but told a fellow who was with me at the time that we would have to give her milk. She fought the idea of being forced to do anything, but when she got a drop of that milk, she changed at once and never lost a drop. The next morning, she came to us, and after that, she would take the milk out of a pan or out of a bottle, warm or cold, it made no difference. It was good nourishment, and she was thankful for it. When I started to sell produce later, she followed the same as if I was driving her mother. Everyone loved her. One day, a three-year-old Sanborn boy was seen sitting under her belly stroking her hind legs, but no one was afraid he would get hurt. When she was hungry, she would put her little nose up over the edge of the wagon, with her eyes on her master, who would always give her a nice green corn husk.

One day she was seen rubbing on a small apple tree. I called to her to stop, but when she found she was noticed, she rubbed all the more, so I started over. When she saw me coming, she lay down and rolled over like a kitten, but when she landed, her front legs were bent up against the tree and she was helpless. I said to her "Now see what you have done, you've got yourself in a fix. You wouldn't mind and you thought you would be

funny." She rolled her eyes up and did not move a muscle. She said, "The joke is on me and you can have all the fun you want until you get ready to help me up." I pulled her back by the mane so she could get her feet in a position to raise up. When she was about two and a half years old, she came up behind me one day, raised her feet up over my shoulders and came down on top of me. I got up and said, "What do you think you are doing? I know you used to put your feet over my shoulders, but you have grown up. You are too heavy now." She looked at me a little sheepishly and said, "I forgot that I had grown up."

About six months after this, we were coming through the field and Mr. Green was driving, when Fadie came up in front, then stepped to one side to let the team pass. I thought I would try an experiment and, stepping to the side of the wagon, jumped on her back. As gentle as she was, I rather expected to land on the ground, but she stood there. No one had been on her back before, and this was more than could be expected, for no horse is apt to put up with such actions unless he has been trained, but she pawed the dirt and said, "What do you want me to do now?" I told her I wanted her to follow the wagon and take me home. Presently, she seemed to understand and followed the wagon. On the way there, was quite a stream of water in the creek, and she stopped and said, "I think this is a good place to lie down." But I told her it would not be nice to get me all wet and so she carried me up to the house. Then when I got off, she went back to the field where the other horses were. Thus I got my first ride without even a rope or any previous understanding.

Puntie was about her age but was a little rough in his ways, so he did not get to follow the wagon, but when I was working, it was his delight to get right in my way and lie down. Then I would take him by the hind feet and drag him out of the way; he enjoyed this, but soon he got so heavy it was impossible to drag him, so I would roll him over and sometimes give him an extra roll for good measure.

In teaching the horses to come to me I never used sweets or any inducement but would sometimes throw clods at them. They were not afraid of getting hurt but knew what I wanted and would come up, so I taught the colts the same way. One day, Puntie was eating grass and didn't want to come; the clods didn't hurt anyway, and he wasn't sure that he had to mind, so I told him I would have to put a rope on his neck and make him come. I pulled and pushed and got him down in front of the gate, but he could not see it, so I walked around him with the rope and gave a hard pull that spun him around. He was inclined to be a little stubborn and hung his

head by his side, so I went around again and spun him around like a top. This time, he saw the gate and walked in.

I had to watch all the gates and make special latches to keep the horses from opening them, but I enjoyed matching wits with them. The gate that I went through in going to the coast was heavy, and I was careless with it and leaned it against the post. But the feed was better outside, and they finally opened it, so I put some wire on it and looped it over the post. They pushed this off and went out, so I drove a staple in and put a snap on it. Sunday afternoon, they went down and stood by the gate, and I said to myself, *I guess you won't open that gate any more*, but the next morning, the gate was wide open. They had pulled the staple out of the post. Now I do not want anyone to think they had taken hold of that staple with their teeth and pulled it out, but there were the marks on the gate where three horses had taken hold of the board and pulled until the staple had come out. I had to go to the shop and make a larger staple and then regretted that it was necessary to keep them in.

The stable was made for four horses, but when Puntie and Fadie came, this made six. However, I was not afraid that they would get hurt, for they all had excellent manners. They were never tied in the barn and were free to move around but never fussed with each other.

When these youngsters grew up and it came time for them to do their share of the farm work, they never made the slightest trouble. There was no room in the barn for them now, so I fed them outside, and when I came down after breakfast to put their harness on, they would be down in the creek cropping the water grass. When they heard me come, they would come up and stand in front of the barn for me to put the harness on, and then they were ready to follow me out to work.

When I think of these things, it compensates for all the hardships and all the abuse that I have experienced.

I have heard men say they would rather break a bronco than a pet, but the trouble is that when they start to break a pet they change their attitude and use force instead of the kindness the animal is used to, and he is afraid.

RABBIT

"Hello, little fuzzy nose, you look like a rabbit," and the name stuck to her. When she grew up and had a colt, I called him Jackrabbit. The horses that were running in the hills came to me one day and asked if there was not

some place where they could get better feed. The hair on their noses was all ruffled up where they had been poking around among the brush to find stray spears of grass. I had feed for the ones I was working but no more. So I got some barbed wire and made a fence along the coast to the south. The ground was so hard that the only way I could dig holes was first to make a little basin, haul water in barrels and fill these basins and then the next day I would be able to dig the hole. Building a barbed wire fence is a two-man job, but I used the wagon to string it out along the road and then flipped it up the hill a little at a time until I got it in place, then tightened it with a block and tackle.

When I put the horses in this new pasture, I came down the following day to dig a hole in the creek where they might get some halfway decent water, but they had already been down and gone back. I could see that Rabbit, with her colt, was in sore need of water. As I had no rope, I told her to come home with me and get some water. She understood and followed me down the hill, stopped and carried me over the salty water of the lake, and when she was drinking at home, I gave her some hay and went to the house thinking to get my own lunch, thereby saving an extra trip. But she called to me and wanted to get back to her colt, so I had to take her back. I was surprised several times to find that the horses understood the meaning of certain words that were frequently used.

JACKRABBIT

When Jackrabbit grew up, I found he was well named. Although he was large, he was quick in his actions and always wanted to do more than his share. When I broke him to work, all I had to do was to put a harness on, and he was ready for business. If I ever led him to work, it has slipped my mind, for I remember only his following of his own free will. When I started to put his bridle on in the morning, he would put his face down against mine and hold it there until I spoke, and when I said, "Well, we can't afford to waste any more of this good time," he would raise his head and open his mouth for the bit. I would turn the horses loose to pick on the grass during part of the noon hour, and then when I got the others, if I said, "Come on, Jackrabbit," he would come along. But if I failed to speak to him, he would not come, and I had to use diplomacy to catch him. He thought I was taking too much for granted. Twice he ran away and went to the top of the hill, but

otherwise I had to be careful. I would get right in front of him and shake my finger and say, "I know you have the advantage of me, and I know I forgot my manners and took too much for granted, but you had better be good and come to work or I won't turn you loose on this nice green grass, so after all I still have the advantage." When I got close enough to put my finger on his nose, he would come along to his place.

Jackrabbit was a leader among the horses and kept track of them. Whenever it was possible, I turned them out at night. I would get up and go after them long before daylight but knew where to go. One morning, I brought them in from the coast, but Jackrabbit was not with them. When I got home, there he was right near the barn, with his foot in the corner of the fence, held by several strands of barbed wire. He was not hurt in the least. He had stood there all night and let the rest of them go out to feed, knowing that when morning came I would be able to get him out of his difficulty and had been careful not to hurt himself.

THE EARLY AUTOMOBILE

When automobiles began to come, they struck terror to the hearts of the horses, but I was frequently called upon to help some of these machines out of difficulty. While the horses were deathly afraid of them, they seemed to recognize when they were in need of help. One night late in the evening, four people came to the house and said they had a car stuck in the mud and wanted to know if I could help them. I said the horses had been turned out, but I could get them, so we all went down and found them in the creek. I called Rabbit and Dandy, and they came over where I could get them without wading in the water. Now this was a very unusual proceeding, and they came over with a readiness that made me feel they realized these people were in trouble and required their help. The people had driven down a steep bank, and the front wheels had stuck in the mud, while the hind wheels had no traction. They had gone to Arch Beach, two miles away, and had been sent back to me, less than half a mile from the place. When we got the car out, the driver handed me five dollars, saying his name was Jack Frost, that he was from the Hawaiian Islands and was touring California with some friends. They seemed as pleased with the action of the horses as they were to be on their way.

A RUNAWAY

One day, I came to Laguna with a lot of olives in a barrel. After selling what I could around town, I tied the team in front of a little store that stood where the Five and Ten Cent Store now stands beside the bank. This was an extra precaution, because I did not make a practice of tying them. Presently, one of these chug wagons started to come down Forest Avenue. The horses jerked loose in terror and started to run. They went across to where Rankin's Drug Store now stands and onto the ground which the White House Café now occupies. Here there was a eucalyptus tree standing, and they straddled it, the wagon tongue catching on it and stopping them. A column of olives went up in the air above the barrel, but the barrel did not tip over, so most of them fell back in—all but about a couple of gallons. Feeling that I had got off cheap, I told the people they could have all that fell outside of the barrel.

Years later, I heard that I had a span of horses that would run away at the drop of a hat. They had failed to realize what had frightened them.

One Sunday, I was coming over to town, and it occurred to me that perhaps all the horses might like to have a romp, so I left the gate open to see if they would follow. I had twice as many now as I could use but refused to sell any of them. Sure enough, they all came along and had a big time, little, old and young. Jackrabbit and Ginger had a big time chasing each other. They romped around over town while I was doing my trading—and where there was nothing they could hurt—and then followed me home again after enjoying their Sunday outing.

DANDY

One day after a flood, I went down to repair the fences, which of necessity had to cross the creek bed. The water had backed up in the lake and was about two feet deep right at the place where much of the fence was buried in mud and debris, while it was still fastened to the posts. I worked for a while and decided it was a hopeless proposition. Then a bright idea came to me, and I went and brought Dandy down to help me out. I hitched him to the wire and told him to pull it out. As he pulled things to the surface, I removed the staples and threw the posts out of the way. In a short time, we had the job done. Though he might be two hundred feet away, he would pull just as I wanted him to do.

Dandy was good to follow, but I had taught the horses if they would meet me halfway I would be good to them. Dandy took advantage of this to play a delaying trick on me. He would stop at the edge of the creek bed and refuse to come until I would start back after him, then would meet me halfway. I got tired of this, and one day I got cross and said I would have to break him of it. So I took the other two down and stood them in their places at the cultivator and came back with a rope. I was also carrying a whip, but he met me halfway as usual. I threw the rope over his neck, but there was something wrong; there was no need of the rope, and I did not speak to him. He jerked his head up and ran away before I could tie the rope. Now I was not exactly in a good humor, and this did not help the matter. I thought, *he will stop where the other horses are,* but he did not stop—in fact, kept right on going. He was down near the other side of the field with his head down in a brown study. As I passed the other horses, who were still standing in their places watching to see how things would come out, it occurred to me that there should be some other way. I said, "Come on back, Dandy, I won't whip you." He turned without the slightest hesitation, walked back and put his head in my arms. I said, "Dandy, you know better than this. You know what I want, and you mustn't try to play tricks on me. Now go and get in your place." He went right over and walked into his place between the other two horses. I went over and showed him that I understood and thoroughly appreciated what he had done, also the others who had been patiently watching the performance.

Dandy had thoroughly learned his lesson.

I used to come home with four or five horses in the team and turn them all loose to go to the barn, where I would take the harness off as quickly as possible. They were very thirsty, and it was their habit to go to the trough and drink. But there was a field of corn right by the trough, and they would start nipping off the leaves of the corn. As soon as the harness was off, I would call them back to the barn; then they would go over to the trough and start to drink. They were careful not to break any corn down or get hold of the stalk and pull it up, so I let them get away with it. But I always said I did not think it was fair to eat corn on their time and drink on my time, but I never could convince them that there was anything wrong about it.

Part III

Ginger

Ginger was a long-legged black colt; he had a sparkle in his eye and was filled with the joy of living. He was also filled with curiosity. I called him Ginger because the name seemed to fit but told him it might have been All-Spice. However, he was satisfied with his name. When he was only three weeks old, I had to go to Santa Ana and thought he would enjoy the trip.

On the way back, I noticed he was favoring his feet and realized that they had never had a chance to harden, and we were still sixteen miles from home. I stopped at a blacksmith's shop and picked up some string and old sacks. He lay down to rest, and I tied some of these sacks on his feet. When he got up, he noticed it was quite a help, but the sacks were soon worn through, so I stopped to tie some more on. He picked each foot up as I came to it so I could fix it up but did not lie down. Each time I added more but took nothing off, and by the time we got to the village, each foot had a wad on as big as a hat. He looked like a clown and was acting the part.

Ginger was extremely friendly from the time he was born. His aim in life seemed to be to have all the fun he could, and he was very nice about it. If I wanted him to go with me, I would put my arm over his neck, and he would walk along beside me, the only colt I ever saw that was willing to do this. But one day, he said, "I don't think I want to go this time." I tried to get him to go, but he still said he didn't want to go; so I told him I would have to get a rope, and if I did that, I would surely make him go because I had other things to do. However, he could not make up his mind, so I got a rope and put it round his neck. Now he had been figuring this out all the time and said to himself, "We'll see who gets fooled." So when I got the rope tied, he reached down and nipped my pants. Then he came along and kept so close to me that I never got a chance even to lead him.

Ginger used to go with me when I was selling produce, and he would go into every nook and corner he could find on the way. I always reminded him to come out the same way he went in, and then he would not get into trouble. So he would stand and look things over, then turn around and run out kicking his heels. On the way over there was a fence that stood by the side of the road for about half a mile. There was a hole in this fence, and a little farther on there was a gate, so here was one place where he did not have to come out at the same place he went in, and he never missed a chance to go through these two places. One day, I had got well along by the fence when I heard a wee voice. I looked back, and there was Ginger inside the fence. He had gone in at the wrong place and now had come to a sharp gulch and was

183

calling for help. I disliked very much to have to drive back and called for him to go back and come out where he went in. Finally, he seemed to understand and started back, but he did not go far enough and was soon back at the gulch. I called, "That will never do! Go way back, way-way back." After calling to him for a while he raised his head, cocked his tail up over his back and started on a dead run. There was a small gulch to be crossed, and he had to go far out of sight, but I knew he was going to make it. Pretty soon, he came pattering down the road as proud as you please.

Everybody loved Ginger. One day, I changed horses, and one of the little Seeman boys came out. He looked down the road from where I had come, then he looked the other way and looked up to me and said, "Next time you come, bring Ginger." His mouth closed, and he went back into the house.

We came around the corner one day where Mrs. Seely was digging in the garden. She was on her knees, and Ginger looked over and said, "This is where I am going to have some fun." He ran over and raised his feet high above her head. She did not scream; she did not jump up and run. In fact, she paid no attention whatever to the danger she was in but just kept on digging in the ground. He soon found it was very awkward, to say nothing of being difficult to stand on his hind feet, so he put his front feet carefully down to one side. He looked her all over and seemed to say, "I guess you are a good sport, but you spoilt my fun."

I frequently had to go up on top of the hill after the horses in the morning. This was about half a mile, and in coming down, I did not pay any attention to Ginger because I did not care whether he came or not, so he would lag on the trail and when we got far enough ahead would come running down and try to run over me. I would have to step to one side in the brush to let him pass. One morning after he had been doing this, we had reached the top of the Elephant's Head, and I told him he was just no good; that he was a nuisance; that he wouldn't work and was always in mischief; that I didn't like him anyway because he tried to run over me. Then I started to pass in front of him, and he clamped his chin down over my shoulder, raised his right foot up in my hand and said, "Don't tell me you don't like your Ginger baby."

LET THERE BE LIGHT

When Laguna began to grow and there were a few people who had decided to make it their permanent home, if anyone wished to go out in the evening

when the moon was not shining, they found it convenient to carry a light. The old-timers either knew their way around so well that they did not need a light or they had a lantern, but the newcomers had no lantern, so they improvised one by taking a small block of wood and driving three nails in it. These were just far enough apart so they would support a candle, and there would be other nails outside that would support a lamp chimney. A small piece of lighted candle would be put in, the lamp chimney set in its place, and they had a very good lantern.

There was little danger in walking out or going to call on a friend, but with people who are timid, a little light relieves the strain on the eyes by assuring them that there is nothing lurking in the dark ready to spring on any unwary person who might pass by. Then there was a little bridge over the permanent mud hole made by the creek, and while it was strong enough to hold a team and wagon, it was convenient to have a light, as all old-timers will remember, so that in crossing this bridge, which was in the center of things near where the theater now stands, they might be able to avoid putting their foot down right at the place where one of the planks had been broken out. So some of the newcomers made use of these very convenient and inexpensive lanterns.

Finally, someone conceived the idea of installing a lighting system. Three lamp posts were set up at strategic points. The lamps that were installed were about the size and shape of a five-gallon coal oil can and were provided with a coal oil lamp. Of course, they were provided with glass panels at the side, but outside of this, they resembled the historic cans. They were set on posts that were the right height to make it convenient to light them with a match, and they survived for a number of years. I noticed them occasionally when I came over in the evening, and if the night was clear, they could be seen for some distance. Finally, however, there was an engine set up near where the post office now stands, which provided electric lights for the nearby places and paved the way for the Southern California Edison Company.

SPECULATION

One day, I was unloading some watermelons at a little stand connected with Nick Isch's old store and the post office. A man by the name of Tom Sales came up and began to talk. He had no business with me and was a newcomer. He had a grouch on and was letting off a little steam. He was talking about having an appointment with a woman who was to have come down at ten

o'clock, and now it was two and she had not made her appearance. He was going to show her a large tract of land that was to be sold at a bargain. He rambled on while I was unloading the melons. When I got through, I said, "I'll go up and look at it if you don't mind."

So we walked up the hill a little over a quarter of a mile where I could see what he was talking about. I had little idea of the extent of the tract but could see it was a good buy, as Laguna had been showing increasing signs of life. So, I said, "I'll tell you what I'll do, Tom. I will take it if I can get the money." He said, "All right," and we went back and I went home. It was not long before the money was forthcoming, and the deal was made. I realized then that I had bought the land originally owned by George Rogers, which included the place where Frank Goff had been living when I discovered that neighbors were coming. The cabin in which he was living had since been moved down and made a part of the home place. It now belongs to the Woman's Club, the only original house now standing along the coast. Leon Goff, I believe, was the first child I had ever seen outside of my own family since coming here, and at that time I was over ten years old.

When Tom Sales began to talk that day, I had about as much intention of buying property as I had of taking a trip to the moon. After getting it, I found there were several others who had been after it but were evidently trying to drive a bargain.

In a few years, enough of this property had been sold so that had the money been applied exclusively to the purchase price it might in time have cleared itself, but the more level land was being sold and it needed my personal attention to make plans to avoid selling in such a way that it would be impossible to make roads up into the hills, which would defeat the purpose of most of the land.

The value of hill land for residential purposes depends entirely on the roads. Good roads that can be easily traveled are what makes it valuable, so I had to give this a little study.

In determining the grade of the roads I took a string and held it straight on the level of the horizon of the ocean and, by looking across this at the land, could tell fairly well where the road should go. If I wanted to be definite, I would take a stick that was twenty-five inches long and by putting a raise one and one-half inches high at one end, then by drawing a string over this raise and down to the level at the other, the stick being one-fourth of a hundred inches, it would make the string represent a 6 percent grade when the stick was level with the ocean and the string was sighted against the land. This was rather crude surveying, but I determined where

Nick Isch's old store and post office. *Historical Collection, First American Financial Corporation.*

the roads should go and then saw that the engineer made them where I wanted them.

The hills have always had a fascination for me. I enjoy walking over their sloping, graceful contours, the hills that I have been so familiar with ever since I was a small child. Everyone should wander in the hills seeking inspiration, and get acquainted with them, while also they are furnishing physical as well as spiritual strength. They are the temples of creation and it would be a drab country if we did not have the hills.

Some years later, the question arose as to what we should call them, and in casting around for a name, it was finally decided that they should be called TEMPLE HILLS.

ROMANCE

During the course of events, a young student came to Laguna to begin her career as a teacher. She had just finished her course of preparation and was called to fill the unexpired term of a teacher who had given up her job. It was a hard school to handle, and it was a rare thing if a teacher stayed for more than one term.

There were twenty-five children enrolled in the eight grades, with an average attendance of fifteen, and she found herself tested out with all kinds of pranks. One morning, upon opening her desk she was greeted by a large snake that had been coiled up inside. To have shown fear would have meant to lose control of the school. At another time, she found a horned toad sitting on her shoulder, which she pretended to enjoy very much and thereby gained the confidence of the school. The big bully of the outfit at one time got a slap on both sides of his face that came so quickly that he did not know what was happening until it was all over, but he had it coming and took it. The children learned to love and respect her, and she stayed with the school.

I did not know her because I was too busy with my work. Teachers, like summer visitors, came and went, and I pursued my way. In the wintertime, I came over to the village once a week to get the mail and a few groceries, frequently coming late in the evening.

In the meantime, this teacher married, as teachers sometimes do, but it proved to be an unhappy affair. The man in the case had a garage and repair shop and also was in the transportation business. Finally, this was sold, and they went to Los Angeles to live, where they stayed for some time. She came back and renewed her position as teacher but with two small girls to support. Eventually, she found herself with a crippled mother and a younger sister to support besides her two small children on a teacher's salary that was very small at that time.

The children would come down and climb on the wagon, like all children did. They were not backward in saying "Mama wants a melon." Of course I knew they were speaking once for mama and twice for themselves; I also knew that mama was not buying many melons. They showed in little ways that they liked to be with me and would go further than they were expected to go.

This teacher, who was formerly a Miss Harding, would put on a play at the schoolhouse every Christmas, and I came

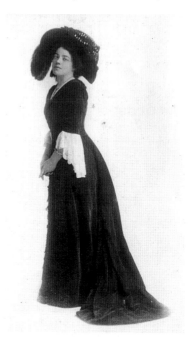

Marie in costume to perform in a play as Madam Madjeska. *Thurston-Boyd family collection.*

188

over to see them. These plays were written and produced entirely by herself, as she was also an actress. One time, I was standing in the back of the room, as the seats had all been taken, and when the play was finished, I heard a man remark, "I have seen school plays in several states in many cities, but I have never seen a school play put on so beautifully before anywhere." He was a man who looked to be about seventy years old.

At this time, the road was paved, and I was hauling produce throughout the county with a car and trailer. In order to get by the hills and get a good start in the morning, I came over in the

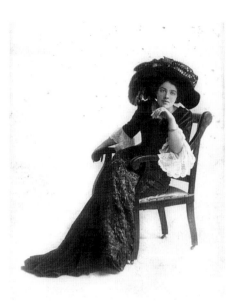

Marie in costume as Madam Madjeska.
Thurston-Boyd family collection.

evening. At this time, my principal crop was muskmelons that I raised on the coast. They were of superior quality and gained a wide reputation, being known as Thurston melons.

Coming over in the evening gave me a chance to call on her. Perhaps it was the struggle she was making against almost overwhelming burdens that brought us nearer together and made me wish to share with her. I was much older and would not have encouraged such a thing were it not for the burdens she was bearing.

I told her one evening that I would like to help her with the little ones and would build her a house if she would choose the place she would like it to be. This was only a few years after I had bought the property, and she said she had often looked up to the hills and wondered who they belonged to when she first came.

She chose a little knoll near the schoolhouse, and there we built a home, calling it "Dream Knoll." We came to look one evening before the windows or doors were in place. Out of one opening, the moon was rising over the hills in the east, and out of the doorway to the west the sun was just sinking down beyond the ocean.

We were married on the fifteenth day of June, 1921, at the little church. The sun had been hidden for two weeks and had not been able to show

Above: Joe and Marie's wedding, June 15, 1921. *Historical Collection, First American Financial Corporation.*

Left: The newlyweds with Marie's daughters, Virginia (*left*) and Doris, both of whom Joe later adopted. *Historical Collection, First American Financial Corporation.*

his face, but on that day, he came out in all his glory and welcomed the wedding party.

We went to Catalina for our honeymoon. I had lived in sight of this island practically all my life but had never been on it, so we spent a week there. While there, we took a trip down to the isthmus. This was not the Isthmus of Panama but the Isthmus of Catalina. There was quite a large party of people who made this trip together, having been recruited from all over the world, and we followed the guide around to see the sights. We were total strangers but began to feel a little acquainted as we were all in the boat on the way back. Someone asked our name. Now sometimes people speak and then think afterward. Sometimes they speak in a hurry as though they thought time was of great importance, but even at that, people can as a rule tell their own name. She said, "Frasier." She caught my eye and changed the answer, but it was too late. The cat was out; there were no further introductions needed. The restraint that is common between strangers had disappeared, and from then on, it was just one jolly party.

Someone looked at our hands and said, "Oh-ho, two executives." But we have tried to be charitable, without which no one can get along.

According to all the rules this should be the end of the story, but life does not end at marriage, for it is only a milestone and another beginning. Also, this is not a story except that it is a record of events, and we will have to go back and make some further reviews.

OPPORTUNITY

It has been said that opportunity never knocks but once. There may be a lot of truth in this, but it is also true that different opportunities may knock at different times. It is also true that opportunities are not always good, and sometimes it is better that we disregard their knocking. Furthermore, it is also true that blessings often come in disguise and do not have the appearance of an opportunity. Opportunity may come swiftly and unexpectedly; it may come slowly like the growth of a tree, but she always has something hidden away that cannot be seen. She may come on the wings of a bird, or she may come on the wings of a bat.

Everyone dreams of making money, but more money than one needs on his journey through life is not necessarily a blessing. Some dream of the limelight and fame, which might be laden with sorrow. They dream of the

limelight while they are raising a family, sharing their pleasures and sorrows, while they are living a full and useful life. Perhaps they have been shielded from a life that was empty, a life made up of tinsel and glitter.

On a cold and stormy night, a machine stopped in front of a little restaurant in Laguna Beach. Four young people got out of the machine to get some sandwiches and hot coffee. One of the girls began to complain of the very disagreeable ride she had been forced to endure. They had come up from San Diego and were on their way to Los Angeles. They had come through the wind and storm for more than seventy miles and had fifty yet to go.

They had gone to an airfield where she had expected to get a seat on a plane. She had expected to reach home in comfort. It is quite possible that she had been able to have all the comforts of life and thought she was entitled to the best of everything. However, when she reached the airfield, she found that all the seats in the plane had been taken, and the only way to get home was to come in their own car and ride in the rumble seat. It was cold, a storm was brewing and this seat was not inviting.

As they sipped their coffee in the little restaurant, the radio was going steadily. No one was paying much attention to it until it stopped.

A voice was heard bringing an important announcement. A plane, coming up from San Diego on its way to Los Angeles, had been forced down in the storm. It had taken fire, and all of the eleven occupants, including passengers and crew, had been burnt to death.

The radio went on with its program. The four young people looked at each other. Their faces turned pale. They sat for a few seconds, and then went out into the darkness and storm, thankful for the comforts of the rumble seat, thankful that all four of them had been permitted to return to their homes and mindful of the one who was fortunate enough to get the last seat in the ill-fated plane.

THE NEWSPAPER

A young fellow by the name of Orin Robbins came to Laguna. He had probably had some experience with printing in his school work, for he got some type and started a newspaper. This was made up of such little "wit-bits" as could be found about the village. It was a small paper printed on what might be called a large handicap. I do not believe it was supported by

any advertising because there was no reason for this. Orin only had enough type to print one half of a page at a time. I saw him at work one day, and he said he set up enough type to print half a page, then he took all the copies he intended to print and ran them through the press. Then he would have to set the type up again to print the other half of the sheet. Thus, to print a paper containing two sheets, it would take eight operations, this in addition to the fact that he would have to ink the press by hand. I do not presume that he printed more than twenty-five copies, but even at that, he would have to set the type up eight times and make two hundred press operations besides an equal number of operations in inking the press.

This kept him fairly busy because he was chief editor, assistant editor, business manager and typesetter. Then he was also the news-gathering staff and treasurer. I do not know what salaries these offices paid but presume that was of secondary importance, the main thing being to get the paper out. However, there was one advantage in his favor: he did not have to pay the salary of a linotype man and was not troubled with strikes or the rules of union labor.

I do not know whether he had any other income or not, but he finally married a Laguna Beach girl. Unfortunately, he was not long for this world. He left a small boy who has since gone through high school.

This little paper, which was called *Laguna Beach Life*, was taken over by Frank Hansen, who had been on the staff of a large paper. He had been involved in a railroad accident in which all his family had been killed. He had an income that assured him of a living, took the paper as a pastime and had it printed in Santa Ana. His office was on the ground that is now occupied by the Laguna Federal Savings and Loan Association. He was the town wit and could be seen almost any day jollying with someone or playing with his big dog, which was his only by adoption, as it really belonged to Elmer Jahraus.

The name *Laguna Beach Life* lived on through various vicissitudes and changes of ownership, until it finally disappeared.

A young man by the name of MacLean came to town. I think he was a college man but doubt if he had had any newspaper experience. He got a press and such machinery as seemed necessary and took over the paper from Frank Hansen. He ran it with such success as might be expected in a town that could support two schoolteachers.

Finally, Edward M. DeAhna, who had had newspaper experience, came from Texas and took the paper from MacLean. He ran it for a number of years, and it seemed to be quite satisfactory. But the people wanted

something with a wider range of expression, as the town was growing, and Belle McCord Roberts (principal owner of the *Long Beach Press Telegram*) was induced to come down. She offered to take the paper and print it as a branch enterprise, leaving Mr. DeAhna his job press.

The first manager was a young fellow by the name of Joe Hicks. He was afterward replaced by Hal Forest, who was taken from the editorial staff of the *Press Telegram*. He was an able editor, and everyone seemed satisfied, but as the paper was printed in Long Beach, it was barred by law from printing legal advertising. And as the people did not see fit to put a press in Laguna, it left an opening for another paper, so a small group of people who had accumulated a grouch induced a man to come in and start another paper, bringing in a small press. This was called the *South Coast News*.

This man put a chip on his shoulder and produced a scandal sheet. Each issue laid him wide open to a suit for libel, but the people went on with their business and permitted it to live on such as it was able to find.

It would be difficult for two papers to live in a town ten times the size of Laguna, and in a short time, this paper was sold to William T. Lambert, who brought it out in a more agreeable form. It survived for some time, but both papers were now losing money.

Harold McCormick, of the McCormick Harvester Company, came to Laguna. He liked the place and wanted to do something for it. He bought both papers and put Sumner Crosby in charge, who managed the paper for some years.

This left Mr. Forest out of a job, and he very much disliked to have to leave Laguna, so with the help of a few friends, he started another paper. The *Laguna Beach Life* had been sold, and he could not use that name, so he had to find another, but the fate of the paper was a foregone conclusion. When the waves were rolling high and the rocks were about to receive the wreckage, good old Harold McCormick threw out the life line and brought in the last survivor.

In the next and last move, the paper was taken over by the *Pasadena Star News* and run as an independent paper.

After all these vicissitudes, angles and triangles, the name *South Coast News* was retained. I have been told that this name was used because it covers a wider field of influence, but I am unable to see the point. I do not believe the *Los Angeles Times* would cover a larger field or have any more influence if it was called *Southern California Times*. Neither do I believe that if the *Santa Ana Register* were to be called *Orange County Register* it would increase its influence in the slightest degree. I believe one of the stupidest things a paper can

do is to fail to feature the name of the city that supports it, and I am still undecided whether it is trying to feature the Cape of Good Hope, the Gulf of Mexico or the South of Ireland, for they are all on the south coast, while Laguna Beach is supposed to be on the West Coast.

PUBLICITY HOUNDS

Newcomers wanted to change the name of Laguna Beach. They wanted something that was more musical, something uncommon—didn't like the sound of the word BEACH. They would like to use the words that meant the same thing but which were expressed in a foreign language. They wanted to use words that did not belong to the English language. The name and the place were becoming known far and wide, and they wanted to blot the name by which the place was known off the map. The place was connected with the history of the country, and when anyone spoke of Laguna Beach, people in the far corners of the country knew where it was. By changing the name, all this valuable information would have been sacrificed, but failing to agree on a suitable name, this scheme was finally abandoned.

However, there was another point of attack. Why not change the names of the streets? Why not name them after artists, using the names of old masters for all that ran toward the ocean and the names of living artists for all the rest. This scheme received considerable attention, but a general agreement was not reached. Things had gone far enough so that something had to be done, however, and it was proposed to give them numbers along the Boulevard. Someone called me up one day and asked me about it, and I asked what was the idea? "It would be so much easier to find certain places."

"But do we not have names on the street corners?" I asked, "And why do we give names to people?" This party replied, "In some places they have numbers." I answered "That is a good reason why we should not use numbers in Laguna Beach." I hung up the receiver, and that is the last I ever heard of numbers.

The undercurrent still survived; the matter had reached the city council, and the names were to be changed. I asked a newspaper party what was the idea? Publicity. Look at the publicity it will give us. But, I replied, why take it out on the city? If you want publicity, why don't you go and shoot someone? That will bring plenty of publicity. But the mill was grinding, and the changing of the names was coming to the third reading, so I made

up a petition and secured the names of a number of prominent citizens. A committee had been appointed to decide on the names, and they were before the council. However, there were several petitions that had to be read, most of these being protests against the changing of the names of certain streets, and they contained the names of the people living on those streets. Then they picked up mine, which read, "The city has survived up to the present time under the quaint little names that the original subdividers saw fit to give them, and we believe that it will continue to survive if they are permitted to retain those names."

There was not a word in favor of changing the names; the balloon had blown up, and with the exception of a few that had been duplicated, the names of the streets of Laguna Beach had been saved.

The Artists

It has been said that the artists made Laguna Beach, but that is not so. The artists just discovered it. It is true that it has become known as the Art Colony, and this is a title for which the artists are entitled to full credit, but the artist who carved out this bit of coastline and laid the little range of hills just far enough back of it to make a cozy place for people to come and live, where they might enjoy the sunshine and the sea while being protected from the rough elements of the world, had completed his work before man came on the scene.

It has furnished inspiration for the artists, both those who wield the brush and those who wield the pen, and this inspiration has gone out to the four corners of the earth, but Laguna Beach was, and is and will be.

There has been some question as to who was the first artist to come here. This question has been determined because it was our highly respected and well beloved Isaac J. Frasee who came here and made a slight sketch of the coastline in 1877, before there was a soul living at the beach or a shack had been built to mar the landscape. He did not paint a picture but just enough to show that he was here; neither did he establish a home until he wandered back many years later after he had raised a noble family in a little canyon in San Diego County, called Moosa.

The first artist that I became intimately acquainted with was George Gardner Symons. I do not know the year he came, but it was one of the wee small years of this century, and he established a home at Arch Beach. This was the time when he was just reaching the height of his career, which

spread far and wide due largely to his handling of the California poppy. He had a style of his own, and the effect was very fine. He liked the colors, both of the hills and of the water. I think he learnt to paint marines while here. He was genial and told me some of his experiences as a struggling artist. He told me how he had worked with a young fellow by the name of William Wendt, saying that young Wendt had been a great help to him. I looked as if questioning how this was done. He hesitated a second as if to find the right word and then said, "He made me honest."

Mr. Wachtle was a rapid-fire artist. He set up his canvas and in about half an hour had a fairly large completed picture. I do not know that it would have stood the test, but it looked very good. A deaf and dumb artist came out to the wagon one time. I offered him some corn, but he shook his head and pointed to the horses, evidently considering it only horse feed.

Conway Griffith was the first artist to make his permanent home here. He was genial, and everybody liked him. He used both watercolors and oils and painted both ocean and desert. He lived alone but unfortunately did not depend on water as a beverage. He might have thought that water was too common and chose a beverage that was stronger, but apparently it led him to an untimely grave.

After gleaning some information from Mrs. St. Clare I find some of the reasons why Laguna Beach became known as an art colony. Mr. St. Clare came to the coast in 1899 and stopped at Dana Point. There he heard of Laguna Beach, and the following year came here. He came to El Toro, the nearest railroad point, but found no conveyance to bring him the rest of the way. This must have been in the winter, because there was no stage service, so the station agent told him he would bring him over if he would wait until after hours. When he arrived, he got a room at the hotel from Mr. Isch, who had charge in the wintertime, but there was no place to eat. Now it would not be nice to let him starve or have him leave town just because there was no place where he could eat, so Mrs. Isch was prevailed upon to furnish him a place at her table.

All Mr. St. Clare had to do was to paint, so he painted a lot of pictures and took them back to San Francisco, where he put them on exhibition. There must have been something attractive about those pictures, for it was only a short time before other artists began to come. This is about the time that Gardner Symons came, but whether this is the reason or not, I do not know. There have been many artists here since that time, but I do not dare mention any more because I would have to mention them all—and this I could not do.

When Mrs. St. Clare came with her husband in 1903, her youngest boy was quite small, but the others were old enough to go barefoot. By the way, I do not think a boy has had a fair deal until he has gone barefoot, either from choice or necessity, but preferably from necessity. They were normal boys because they liked watermelons, and I am told that they enjoyed the little colt that would put her feet up over her master's shoulders. They all came back to Laguna Beach to live, and those who know them must acknowledge that they have all made good.

THE CITIZENS BANK

Yes, we have a bank in Laguna Beach, but there was a time when there was no bank here. The time came when it was inconvenient for many people to go to Santa Ana to do their banking. About that time, it was rumored that we might have a bank of our own if people would subscribe half of the necessary money. There was a promoter in town, and he was soon calling on people to see if this could be done. All that was necessary to qualify as a director was to invest $500 in the securities, and when the bank was ready to do business, this man would act as cashier until the bank was able to get on its feet. As it appeared the campaign would be a success, a suitable building was started and finished during this time. The money was finally gathered in, and the Citizens Bank of Laguna Beach was ready to do business.

Mr. Springer was a broker who had been operating in and around Los Angeles. Apparently, no one knew anything about him except that he was ready to put up $12,500 in the venture. Of course, the banking business was safe because it was thoroughly protected and governed by law.

One of the first things we discovered was that the man who was to act as cashier until the bank could get on its feet wanted two hundred dollars per month for this service, and Mr. Springer wanted seventy-five dollars for acting as president and attending two meetings, while the directors were offered five dollars for each meeting, but they refused to accept it. The next thing that became apparent was that we were not getting all the business of the village. We had a bank, a president, a cashier and a board of directors, but did not have a banker. There was no one in the outfit who knew anything about the banking business. This went on for some time, while the directors knew very little about the real condition of the bank.

Part III

Finally, we were summoned to San Francisco to report to the bank examiner. Here we were told that certain things would have to be done if we were to keep the bank open.

Mr. Springer, being president and owning half of the stock, suggested that we see a friend of his who was working in a bank in a small town and see if he would act as cashier. So this man was engaged, but before he had taken his place, a man walked into my office (as I happened to be vice-president). He said his name was James B. Neal, that he was experienced in the banking business and had a friend, a Mr. Wood, who would act as president if he were to have the job of cashier. Mr. Wood was well known as a man of experience in banking, and this was the setup that we should have, so I recommended that we make the change. This was acceptable, and the other man was given pay for one month and permitted to look for another job, which he found.

There was another man who wanted to buy the bank, but this did not meet with approval in town, so one day I went to his place to try and talk him out of it. I was with him for about two hours. He wanted the bank and wanted me to stay with him, but I could not see it that way. I finally told him he was not popular in town and would only be buying a headache.

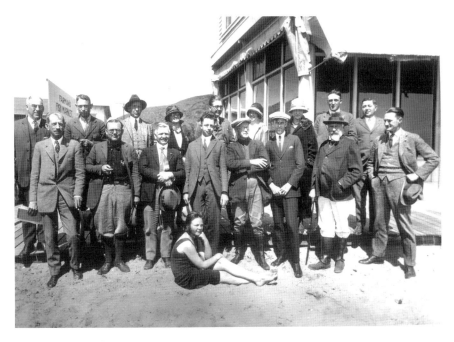

Laguna Beach Chamber of Commerce. Joe is standing in front, third from left. *Historical Collection, First American Financial Corporation.*

Finally, his aged mother came out from where she had been sitting in an adjoining room and advised him to give up the matter, as I had suggested. She did this in a nice way, and I honored her for it, while to win the mother over against the wishes of her own son made me feel like a diplomat.

All this adds up to the fact that Mr. Springer still was practically the owner of the bank, that no one wanted him and that there was no way to make him sell his stock.

The stock was a liability and if the bank should close its doors would be worth less than nothing, but Mr. Springer wanted a profit, and arrangements were finally made whereby he was paid a handsome profit for his holdings. All this added burdens to the bank and cost Mr. Neal several years of careful work to bring it onto a sound basis.

Later, it was sold to another group of men who seemed more interested in personal gains than they were in the good of the community. It was finally sold to the Bank of America. Though the Citizens Bank of Laguna Beach was no more, it had made good.

THE TOWN PUMP

The water system broke down. This was the water system that had grown up with the town, or perhaps it would be better to say that the town had grown up with the water system. However, this water system had neither made a tree nor a vine; it was just a meandering plant. It wandered along the roads and over private property in its efforts to serve the people as they came in. Now the town had outgrown the water supply; the steady pumping had taken the sand from the bottom of the well, and it had caved in.

People had got along without water, but they could not go back to the old ways. The situation was serious.

I permitted water to be brought from my place in Aliso Canyon, but this took time—and the water was quite salty. It was good for many purposes but not good to drink, and many flowers and shrubs were killed by it. However, we managed to pull through the crisis with the help of what became known as the old town pump. This pump had been installed several miles up the canyon by the side of the road where there was a very small seepage of water. It had been installed by a farmer who had moved away. It was very rickety and loose-jointed but would bring up the water, and the water was good. This old pump began to assume an importance that was

entirely out of proportion to its true value, as there was someone standing ready from early in the morning until late at night to draw out what little water was able to trickle into the well. A line would form composed of people armed with jugs, bottles and canteens, ready to carry the precious fluid away to their homes.

There was no other watershed to which Laguna Beach had any legal right. The only adequate supply was in the Santa Ana river basin fifteen miles away. If we were permitted to get water there, it would be very expensive to say the least, while it was being drawn on heavily for local use and the entire county was beginning to feel the shortage of water. Anyone would be able to start an action in court, in which case there was nothing we could do. However, there was no alternative. We had to get water or fold up.

It was figured that the necessary land, pumping machinery, reservoirs and distribution system would cost $600,000, and this proposition was put up to the people for a vote. Almost the entire voting population came to the polls, and out of 438 votes that were cast, there was not 1 dissenting vote. One vote was thrown out because of some irregularity, but the vote was unanimous. I presume this was a world record. The people might have been divided on other things, but they were not divided on the necessity for water.

Each vote carried a financial burden equal $1,370.

This water system has a history of its own that has no place here, but after it was installed I found that nearly all of my land was high and dry; my part was represented by taxes instead of water, for a plan was adopted of serving only the land that had already been served. I found that cooperation could be a one-way road instead of a street that carries traffic both ways. However, the city continued to grow. It did not come to the end of the line.

The town pump was abandoned, forgotten; it disappeared or was stolen. People wondered what had happened to it and felt that it had not been properly honored. But things have queer ways. One morning, it was found resting on the steps of the Water Office, and it has been restored to its proper dignity as a relic.

Life as We Find It

In my isolated experience, as recorded here, I had placed my estimation of humanity a little high. In view of my experiences, perhaps I was not justified. I knew there were many persons who could not be trusted but did not know

how many there were or where they lived. The common underground current of taking advantage when it was possible was somewhat new to me. Like the primitive Indian, I expected people to do what they agreed to do. I thought that people most always reached places of responsibility and trust because they had been found worthy. It was difficult to realize that people sometimes used words just to cover up their intentions. I had been living in a world of my own and had given little thought to such things.

I realized that everyone was able to see things only from his own viewpoint but did not know how much that viewpoint might be influenced by their desire for gain. All my life I had longed to be able to talk things over with other people, only to find that it multiplied troubles instead of reducing them. I had been playing the part of a lone wolf for a long time. Now, in my new position, I found I was playing the part of a little lamb.

I have made lots of mistakes but always thought they had some value. Perhaps the lesson was worth what it cost, but the most expensive and the most difficult lesson to learn was in contact with my fellow man where I was in the position of having to decide when he was using words to cover up his intentions. So I am going to digress and make a few observations on this point.

This is not that I think less of the human race, for I think they are on the way to bigger and better things and the only way to reach bigger and better things is to be bigger and better. There is no use becoming discouraged because these things come slowly. So the following comparison is not because I am dissatisfied with the human race but that I think more of some of the other animals.

When I was on the ranch and a coyote made his appearance, I knew he was honest. That is, I knew he would steal chickens. I knew he did not come with any intention of trying to make them think he was their best friend. I knew—and so did the chickens—just exactly what he wanted. We therefore knew just what to do, and I had my own way of dealing with him.

When it came to dealing with my fellow man, I found it difficult to tell whether he wanted to steal chickens or not. It is also difficult to tell how many he will take if he can get a chance. Then it also makes a difference how fat they might happen to be; for a fat chicken is easier to catch and also is better eating.

Then there are men who would not think of stealing just one lone chicken, but if you trust him you may wake up some morning only to find that he has cleaned out the whole roost. Then the worst part of the situation is that when a man steals chickens, he claims protection under the law, while a

coyote never claims any such protection. It can thus be seen that it is much more simple and more satisfactory to deal with a coyote.

I presume that all the traits that go to make up animal life in the world are to some extent still lingering in the human animal. However, there is one of these animals that seems to have left a more enduring mark and lasting impression than any of the rest. This animal is known as the fox. He is smaller than the coyote, and his nose and ears are a little more pointed. He is an attractive fellow and very clever. In some ways, he is very useful, for he furnishes a great deal of sport for the men of the race, and the girls are almost universally very fond of him. That is, they are proud to have his skin. As stated before, he is very clever, and it is not always possible to tell what to expect of him. Sometimes when you think he is on dry land, you will find he has been wading in the water. Then when you think he has been going downstream, you will find he has been going upstream. When you think you have him cornered, you just find that he is not where you thought he was. However, you can always be sure that he will steal chickens. Then there are other things he will take, and he is not particular to whom these things belong, so it becomes necessary to keep watch on everything when he is around, and if possible to keep it under lock and key, for even your reputation is not safe.

He has a worldwide reputation that he has justly earned. In fact, his cleverness has earned him a reputation that is enjoyed by no other animal, but he is honest and justly proud of his reputation. He does not try to conceal the fact that he will steal chickens and, when he is caught, will take the rap himself and does not claim protection under the law but will go down fighting.

There can be no doubt that it is desirable to be clever, but there are other ways for a human being to be clever besides stealing chickens. However, there may be some good in all of this, for it teaches people to be alert and not to be too sure of themselves. I have no intention of criticizing the plan of things and am still a confirmed optimist. I believe the human race is going forward—also that there is plenty of room where they are going—and they are not likely to come to the end of the line.

There is one more animal to which I wish to draw attention. It is not necessary to mention his name, for he is well known. Indeed, he is almost as well known as the fox. His reputation is worldwide, and sometimes it reaches even where the fox is unable to go. He is an attractive little fellow and is partly black and partly white. He is rather innocent in his ways and does not steal chickens—that is, unless they are very small. However, he

will suck eggs, but he does more good than harm and, in fact, is a rather likable chap. Unfortunately, however, his principal bid for fame is that he is not good company. One of the reasons why he is not good company is that he has been provided by nature with a disagreeable means of self-defense. He does not come out in the open and take his part in a fair fight but tries to get away under cover of what are considered very disagreeable conditions. Therefore, his reputation rests under a cloud; it does not stand out in bold relief like that of the fox.

These animals are not entirely responsible for their attitude toward things, because they have grown up that way and do not know any other way, and it is quite possible that this particular animal does not know that he has a bad reputation. For, in reality, he is not bad.

A human being is in an entirely different class from these animals, for he walks upright on two feet while the others have to use four. Then he has hands to do things with and a voice with which he can express all his thoughts, so he is living on an entirely different plane from all the other animals.

The difficulty comes when he fails to use his superior faculties to serve the purpose for which they have been created and sometimes uses his voice for the purpose of deceiving.

The only way the four-footed animals can speak is through their actions. In this way, they reveal themselves.

In this way, man is much the same. He reveals himself through his actions. By his actions he is classified and remembered.

Joe surrounded by his grandchildren: In his arms, Kelly Boyd (*left*) and Bebe Santmyer (*right*) with Steve Santmyer behind Joe. On the floor are (*left to right*) Thurston (Happy) Boyd, Gretchen Santmyer and Barton (Bo) Boyd. *Thurston-Boyd family collection.*

A local artist presenting to city hall her portrait of Joe with Lou Zitnik in the center of the photograph. *Historical Collection, First American Financial Corporation.*

Joe giving his grandson Kelly Boyd and neighbor Bonnie Couse a ride in a wheel barrow followed by his grandsons Steve Santmyer (*left*) and Happy Boyd. *Thurston-Boyd family collection.*

EDITOR'S NOTE

During the time my wife was collecting photographs at First American Financial Corporation in Santa Ana to include in the reprinting of grandfather's book, she was handed a folder that contained a news article from the *Los Angeles Times* dated November 15, 1971. It told of a Thurston family reunion held at the site of the Thurston homestead—known then as Aliso Creek Inn and Ben Browns Golf Course. The reunion was arranged by the Laguna Beach Historical Society along with the daughter of Joe's sister Mrs. Charlotte Jennings of Santa Ana (then age ninety-two), her mother being Harriet Elizabeth Thurston Buccheim. Also in attendance was eleven-month-old Dennis Haughry; his mother, Lorna; and Harold Garland of Santa Ana, whose mother was Claire Thurston, among others in attendance. The news article also told of a 1,322-page manuscript called *Children of Aliso*, written by Harriet, Joe's sister, and indicated that it might be published as a book some day. To be able to locate this manuscript would be fantastic. The family also stated that Marie was Joe's second wife. This was a very big surprise to me. However, it is stated by Joe in this book that some things were intentionally left out.

In the future, our family would hope to hear from any descendants of Joe's sisters and brothers to possibly hold a twenty-first-century reunion at the original site of the 1871 homestead, which is presently and fittingly named the Ranch, the new owners having completed a lengthy, full renovation of the ninety-two-room inn and restaurant, with the nine-hole golf course remaining as beautiful as ever.

The Ranch holds concerts regularly, which are enjoyed by all. My grandfather felt the site would be perfect to hold concerts, as noted from an excerpt from his book in the section entitled "The Place": "Back of me on the steep side of the hill are the great rocks that fell so many years ago. They are still standing on the steep side of the hill where they stopped in their headlong crash, but the hill is once more covered with native brush. The steep bluff whence they fell makes a great sounding board that sends the vibrations all over the valley, and sometime in the future it may serve to send sweet music where it may be heard by throngs of people."